HAUNTED
BLOOMINGTON-NORMAL,
ILLINOIS

HAUNTED
BLOOMINGTON-NORMAL, ILLINOIS

DEBORAH CARR SENGER

FOREWORD BY JANICE OBERDING

Published by Haunted America
A Division of The History Press
Charleston, SC
www.historypress.net

Front cover: McLean County Museum of History/Cruising with Lincoln Route 66 Visitors Center. *Courtesy of Stevenson-Ives Library Collection.*
Back cover: Route 66/Main Street Historic Bloomington. *Courtesy of Cari Towery; inset:* Architect Bob Edwards's restoration vision of Ryburn Place. *Courtesy of Terri Ryburn's collection.*

The image that appears on the part division pages is the Historic Illinois U.S. 66 Route shield. *Courtesy of Illinois Route 66 Scenic Byway.*

First published 2016

Manufactured in the United States

ISBN 978.1.62619.663.6

Library of Congress Control Number: 2016938312

Notice: The information in this book is true and complete to the best of our knowledge. It is offered without guarantee on the part of the author or The History Press. The author and The History Press disclaim all liability in connection with the use of this book.

For my grandchildren: Sage and Brenna

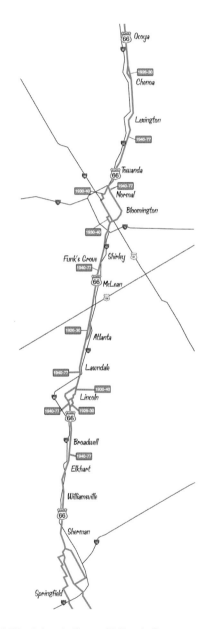

Central Illinois iconic Route 66 Scenic Byway map.
Courtesy of Illinois Route 66 Scenic Byway.

CONTENTS

FOREWORD

Writing a book is a daunting task, all the more so when the writer has chosen to incorporate two of her favorite subjects: history and hauntings. Why is this? You see, there are any number of books on history and just as many on ghosts and hauntings.

However, the number of books narrows considerably when the two subjects are combined. This is because many people don't see the correlation between history and hauntings. Admittedly, such a connection is not always evident. But it exists nonetheless. And it is such that you cannot fully appreciate one without an appreciation of the other.

The premise of Deborah Carr Senger's book is that the existence of ghosts and hauntings is a fact, one that is woven into the historical background of Abraham Lincoln and Route 66 in Bloomington-Normal.

History and ghosts—few topics are as fascinating. Ghost hunting is a popular endeavor, thanks in part to weekly TV shows on the subject. And while these may be interesting to watch, they bear little resemblance to a true haunting investigation. As a ghost-hunting historian, Deborah Carr Senger brings her readers along on some of her real investigations in the Bloomington-Normal area. And because she is a ghost hunter who also happens to be an amateur historian, Deborah has a definite advantage. She possesses a fuller understanding of the locations and the ghosts she encounters. Understandably, it is difficult for those who don't share this dual interest to comprehend, much less see, the connection between history and ghost hunting.

Ghost hunting and history should be enlightening, enriching and fun. And this is where Bloomington-Normal's own Deborah Carr Senger excels. Deborah is my friend. I first met her many years ago at a ghost event in Virginia City, Nevada. With a shared interest in history, ghosts and hauntings, we formed a fast and lasting friendship.

Since that time, Deborah and I have investigated many locations together. From those experiences, I can tell you she is vivacious, energetic and meticulous; she is a gifted medium who possesses a keen awareness of the importance of history, coupled with a witty sense of humor. You will soon discover this in the pages of her book. You will also see that Deborah is a ghost hunter who leaves no stone unturned as she weaves her historic and investigative paranormal stories.

Also evident within these pages is the love Deborah has for her subject, her chosen home of Bloomington-Normal, and for its unique history and hauntings. Her investigations are not merely flat field reports of EMF readings and EVP reports. She makes good use of her God-given gift of mediumship whenever she delves into a haunting case and shares it with her reader. It is this mediumship that adds richness and depth to Deborah's book.

As her friend, I will tell you that she wears many hats in this field. She is a ghost hunter, a medium and a paranormal investigator, researcher and historian. This may be a heavy appellation to pin on the diminutive Deborah, but it is one she rightfully deserves. There is no denying that she is a lover of history who knows ghosts. Now prepare yourself for a delightfully entertaining journey into history and the realms of the paranormal. Once you've seen Bloomington-Normal through Deborah Carr Senger's eyes, I promise that you will never look at it in quite the same way again.

Janice Oberding
Author, para-celebrity, historian

ACKNOWLEDGEMENTS

With sincere thanks and love to:
My husband, Tom,
My mentor and dear friend, Janice Oberding

And

To the Spirits of Bloomington Investigation Team (past and present):
Adam, Barb, CJ, Chris, Chuck, Connie, Diane, Heather, Holly, Jan, Janet, Laurie, Lillian, Linda, Lisa, Pamela, Phil, Phillip, Sean, Steffanie, Stephanie, Susan, Tanya, Tim, Tom, Veronica and Wally.
Special Guests: Chris Hotz, Janice Oberding and Paula Schermerhorn
A special thank-you for your outstanding photography talent: Cari Towery.
A sincere thanks for all the insightful paranormal impressions so readily shared for this book and to local merchants, home owners and historians and to our participants on all of our tours and investigations that allow us to continue to bring history and haunts alive on Route 66 in Bloomington-Normal.
You know who you are.

A special gratitude to . . .
The past and present citizens of McLean County and beyond . . .
The true *spirits* of history and haunts on Route 66 in Bloomington-Normal.

Special thanks to the following:
Bloomington Public Library, 205 East Olive Street, Bloomington, IL 61702
Cruisin' with Lincoln on 66 Visitors Center, 200 North Main Street, Bloomington, IL 61701
"The Fort," Lexington Genealogical & Historical Society, Inc., 318 West Main Street, Lexington, IL 61753
Illinois Route 66 Scenic Byway, Springfield, IL
The Lincoln Heritage Museum's McKinstry Room., Lincoln Heritage Museum., 300 Keokuk Street, Lincoln, IL 62656
Lincoln Public Library, 725 Pekin Street, Lincoln, IL 62656
The Stevenson-Ives Library, McLean County Museum of History, 200 North Main Street, Bloomington, IL 61701

This book contains personal accounts of my own and shared paranormal and historical experiences. These observations are based solely on my own interpretation of the events unless otherwise noted.

INTRODUCTION

Bloomington-Normal has many haunted stories to tell. The community was established in the early 1830s, when James Allin heard that the area was being considered for the county seat. He immediately donated some of his own property to establish "high land" for government and business opportunities. The area would become downtown Bloomington. Here a young, eager Abraham Lincoln soon showed up to join the Eighth County Court Circuit.

Mary Todd Lincoln brought me to Bloomington-Normal. Work brought my husband, Tom, to the area. When we first visited in December 2007, we were content living in the St. Louis area. Family lived nearby, so Tom planned to work in the Bloomington-Normal area while I used St. Louis as a home base for my work as a spiritual medium and historic-paranormal investigator.

Bloomington continued to thrive through the decades, evolving into the Twin Cities of Bloomington-Normal. America's historical timeline is clearly marked through the development of these midwestern towns. Lincoln, politics, the universities, the railroad, Prohibition, Al Capone, women's rights, Route 66 and major corporations set the stage for historic benchmarks and provided the ideal backdrop for local legends, lore and ghost stories.

From that very first snowy morning in December 2007, we were enchanted. Historic homes, sites and neighborhoods and Route 66 remain, reflecting the growth of America from the 1800s to today. The David Davis Mansion and Ewing Manor offer frequent tours, and yearly events such as

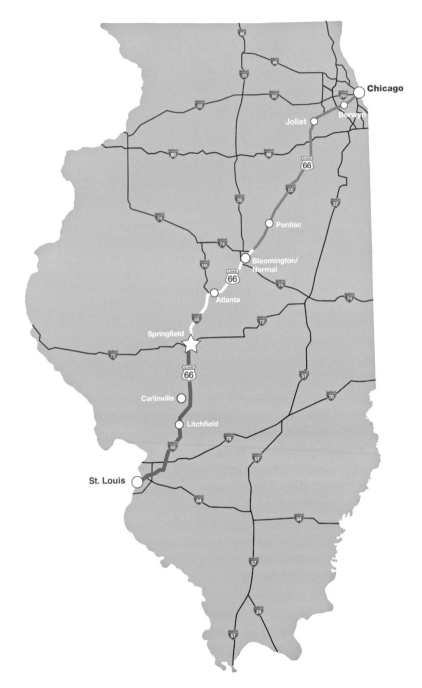

Illinois State Route 66 Scenic Byway map. *Courtesy of Illinois Route 66 Scenic Byway.*

the Old House Society's Annual Tour of Homes and Christmas at the Mansions allow ample opportunity to glimpse into the past. Route 66, built parallel to the old Chicago & Alton Railroad, has local sites such as Funks Grove and Ryburn Place/Sprague's Super Service. Visitors can experience "The Mother Road's" tourist attractions while "Cruisin' with Lincoln on 66."

Enthusiastic paranormal participants. *Courtesy of Connie Hoagland.*

Mary Todd Lincoln and the spirits of Bloomington and Normal told their stories to me. Clearly, history still echoes down the streets and alleys of the Twin Cities. "Looking for Lincoln" signs mark the residual shouting grounds of political rivals and haunts. You can almost smell the burnt cinders as they fell through the air during the early morning of the great 1900 fire. Prohibition still resonates with the screeching tires of a gangster's getaway on bloody Route 66. Big Foot sightings are still questioned by experts and locals. Along with the incredible history lessons, these are the tales not found in the reference sections of local libraries, but are buried in the peaceful and manicured cemeteries.

As the Twin Cities' secrets unfolded, so did my relationship with Mary Todd Lincoln. A few local ghost stories and legends are well known: Kelly's Bakery's little girl ghost; University of Illinois's ghost, Angie Milner; the "lady in red" at Illinois Wesleyan University; and Bigfoot appearances in the Funks Grove area. In addition to these local classics, other realms of the paranormal, both present and past, are now being told. Murder, mayhem, tragedies and Mary Todd Lincoln can be found in these stories, and there are other spellbinding tales down the "yellow brick road" of haunted and historical streets of Bloomington-Normal.

PART I

FUNKS GROVE:
CRUISING IN ON ROUTE 66

1

FUNKS GROVE

LINCOLN AND ROUTE 66

Iconic Route 66 stretches a little over 300 miles in the state of Illinois, the "Prairie State," from Chicago to East St. Louis, on Missouri's border. McLean County's Route 66 was built parallel to the old Chicago & Alton Railroad and winds its way south from Funks Grove and as far north as Chenoa, with Bloomington and Normal being the primary cities in the county. Funks Grove is the midpoint of Route 66 in Illinois. Abraham Lincoln practiced law in McLean County, and friends such as pioneer Isaac Funk played a key role in his election and presidency. Funks Grove is the perfect gateway into haunted Bloomington-Normal.

FUNKS GROVE

About twelve miles southwest of Bloomington-Normal is Funks Grove—a historic ghost town filled with legends, haunts and the supernatural. Majestic timbers carefully preserved from McLean County's virgin hardwood groves of long ago stand roadside, like sentinels preserving memories of the past. First settled by the Funk brothers and others in the 1820s, the town was home to cattle ranching that fed Chicago's beef industry. Abraham Lincoln was the attorney for the Funk family, and together they helped bring the railroad

to this part of Illinois. Some Funk family members are even rumored to have hosted slaves escaping the South during the Civil War.

Many attractions and historic sites remain among the timbers to entice a stop, including the syrupy taste of Funks Grove Pure Maple Sirup. Locally manufactured and sold by the Funks since 1924, the product is made by boiling sap and not adding sugars. It makes for an incredible, natural sweet treat. The "sirup's" discovery, however, is a mystery. History suggests that the syrupy benefits of the maple trees were likely produced and enjoyed by the local Native Americans to season and sweeten food such as corn and meat.

One of the most popular legends involves an Iroquois chief named Woksis. One night after returning from hunting, Chief Woksis plunged his hatchet into the side of a tree for safekeeping. Underneath the cut was a bowl. The next day, his wife used the liquid from the bowl for water in a venison stew. As the stew cooked, water evaporated from the sap, leaving a thick, sweet substance. The chief and his wife were pleasantly surprised by the sweet-tasting stew. In this way, it was discovered how maple sirup could be made from tree sap.

Bigfoot sightings have been recorded in many areas of the world since the beginning of man. Pacific Northwest Native Americans told "wild men" stories. According to Bigfoot enthusiasts and scientists, these hairy creatures are usually drawn to areas where food is readily available. Some believe that Sasquatch actually migrate southeast from the Pacific Northwest, following the creek beds and seasonal vegetation. Funks Grove could possibly provide the necessary foliage and water source, not to mention the sweetness of sirup, to entice a Bigfoot to get his "Kicks on Route 66."

In the summer of 2005, a local resident was slowly cruising down Route 66 in his 1990 Mustang. Enjoying the beautiful day, he was completely stunned when a large black creature ran behind his car. At first he thought it was a big black bear running into the woods, but then he felt a giant slap on his car. Startled, he pressed down on the gas pedal and quickly sped away. With his heart pounding, he finally slowed down and came to a complete stop. In his mind, he questioned what he had witnessed. After calming down,

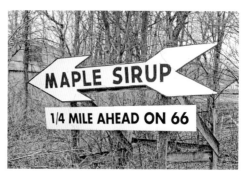

Funks Grove naturally sweet maple sirup on Route 66. *Photography by Cari Towery.*

20

he slowly opened his car door. Looking cautiously in both directions, he got out of his car. He had clearly heard *something*. He carefully examined every inch of his beloved Mustang. As he went around to the back of his car, he couldn't believe what he saw! Five large claw marks were clearly seen on his car's trunk. He was shocked, not to mention stunned and upset. Who was going to pay for the paint job? How was he going to explain these markings to his insurance company? He went home and started to conduct research on the Internet to figure out what could have possibly caused such damage. Despite the markings on the car, many people did not believe his story.

A few months later, there was another sighting from folks who claimed they had seen a large, hairy, upright creature in a ditch. They were in a rural area of Shirley and not going to stick around to see what "the monster" might do!

The Illinois Department of Natural Resources states that there has never been a public request to check for the possible sightings of a Bigfoot. A local zoologist claims that even though Funks Grove is a wooded area, the vegetation is not conducive to supporting a large primate.

The Mustang owner was able to contact a Bigfoot research team in California. The group travelled to the Funks Grove area and visited the areas of the sightings. They did a thorough study, including examining the markings left by the creature and studying the possibility of a Bigfoot's survival in the area. The findings were inconclusive. According to the group's secretary, "the marks [on the car] were not distinct enough to indicate the kind of creature that may have made them." The researchers did conclude, however, that there are enough small rodents, grubs and vegetation for the hairy creature to survive. No mention was made of Funks Grove's naturally sweet maple sirup.

Among the timbers of Funks Grove is the historic Methodist church and old cemetery. Adam Funk, the patriarch of the family, chose the location of the cemetery. In 1830, he was one of the first to be buried there. The church was completed in 1865. Both sites are flawlessly maintained by the Thaddeus Stubblefield Trust to provide for religious and educational benefits and for beautification of the grove. Beautiful and serene, the grove is no place for lost souls.

With simple dignity, Funk's Grove Church welcomes families of all faiths.

Just inside the entrance to the cemetery is a large stone that once marked the location of Isaac Funk's cabin. This memorial was originally located at

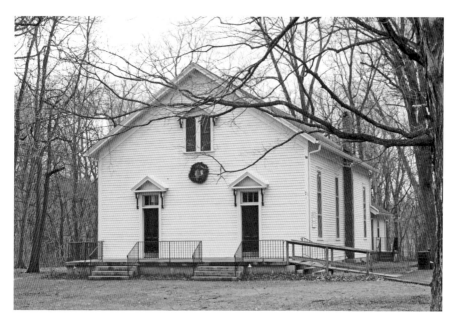

"With simple dignity, Funk's Grove Church welcomes families of all faiths." *Photography by Cari Towery.*

what is now the Funks Grove rest area on I-55. Also near this location, some say, is an old well—and the ghost of a murdered railroad worker. As the story goes, among the group of the railroad workers were two particular men who could not get along with each other at all. Their personalities clashed so greatly that they were kept apart "for their own good." One afternoon, the two men were unknowingly left behind, alone with each other. When the others returned, one man was dead and the other was alive. The survivor said that the other man had tripped and fallen into the well. The dead man apparently has another side to the story, and his screams can be heard in the dead of the night. The location of the well has long been forgotten.

The construction of the railroad lines from Springfield to Bloomington was backbreaking work. Local businessmen, attorneys and politicians such as Isaac Funk, Abraham Lincoln and Asahel Gridley were able to sidetrack the Chicago & Alton Railroad route through Peoria into the region. However, it was the Irish immigrants whose blood, sweat and lives were spilled to build it.

The Irish, escaping starvation from the potato famine, eagerly escaped to America, arriving at an opportune time. The country was growing, and it needed men to do the heavy work of building bridges, canals and railroads. It

was hard, dangerous work; a common expression heard among the railroad workers was "an Irishman was buried under every tie." Construction of the Chicago & Alton Railroad line was no exception.

It has been said that, in the old cemetery in Funks Grove, there is a haunted sadness that leads toward a certain location. This gut-wrenching feeling seems out of character, given the enduring faith and love of the Funks and Stubblefield families. Often I and, later, others have heard the words: "We cannot be forgotten." It is an eerie and ominous feeling of loss. "We cannot be forgotten." And then you see the cross.

A magnificent Celtic cross memorial marks a mass grave honoring more than fifty anonymous souls buried in the 1850s. Railroad workers were often buried in forgotten trackside graves. They died of cholera and were quickly buried in this mass grave. Unmarked for over 150 years, these immigrants and their unmarked grave were honored by area residents haunted by the site. Citizens erected and dedicated the Celtic cross memorial in 2000. The memorial reads as follows:

> *This Celtic cross honors the memory of more than fifty souls buried here in the early 1850s. These immigrants from Ireland were driven from the land of their birth by famine and disease. They arrived sick and penniless, and took hard and dangerous jobs building the Chicago & Alton Railroad. Known but to God, they rest here in individual anonymity—far from the old homes of their heirs—yet forever short of the new homes of their hopes. Their sacrifices opened interior Illinois and made it possible to develop the riches of the land we share today.*

The church and cemetery area also include the Chapel of the Templed Trees. The beautiful outdoor sanctuary in the woods is used for weddings. The pews are made from American red elm logs, and the pulpit is cut from a tree stump. Other attractions in the Funks Grove area are the outdoor and indoor Sugar Grove Natural Center and historic Funks Prairie Home.

The Funks Prairie Home and the Gem & Mineral Museum are just a few miles away. The home was built by Isaac's fifth son, Marquis De LaFayette Funk, in 1863 and 1864. He followed in his father's footsteps as a cattle king, statesman and leader. Marquis's oldest son, Eugene Duncan, founded Funk Brothers Seed Company and created the first commercial hybrid corn in the world. His youngest son, Marquis DeLoss, completely electrified the home, farm and even the grass tennis court. Eastern journalists named the well-lit Prairie Home the "City on the Prairie." During the Civil War, the

Funks Home "City on the Prairie." *Photography by Cari Towery.*

Underground Railroad network assisted fleeing slaves as they headed north. Funks were known to aid those in need and help them continue on their way to freedom. Funks Prairie Home continues to reflect the hospitality and warmth of a bygone era.

Unlike other area hauntings, there is no mischievous or bad feeling at Funks Prairie Home. Here, you are welcomed with a Funk's goodness that permeates the land and the home. As you step through the comfortably decorated rooms, the warm furnishings reflect the family's traditions. A rocking cradle or moving chair is simply the result of a crisp spring breeze floating through the window.

Funks Grove deserves a stop before you continue north on Route 66 into Lincoln's Bloomington-Normal. A mysterious creature and lost souls linger among the woods and farmlands. In this town rich in history, the spirits of long ago speak out, and the Funks' and Stubblefields' enduring faith and generosity live on through their living legacies.

PART II

BLOOMINGTON: DRIVING ROUTE 66

2

THE EAGLES CLUB

ROUTE 66 AND LINCOLN CONTINUES . . .

Heading north on historic Route 66 toward haunted Bloomington-Normal, one has several options. Through the years, the "Mother Road" has been reconfigured to allow for city and road development. The South Morris Avenue runs by Park Hill Cemetery, a final resting place for some of Bloomington's most interesting spirits. The avenue then continues by the Miller Park Zoo. The zoo unofficially began around 1900 with the arrival of "Big Jim." Reportedly, a cub had fallen off a circus train into a farmer's field and then was donated to the city. Miller Park Zoo, open daily, is one of the few zoos located directly on Route 66.

The second option is to travel down Veterans Parkway to shopping, restaurants and hotels. The third option is far more haunted. Take a left onto South Main Street and head straight into historic downtown Bloomington.

THE EAGLES CLUB

Contrary to beliefs, a ghost can be quite patient. One of the most haunted locations in downtown Bloomington was the site of the original Phoenix/Mid-City Hotel. Early investigations at the Mid-City revealed a possible Korean War–related ghost named Mike. He was described as a middle-

aged, dark-haired spirit who liked brunette women. In one incident, he tried to separate a couple by pushing the boyfriend from the room so that he might keep the dark-haired beauty for himself.

Unlike most of the other spirits at the Mid-City Hotel, his ghostly presence had not been confirmed before the site was renovated into condominiums. Mike's paranormal activity was rare; in fact, since the Mid-City Hotel tour closure several years ago, he had been quiet—very quiet.

The Fraternal Order of Eagles Club is on South Main Street in downtown Bloomington. Organized in 1898, the FOE is a North American organization that has played a key role in the creation of Mother's Day, Social Security and Medicare, thanks to a dedicated membership. Over sixteen hundred clubs are located throughout the United States and Canada. As community leaders and citizens, FOE members pledge to help friends and neighbors in need. Together, Eagles raise nearly $10 million annually to help fund the FOE Charity Foundation, which awards grants to local and international organizations to aid in patient care and prevention for a variety of causes. Their clubs are open to the public and offer private event opportunities and entertainment for local communities.

In January 2016, Route 66 enthusiast Terri Ryburn was raising money to fund the taping of a Route 66 *Hank and Rita Show* movie. She was using the local Eagles Club for her fundraising activities, including the movie and a comedy show featuring Robin Brayfield and headlining Dr. Ryburn.

I love to travel Route 66, especially in Illinois, to gain information and stories in order to promote, develop and preserve the iconic road. In January 2016, the Spirits of Bloomington paranormal investigation team had been given permission by Terri to look into her historic Ryburn Place, formerly known as Sprague's Super Service in Normal. As the investigation ended, she served tea and asked if any of us were interested to play 1980s audience extras in her film. My intuition immediately said "yes," before logic set in. I was writing, and my time was very limited. Another investigator, Heather Brown, said she would if I would. I had to trust my intuition; besides, I knew Heather. It would be a good time. Neither one of us had ever played extras on a real movie set!

Heather and I attended the Eagles Club several times that week. On Friday night, during the live production of *The Hank and Rita Show*, I felt the existence of a male spirit behind me. His presence was strong, despite the attention I was giving to the show. He was persistent. I acknowledged his presence and asked him to please provide me some more information. He

appeared to be a dark-haired man, very sad and holding a folded American flag. He was a bit disheveled, dressed in casual pants and a collared shirt. As the evening progressed, my mind was on the entertainment, but I felt his presence standing behind me. As the show was coming to an end, I felt him nudging me and being a bit more persistent. He had a very special request. I would be returning the next morning to serve as an extra in the audience. As I was leaving, I assured him that our conversation would continue the next day. Besides, I needed some personal time to figure out my Madonna outfit for the filming.

The next morning, during the taping of the show, he appeared again, still holding the flag. He told me his name was Mike and reminded me politely but with determination about his special request. I assured Mike that I would try to help him out. I immediately wondered who could help, and Robin's name came to mind. I had met Robin during the fundraising events and knew she was affiliated with the club. She had been seated at the table with Heather and me during the rehearsal and taping of the movie. During Saturday's lunch break from taping, I felt compelled to share Mike's information and particular request with Robin. She remembers the account well, as she describes below:

> *I had the pleasure of meeting Deborah Carr Senger at the Eagles Club in Bloomington, Illinois, while rehearsing for a taping of a show during the weekend of January 29, 2016. We both attended the show on Friday night and the taping on Saturday. During our lunch break on Saturday, Deborah shared with me that she had connected with a male spirit during her visit to the club Friday evening. She told me that the spirit poked at her shoulder and told her, "Tell them to put the flag back up." She told me she believed his name to be Mike and that he appeared to be a veteran. He showed her a United States flag that had been folded in a triangle and placed on a shelf.*
>
> *I was dumbfounded, because I knew the flag was in the office of the Eagles club and had been for some time. J.R. Quinn found the folded flag that had been placed on top of a file cabinet. We did a little investigative work and discovered the flag had previously hung under a spotlight on the wall at the club, right behind where Deborah sat on Friday night. It had been taken down when the interior was painted a few years ago and had not been put back up. A little research of the building revealed it had originally been built to house both the Eagles Aerie 527 and the Machinists Local 1000 union office. A check of the original Aerie*

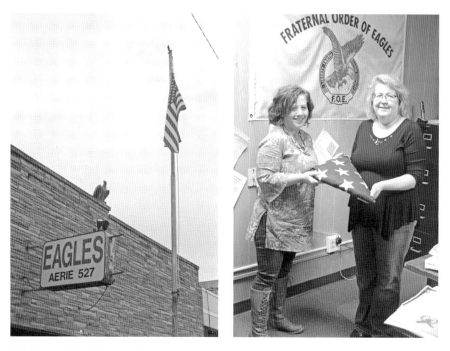

Left: Eagles Club: "Respect, honor and doing the right thing." *Photography by Cari Towery.*

Right: Shivers went up and down my arms when Mike's American flag was first presented to me by Robin & J.R. Author pictured with Robin. *Photography by Cari Towery.*

> *charter from 1904, which is still hanging on the wall, showed a founding member named Michael Fitzgerald.*

J.R. explained that the flag dated to the Korean War and had been put up for years. As I was handed the folded flag, a surge of energy jetted through my hands and coursed throughout my entire body. Flashbacks started rushing in: Korean War, Mike, dark hair . . . and then I knew it was Mike from the Mid-City Hotel. There is no evidence that he stayed at the hotel, so perhaps he had been trying to communicate about the fallen flag all those years ago. The hotel was less than a mile down the road. Perhaps he had reached out then and waited patiently until someone listened at the Eagles Club downtown.

A few days later, as I was reading over some Funks Grove history for research, my mind kept reflecting back to the Eagles Club experience. Michael Fitzgerald had found a way for the flag to be remembered, and my thoughts took me to Funks Grove Cemetery and its Irish Railroad Workers

mass grave. Those poor souls haunt me. "We cannot be forgotten." The six-foot Celtic cross marks the mass grave of the fifty anonymous railroad laborers who died of cholera in the 1850s.

As I read on, I was reminded of an interesting fact. The organization that remembered them and dedicated the Irish Railroad Workers Monument in 2000 was Machinists Local 1000. The union had initially set up shop years ago on South Main Street, inside the Eagles Club building in Bloomington. The two organizations originally housed at this site have strong reputations for respect, honor and "doing the right thing." Michael Fitzgerald wanted honor given to the flag, and the union wanted honor given to the forgotten immigrants. Mike's patience had finally paid off, with the assistance of a brunette female psychic.

EVERGREEN MEMORIAL CEMETERY

LINCOLN AND ROUTE 66

Near the Eagles Club, right off Main Street/Route 66, is the entrance to Evergreen Memorial Cemetery. An afternoon can easily be spent meandering along the winding avenues and towering trees of the majestic cemetery, established in the 1820s. Buried here are many notable past citizens of Bloomington-Normal, including some of Lincoln's colleagues and personal friends, such as Judge David Davis and Asahel Gridley. It is a fine resting place for the treasured and unsettled.

THE EVERGREEN CEMETERY

Before turning off Main Street into Evergreen Memorial Cemetery, be on the lookout for hitchhikers. A local legend claims that a teenage girl will flag down your car and politely ask for a ride into the cemetery. Sitting in the back seat, she aimlessly chats away. Her lively disposition quickly turns deadly silent as the car approaches the cemetery's entrance. As the driver stops and turns toward the back seat, the good citizen realizes that the young girl has vanished! Ghost hitchhiker stories are common, but rarely true. Local legend says that her body is buried in the cemetery, but others question if she ever really existed. She was most active in the 1980s, so perhaps she

Watch out for hitchhikers as you enter Evergreen Cemetery. *Photography by Cari Towery.*

caught the final ride on Route 66 to happily ever-after. The hitchhiker's identity may never be discovered, but the worship of Marie Litta has never been questioned.

A cult following can sometimes lead to unusual rituals. Born Marie Eugenia von Elsner on June 1, 1856, on East Front Street in Bloomington, the young girl had an outstanding talent for music. She acquired "her genius and mental endowments from her father," Professor Hugo von Elsner, and a powerful voice from her mother, Amanda Dimmit, "who was known to have an unusually sweet but untrained voice."

The Victorian era, coinciding with Queen Victoria's reign of Britain (1837–1901), quickly swept throughout America. Decorative fashion, ornate architecture and sentimental customs reflected this romantic and mystical age. Marie's talents, including her engaging voice, sweet charm and angelic looks, represented the refined sensibilities of the time. Her father felt she could become the leading singer in the world.

Her training paid off, and the "Queen of Song," using the stage name Marie Litta, was soon performing throughout the United States to amazing reviews. Newspapers reported that Litta "had to be the reigning musical star of America." Marie's career soon included international concerts in

Europe, including Paris and Vienna. At the height of her career, the pretty young singer's performances were earning her $75,000 a year, which would equal about $2 million today. She sent trunk loads of lavish gifts back home to her friends and family in Bloomington. Despite her international celebrity status, she continued to have a kind, sweet and giving heart. Her fans, both far and near, adored her.

Demand for her dreamy soprano voice grew, and her manager accepted more and more bookings, until her small, delicate body could not handle it. Despite her weakened state, as a worldwide star she was expected to perform, and she did not want to disappoint her audiences. By the spring of 1883, she was deathly ill; she collapsed after a concert in Michigan. Marie quickly boarded the next train home. Thousands of admirers gathered at the station to wish her farewell.

On July 7, 1883, Marie passed away at her mother's home in Bloomington at the tender age of twenty-seven. Her family and friends were devastated. Her fans were overcome by their loss of sweet Marie. They idolized her talent and sweet disposition. Over twelve thousand people from around the world attended her funeral. All the stores in Bloomington were closed to allow the citizens to mourn their beloved "Queen of Song." In Marie's honor, her bereaved fans and hometown citizens raised funds to erect a beautiful scripted monument at her gravesite in Evergreen Memorial Cemetery.

Her sun rose through clouds in the morning and was eclipsed at noon. By a life laborious and heroic, her girlhood witnessed the triumph of genius. Welcome to the banks of the great artists of her time. She was loved most for her pure and gentle life, and so loving hands weave roses with the laurel in her chaplet of fame.

Marie's father had died just a few years before, and her mother was in deep despair. Victorian customs coveted the living's admiration for the deceased. Bizarre rituals, such as weaving human hair into wreaths or corsages, photographing deathbed scenes and using the departed's teeth for survivor's dentures, were customary. In her own grief, her mother mourned her daughter's death by cutting up Marie's beautiful petticoats and gowns into small pieces and distributing them to "the faithful" as "relics" of Marie. Her mother's behavior may seem bizarre, but Victorian customs encouraged survivors to share memories of the deceased. Such behavior was accepted etiquette, allowing people to show their admiration for the dearly departed.

Modern-day citizens of Bloomington remember Marie in a less dramatic way. Bloomington Parks and Recreation sponsors the Marie Litta Park, a small corner playground on Gridley Street near the Oaks Mansion. Marie's sweetness lives on in the angelic faces of children at play.

Other stories of Evergreen Memorial Cemetery involve a "wrinkle in time." The term was introduced in 1963 by Madeleine L'Engle, author of the science fantasy book *A Wrinkle in Time*. Two separate worlds are connected at the same time, bypassing the distance between them. Such time-lapse experiences have been recorded in the cemetery. Witnessed accounts include sightings of ancient Native Americans, specifically a maiden riding bareback on a gorgeous horse; a strolling Victorian couple; and small children playing peekaboo around the tombstones. Separate accounts speak of a clear vision and then a sudden vanishing of the subjects. Witnesses swear the hauntings are true and note that such sightings usually materialize at sunrise or sunset, as the cemetery is opening or closing. A haunting can also be caused by a twist in fate, not time.

Buried at Evergreen Memorial Cemetery is one of America's greatest baseball pitchers. Some say he was haunted to death. Charles "Old Hoss" Radbourn's professional baseball career started with the Peoria Reds in 1878 and ended with the Cincinnati Reds in 1891. In his 1884 season with the Providence Grays, he pitched a personal record of sixty wins and twelve losses. What an arm! His record of sixty wins in a season has never been broken. At the age of thirty-six, he retired and opened up a successful billiard parlor in Bloomington. He continued to enjoy other aspects of life, such as smoking, drinking, playing billiards, hunting and other vices. He had a reputation for being a bit vain and lived life to the fullest.

Radbourn was miserably disturbed by his own life, long before his death in 1897. "He was an ornery character," said *Providence Journal* reporter and local author Ed Achorn. "He was famous for being a tough, cantankerous guy." A colorful character both on and off the baseball field, it is speculated that Radbourn may be the namesake of several sports-related antics. He often suffered painful leg cramps and called his injury the "charley horse."

According to Achorn, the first documented case of someone giving the finger on film came from a Boston baseball player with a bad attitude. "Old Hoss" Radbourn extended his middle digit to a cameraman when two teams gathered for a group photo in New York on baseball's opening day in April 1886. Seemingly becoming the first man captured on film flipping the bird, Radbourn again gave the finger when posing for an Old Judge Tobacco baseball card. Radbourn always loved to leave a lasting impression.

In April 1894, Radbourn was involved in a horrible hunting accident. As "Old Hoss" was stepping from behind a tree, a friend accidently shot him in the face, causing severe damage. His once-handsome face was maimed, his left eye was blinded and he suffered partial facial paralysis and speech loss. The scars were deep, but the emotional turmoil was worse. Radbourn retreated from society and became a sad, hard-drinking recluse. The *Boston Globe* described the former pitcher in December 1896 as "a wreck of his former self, owing to sickness."

Radbourn was haunted by his former self. His 1897 *Pantagraph* obituary says that Radbourn "grew sick, lingered on from year to year as disease gnawed at his mental and physical being, robbing him of speech, feeling and locomotion long before the final day arrived."

Unlike "Old Hoss," some spirits are laid to rest much too early. But time has a way of bringing someone back to life.

For almost one hundred years, a little girl's grave laid undisturbed among the dead in Evergreen Memorial Cemetery. The fall of 1996 changed everything. Dr. Sally Roesch Wagner was researching Matilda Joslyn Gage, a suffragist, abolitionist, freethinker and prolific author who was "born with a hatred of oppression." A tough and independent woman, she worked closely with Susan B. Anthony. During her research, Dr. Wagner uncovered an amazing family secret and a grave at Evergreen Memorial Cemetery.

On March 18, 1898, Matilda died. Less than three months later, on June 11, her beautiful granddaughter was born to Matilda's son Thomas Clarkson Gage and his wife, Sophie Jewel. On November 11, 1898, the darling little baby died of "congestion of the brain." The family was devastated. The death so upset the child's Aunt Maud, who had always longed for a daughter, that she required medical attention. Her husband, attempting to console his wife, as legend has it, decided to name the heroine in his fairytale *The Wonderful Wizard of Oz* after his niece. As theosophists, both the Baums and the Gages believed in reincarnation and thought this child might have been Matilda Joslyn Gage, whose personal spark is apparently written into the character of Dorothy.

Dr. Wagner's hunt for the small child's grave marker was difficult; when located, the writing was found to be illegible. The discovery of the story and grave made the newspapers; soon, attention came from as far away as St. Louis. The actor Mickey Carroll, who played one of the Munchkins in *The Wizard of Oz* movie, was in the monument business, and he offered to provide a new gravestone. On May 31, 1997, a ceremony was held at Evergreen to unveil the marker Mickey had made for the found heroine. Immortalized,

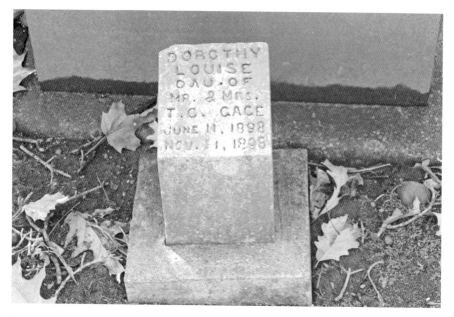

The 1898 tombstone of the original Dorothy of *The Wizard of Oz*. *Photography by Cari Towery.*

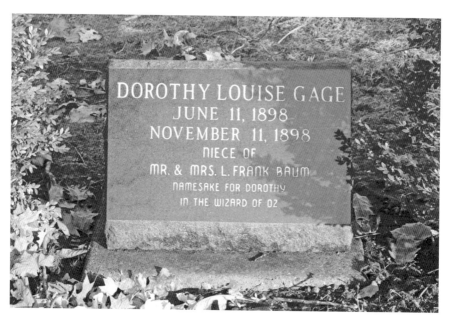

Mickey Carroll's monument dedicated to little Dorothy in 1997. *Photography by Cari Towery.*

sweet Dorothy from the *Wizard of Oz* lives on, like many others in Evergreen Memorial Cemetery. Many childhood dreams do come true.

On the other hand, some childhood memories are best forgotten.

There is a wooden sculpture of a War World II plane crashing into an oak tree, an event that has forever marred the meaning of Memorial Day at Evergreen Memorial Cemetery. The Poppy Plane Crash Memorial marks the tragic plane crash that happened on Memorial Day in 1948. Many alive today are still haunted by that dreadful day; some still see the smoke, smell the fire and duck from flying debris.

Life was slowly getting back to normal in 1948. World War II had ended three years before, and it was time to celebrate freedom and honor the dead. Twin City citizens were celebrating on that sunny spring day, lining the streets in Bloomington for the annual Memorial Day parade, joining commendations at area cemeteries and packing baskets for traditional family picnics. A buzz of a plane flying low over Evergreen Memorial Cemetery changed everything.

Eyewitness Gene Lorch was five at the time, but he can still remember every detail of the day. According to Bill Kemp's interview in the *Pantagraph* of May 29, 2011, Gene was playing outside on that Memorial Day. The sound of a plane overhead got his immediate attention. The young boy was mesmerized by the War World II Vultee BT-13 Valiant training plane in the sky. He noticed the low-flying aircraft as it disappeared over the Bloomington cemetery. Soon after, he saw dark smoke rising from the direction of the cemetery.

He alerted his parents, and they walked the few blocks to the cemetery. They were shocked to see the plane had crashed. Amid the fiery wreckage, one part of the fuselage was in a tree and the other on the ground. Debris from the crash was thrown some 100 feet into a cemetery crowd that had gathered at the Civil War soldiers' plot.

The Bloomington Fire Department quickly arrived, put out the fires and dislodged part of the war plane from the tree. Thankfully no one on the ground was hurt, but the passenger and veteran pilot Chester H. Frahm had died. Pilot James A. Tuley survived. This was no way to remember Memorial Day. Such a senseless disaster still clouds the memories of those celebrating the end of War World II. In 2015, artist Tim Gill carved the sculpture into the dying tree to commemorate the 1948 plane crash.

The "Avenue of Flags" is one of the most impressive displays in the area honoring veterans. During Memorial Day events, the avenues of

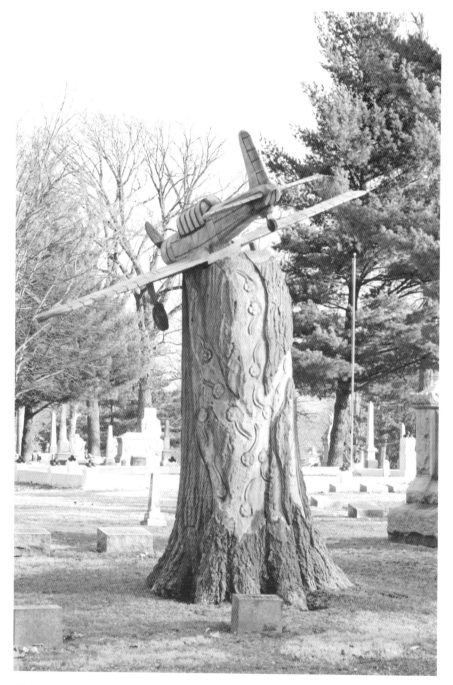

The 1948 Memorial Day airplane crash inside the cemetery is marked by wooden sculpture. *Photography by Cari Towery.*

Evergreen Memorial Cemetery are lined with individualized American flagpoles and plagues representing area veterans. As a spring breeze picks up, over 160 American flags proudly unfurl, symbolizing an impressive display of patriotism. This tradition was envisioned in 1977 by veterans from the McLean County Memorial AMVETS Post 270. Perhaps the flags and recent wood sculpture can help ease the haunted heartbreak of the 1948 tragedy and honor the unforgettable sacrifice of those resting in peace at Evergreen Memorial Cemetery.

PART III

BLOOMINGTON: WALKING DOWNTOWN ON ROUTE 66

McLean County Museum of History/The Cruisin' with Lincoln on 66 Visitors Center

The Heart of Route 66 in Bloomington

The dearly departed are left behind in Evergreen Memorial Cemetery. Some of their stories are right around the corner. Exiting back to Main Street, carefully follow the Route 66 shields as the "Mother Road" reconfigures to the north side of Main Street. The courthouse square provides quite impressive quarters for the McLean County Museum of History and the Cruisin' with Lincoln on 66 Visitors Center on North Main Street.

Following the Looking for Lincoln signs or cruising down the iconic Route 66 in Bloomington-Normal, the McLean County Museum of History and the Cruisin' with Lincoln on 66 Visitors Center provide a great starting point. Integrating legends, lore and ghosts almost always makes history a bit more fun.

McLean County Museum of History and the Cruisin' with Lincoln on 66 Visitors Center

The downtown courthouse square is the starting center for haunted Bloomington. An initial stop at the Route 66 Visitors Center and the McLean County Museum of History provide historical information with exhibits, the Stevenson-Ives Research Library, Route 66 maps and the

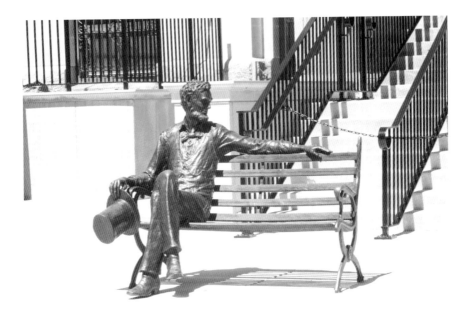

A "selfie" benched opportunity at Harney's Lincoln statue. *Photography by Cari Towery.*

works of neighboring authors and artists. Visitors enter the center through the ground-level plaza on the Washington Street side of the museum. There sits "Old Abe" waiting for visitors to take "selfies" beside him on Rick Harney's statue. The bronze statue was donated to the city by former mayor Judy Markowitz in honor of the Stern family in July 2000. Lincoln knew this location well, because he tried many cases in the second McLean County Courthouse.

When James Allin arrived in the small settlement of Blooming Grove in 1829, he had big dreams. He had heard rumors that the county seat was going to be located in the area, and he was determined to locate the county business site near his general store. He donated much of his own land in order for a courthouse and city to be created. Bloomington was established in 1831. On July 4 of that year, Allin's lots were sold at a big party. The lowest price was five dollars, and the top price was sixty-nine dollars. The money raised from the auction was used to build the first McLean County Courthouse in 1832. The young Asahel Gridley was the contractor for the building. His life, as well as many others, would soon change with the arrival into McLean County of a new attorney named Abraham Lincoln in 1837.

Walking around the courthouse square, "psychic impressions" are a possibility for those sensitive to such residual feelings. An atmosphere of panic may be felt by receptive people. Sensations experienced here include dizziness with sharp chest pain, the smell of smoke and intense burning at the feet.

Four courthouses have been built on the public square. The first one was very simple and immediately erected in 1832 by William Dimmitt and Asahel Gridley. The second was larger and completed on the southeast corner in 1836. The third was more ornate and elaborately constructed in 1868 of limestone and several other outside fireproof materials. Unfortunately, it burned from the inside out in the citywide fire of 1900. Bird's nests fell from the chimney tops of the building into the structure, causing irreparable damage. The fourth courthouse building, still standing, was soon erected after the fire. It has served as the McLean County Museum of History since 1992 and has housed the Cruisin' with Lincoln on 66 Visitors Center since April 2015.

Residual impressions of sharp chest pains and burning sensations, as well as dizziness, can be directly related to the horror of the 1900 fire. Even though no one was killed in the blaze itself, a citizen running away from the

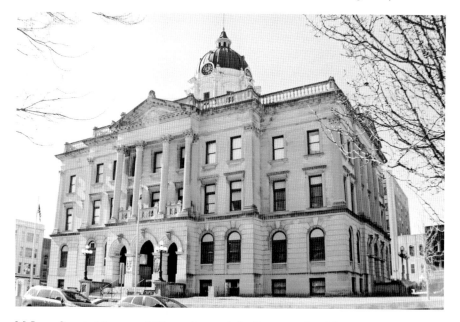

McLean County Museum of History, home of the Stevenson-Ives Library and Cruisin' with Lincoln Route 66 Visitors Center. *Stevenson-Ives Library collection.*

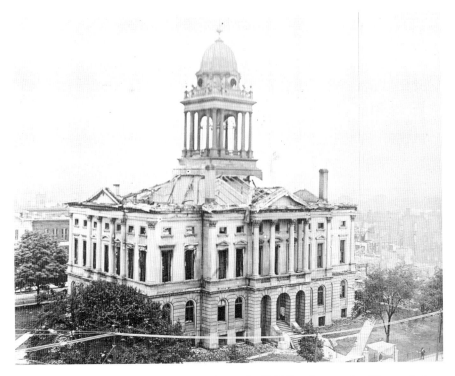

1868 McLean County Courthouse, seen prior to the 1900 fire. *Stevenson-Ives Library collection.*

burning cinders suffered a massive heart attack and died. One report stated that a small, sickly child living in a nearby mansion, dizzy with despair, worried himself to death. Residual feelings continue to bring history alive.

The history museum and research library are accessed via marble stairs or an elevator. The steps are individually indented in the center, clearly marking the century-plus footsteps. Climbing the marble staircase can create a tunnel-like vision, with the residual rush of passing bodies as they quickly move up and down the staircase. Several courtrooms remain open, and the images of the many trials held here for nearly one hundred years can bring a rush of emotions. A feeling that is often described as an "angry" impression along one's own arm has been a rather puzzling psychic experience. This sensation was the impetus to find a reason for such suffering, and soon a search into Abraham Lincoln's trials at the McLean County Courthouse provided a possible answer.

Most of Lincoln's cases in Bloomington and in other towns in the Eighth County Court Circuit were minor squabbles or property disputes. Murder

cases were rare. Lincoln's good friend Ward Hill Lamon was elected state's attorney for the Eighth Judicial Circuit. One of Lamon's first murder cases seemed open and shut, but it got complicated. He asked for Lincoln's assistance on the prosecution. The defense attorney was Leonard Swett, a lanky Lincoln lookalike and a good friend of the future president. Swett was an excellent criminal defense attorney. Lamon and Lincoln had an uphill battle. The following newspaper article was printed almost immediately after the murder:

> *"Murder," DeWitt Courier, October 19, 1855, People v. Wyant, LPAL doc. 133014.*
>
> *One of the most cold-blooded murders we ever heard of, was perpetrated in this place about 2 o'clock P.M. on Friday last. The victim's name was Anson Rusk; the name of the murderer is Isaac Wyant. Last June a difficulty arose between Rusk and Wyant, and the latter attacked the other with a large knife. Rusk tried to avoid a collision with Wyant, but to no purpose; and as a means of saving his own life, he drew a pistol and shot the latter in the arm. Wyant's arm had to be amputated, and he swore he would have revenge, and since that time he has narrowly watched for such an opportunity. A short time before the murder, he said he was going to Indiana; but instead of that, he came to this place, for the purpose of watching the movements of Rusk, as it is supposed. Last Friday Rusk came to town, and Wyant saw him; the latter dogged the footsteps of the other from place to place, and finally into the courthouse. Rusk entered the office of the county Clerk and was standing behind the stove with his arms folded, when Wyant opened the door and commenced firing an Allen revolver at him. The first ball struck Rusk in the side, the second in the shoulder, and the third ball entered his arm. Wyant then stood over the fallen man, put the pistol to his head and fired the fourth shot, the ball passing entirely through the head, and from the orifice it made oozed the brains. Rusk lived near an hour after, but never spoke, we believe. His murderer, Wyant, tried to make his escape, but was secured a short distance from the court house and conveyed [back into the] building. Shortly after he was taken to prison and securely ironed. It is thought nothing will save him from hanging, as a responsible witness was in the clerk's office at the time of the murder. We understand that the wife of Rusk, who was enceinte at the time of his murder, and her child, which was prematurely born, are not expected to live from one minute to another, and perhaps may be dead now. If they die Wyant will be a triple*

murderer, and consequently, he should suffer the severest penalty of the law. Circuit court is now in session, but it is thought his trial will not take place this term. Some think there will be a change of venue.

The case was moved about twenty-five miles away, to the McLean County Courthouse in Bloomington, to provide Wyant a fair trial. The use of chloroform was the key element in the case. Chloroform was used as a surgical anesthetic when the doctors amputated Wyant's arm. It was widely believed at that time that a possible side effect of chloroform was the provocation of insanity.

Swett's witnesses testified that Wyant's bizarre behavior, both physical and mental, happened only after the loss of his arm and the use of chloroform. Despite Lamon and Lincoln's efforts, the defense testimony was quite convincing. The prosecution lost the case. Wyant was indeed found temporarily insane, acquitted and committed to an insane asylum. This was one of the earliest legal cases in America where the defense of insanity actually resulted in an acquittal. Not long after the trial, Lincoln was asked to defend a young man whose only hope was a plea of not guilty by reason of insanity. Lincoln respectfully recommended his good friend Swett to the client.

5

KELLY'S BAKERY

WALKING IN THE STEPS OF LINCOLN . . .

Exiting the Cruisin' with Lincoln on 66 Visitors Center and gift shop on the southwest corner of the courthouse square, one encounters a bricked historic marker, literally. Topped by a bronze plaque, "Center Street Site" reads, "First Brick Pavement in the United States/Innovation to Modern Highways/Installed 1877."

Until the installation of brick streets, local roads were made of dirt and board. When it rained, the slushy mess, combined with the horse debris, formed a thick, deep, smelly muck. A joke still circulates about Lincoln greeting his political rival Stephen Douglas on such an occasion. Douglas, short in stature, was clearly stuck in the mud. Only his divine green silk top hat and head were sticking up from the sludge. Despite their opposing views, Lincoln was a friend to Douglas and quickly asked if he needed any help. Douglas paused and simply replied that he was fine. Douglas then said pointing downward, "Lincoln, I am worried about my horse." The political joke is clearly the product of a myth, and so is the "Center Street Site." Now that's a mystery.

The stubborn, well-worn bricked street saga has been around for nearly 150 years. Like most legends, it holds some truth. Local folks honor the story, and the plaque does correctly state that Napoleon B. Heafer "instawlled" a stretch of brick pavement in 1877. It is also mostly correct that an "innovation to modern highways" was achieved. Anything is better than mud and muck.

The U.S. Patent Office registered the first brick paving patent in 1868, and some claim that Charleston, West Virginia, is the site of the nation's first brick street, in 1873.

Kelly's Bakery

From the bricked marker site you can plainly see the Kelly's Bakery sign just south on Center Street. The bakery has great food and an enduring ghost story. Even though the legend dates back to Lincoln days, Kelly's Bakery is the current site of an active haunting and mystery. Reports say that a little girl is known to stand at the tables near the front window. Dressed in Victorian clothing, she quickly disappears when noticed. She was the daughter of Drs. Eli and Marie Louise Crothers. No one knows her first name or where she is buried.

Prior to Kelly's Bakery, the location was home to Pumpernickel's Deli. According to a *Pantagraph* article in 2004, Terry Groff, former co-owner of Pumpernickel's Deli, had heard the little girl. "A faint 'hello' coming from somewhere deep in the dark and dingy basement stopped him in his tracks. Alarmed, he scrambled upstairs for help." He returned with a friend, and a thorough search revealed that no one was in the basement. Terry was a skeptic, but his curiosity grew when he heard her again. Several of the staff confirmed similar paranormal activity, including flickering lights and glasses falling from above the sink. It has been said that some of the activity still occurs today.

The doctors Crothers were close and personal friends of Abraham Lincoln. The little girl is indeed the Crothers' daughter. After the 1855 fire, her father built the Crothers, Dwenters and the Crothers and Chew buildings at the West Washington and Center Street locations, respectively. The Kelly's Bakery building once housed Centre Hall and the Crothers' pharmacy, office and living quarters.

In 1859, Miss Crothers was cooking at her home. With such a large family, she was trying to help her parents. As she was reaching toward the stove, her apron suddenly caught fire. As she cried out, many tried to help her. Unfortunately, her burns were very severe; despite heroic attempts, she died a few days later. As was the Victorian custom of the day, often, in their grief, the bereaved never again spoke of a dearly departed. Her descendants do not even know her name or where she is buried. Several attempts have

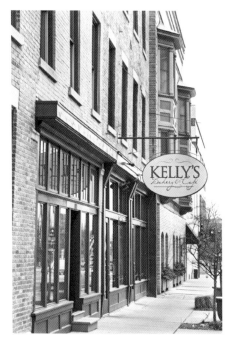

Miss Crothers's little ghost resides in and around Kelly's Bakery and downtown. *Photography by Cari Towery.*

been made to communicate with the sweet spirit and find out her name. Ghosts, even tiny ones, can be very stubborn. Some nearby baffling commotion almost led to her identification.

Several years back, the Spirits of Bloomington paranormal team was contacted to conduct an investigation at a photographer's studio on West Washington Street. It was reported that many of the photographer's clients, especially children, reported seeing a mischievous little girl. She would play and dance among the long curtains that separated the large room. Quick movement from the curtains, then a little girl's giggles, were followed by an immediate search of the area. All the present children were accounted for, and the photographer's clients were becoming a bit unsettled by the unexplained activity. The photographer wanted answers.

During the investigation, the team recorded several bits of communication with a small girl ghost. As confidence was gained with this charming spirit, a request was made to her for her name. So faint was her voice that we thought she said "Lucy," but she quickly corrected us with the name "LuLu."

After the investigation, we did a thorough research of the building and discovered that Dr. Crothers had erected and owned this building in 1856. He indeed was the father to the young burn victim; Miss Crothers may have spoken her true name. As the family history was examined, it was discovered that the doctors Crothers had nine children, four of who lived to adulthood, two sons, Noble E. and E.K. Jr., and two daughters, Louise (LuLu) M. and Rachel A. Both sons were jewelers, and LuLu was the first female pharmacist in Bloomington. Rachel became a famous Hollywood playwright.

Our dear little Miss Crothers still keeps her identity a secret—or has she? Recently, several researchers and historians uncovered the possibility that her name may be Angie. Five young children's graves in the Crothers

Phoenix Building still stands where Abraham Lincoln was first asked to run for the presidency. *Photography by Cari Towery.*

family plot at Evergreen were recently identified. One of the names is Angie. However, the mystery continues because the Crothers family had lost six young children, which leaves one missing. There are no known records to confirm her identity as the burn victim. Is Angie Miss Crothers's name, or has she found a way to keep her family alive by reaching out and acknowledging her sisters Angie and LuLu? Her mystery haunting is still alive, but acknowledgement can lead to some interesting history.

Right down Washington Street, heading west, is the Phoenix Block. Just like the Crothers' properties, many of these buildings were constructed in 1856 after a fire destroyed much of the block. From the ashes, the "Phoenix" provided the perfect setting for a presidential candidacy to rise. It was here in 1858, at Kersey Fell's law office, on the second floor, that Lincoln was summoned by Kersey's brother, Jesse Fell.

Jesse Fell had his own magic. In the early days of McLean County, Jesse W. Fell was probably the most constructive man in the development of the area. Initially an attorney, his career was most profitable in business organization and real estate. He brought the first printing press into the county and, in 1836, with Asahel Gridley and James Allin, founded the first newspaper in the county. He also founded the Uptown of North

Bloomington in 1857, which later was renamed Normal and the Normal University, incorporated as the Illinois State University in 1867 and the Soldiers' Orphans' Homes. The list of his accomplishments and contributions to the community and his fellow man is extensive. Many claimed that he possessed "Magic Circle," due to his great power of persuasion and successful associations with Asahel Gridley, Judge David Davis, Isaac Funk, Judge John McClun and James Allin.

In December 1858, as Lincoln came upstairs into Kersey's office, little did Lincoln know that Jesse had begun casting his magic on the next president. Right there, on the spot in a building that still stands, Jesse Fell convinced Lincoln he could obtain the Republican nomination for president in 1860 and should seek it. Lincoln returned home to Springfield and asked his wife. The rest is history.

6

MID-CITY HOTEL

ROUTE 66 IS COMING ALIVE ON MAIN STREET

From the Phoenix Building on the northeast corner of Washington and Main Streets, head north on Route 66/North Main Street, bypassing the courthouse square a few blocks down. Soon, the Mid-City Hotel sign is visible on the west side of Route 66, next to Beck's Family Florist. Never did a building stand so neglected for so long; Gaye Beck and the ghosts made it come back to life.

MID-CITY HOTEL

Gaye Beck is an amazing local businesswoman and visionary. She has successfully owned Beck's Family Florist for many years. During that time, she has purchased and renovated her present downtown location in the 300 block of North Main Street. Her florist shop and another business are located on the street level; she replaced the roof and windows to preserve the second and third story of her building until she could develop the rest of the property, which once housed the New Phoenix/Mid-City Hotel.

After the great fire of 1900, much of bustling downtown was destroyed. But the railroad industry was booming. Political life, two universities and governmental needs demanded that downtown be rebuilt immediately.

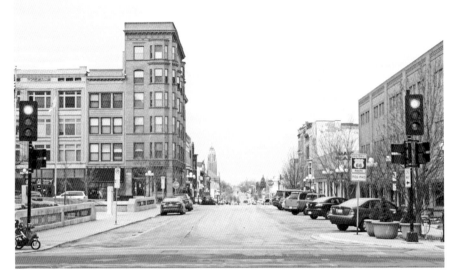

Haunted Route 66 on Main Street in downtown Bloomington. Note the Route 66 shield on the right. *Photography by Cari Towery.*

Accommodations were in high demand for the weekday workers, including businessmen, railroad workers and the like. Originally, the Mid-City Hotel was opened as the New Phoenix Hotel in 1902 (the original Phoenix Hotel, on Center Street, was destroyed in the 1900 fire). It was named the Mid-City Hotel from 1955 until it permanently closed in the 1960s.

It opened as a four-star European hotel on the second and third floors; the street level housed a variety of other businesses through the years. Advertisements for the hotel stated that each room was equipped with a bed, a sink, a small writing table and a mirror. Only outside rooms had windows. Depending on the view and size, the nightly rate varied. The building itself was in the Foursquare style, featuring skylights and windows for plenty of natural sunlight and breezes, even for the interior, windowless rooms. Toilets were communal, and a bath was extra.

The timeline of America's history is directly reflected in the patronage of the working-class hotel. Initially, businessmen, often with their families, and railroad men were registered in the hotel ledgers. World War I, Prohibition, War World II, the Korean War and the Vietnam War eventually led to the conversion of the hotel into a "Men Only" rehabilitation and retirement establishment. It served the needy as well as low-class gangsters. The hotel was the perfect setting for many unsettled souls.

He spelled his name for me: "L. O. U. I. S." He stood at the top of the stairs, watching me climb from the street level into the heart of the hotel. He was hunched over the railing like a rat, very thin and pale. He had light-colored hair, and his face was pointed and aged. At one time, he had been handsome. I smelled alcohol, and his darting eyes unnerved me. Anxious, he asked what I was doing here; I let him know I was looking around for ghosts. Apparently I had found one: Louis.

At the time I did not know that the building had served as a hotel. The sign out front was covered up and gave no indication of what was inside. Gaye had asked my business partner, Chris Hotz, and me to check out the building. Perhaps we could use it for our tours. Perhaps it was haunted. Before Gaye or Chris reached the top of the stairs, I knew the building was haunted. I informed them of this and immediately left Louis behind.

I would be back. There were many other spirits behind him, and I knew it was the perfect place for investigations. I immediately contacted my paranormal associates Paula Schermerhorn and Janice Oberding. With their assistance, the Mid-City Hotel's ghosts came alive, and our investigations began. Janice still talks about how she had never experienced a historic hotel housing so many spirits, excepting only the Goldfield Hotel in Nevada.

Louis was a drunken ghost. Wandering the hotel, his spirit was drawn to blondes and light-haired women. Many ladies experienced his special paranormal attention. He pinched backsides, ran his fingers through hair and adoringly caressed faces. He was the center of attention at the Mid-City Hotel. For some unexplained reason, I did not feel in real life that he was a kind man. Many times I told my team and others that we were better off not knowing who he was, and it remained that way for several years.

Many local ghost stories come from the living. Ben Fike is no exception. Bill Fike was proud of his great-uncle. Bill had retired from his shop, Winnie's Menswear, in downtown Bloomington. He loved the history of downtown and proudly shared the story of his great-uncle with us.

Ben Fike was arrested and served time as a convicted kidnapper and white slaver. The story begins right before World War I. Ben had volunteered for the National Guard and was assisting with flooding issues in Hannibal, Missouri. He brought back home with him two female companions. He had convinced the two naïve ladies that "hotel work" was available for them in Bloomington.

A few months later, there was a big commotion on Chestnut Street near downtown. A half-dressed woman had burst out of a house, called for help and claimed that Ben Fike had kept her captive as a sex slave. There was a

struggle when the cops arrived, but Ben Fike was soon arrested. The tortured ladies were freed, and one testified against Fike. He was tried and found guilty of kidnapping across state lines and white slavery. He was sentenced to a lengthy stretch at the "Big House."

Each investigation of the Mid-City Hotel tested the participants' psychic abilities before the history of the hotel was revealed at the end of the tour. For psychic or cynic alike, it made an interesting exercise. Surprisingly, the same rooms repeatedly received identical psychic impressions.

Several rooms on the third floor were very active. Two rooms in particular seemed to house female ghost prostitutes. In fact, one investigator psychically witnessed a couple having sex in one of the rooms. An experiment during most investigations asked for a male volunteer to go inside the prostitute room, offer money and see how the "spirited" ladies would react. Many times, especially for men with a large amount of money, they were surrounded by paranormal activity, including spirit orbs and close ghostly body contact.

Photographic documentation detailed each experience, with before, during and after images of the man's experience in the room. A dark room was soon clouded with orbs surrounding the "rich client," lovingly encouraging him for more with their sensual touches.

In the fall of 2009, courtesy of an outreach by Lincoln College, the "Godfather" of the paranormal, John Zaffis, visited the site. As John entered the creepy hotel, I asked if he had any money on him. Little did I know until later that he was confused by my request; it never dawned on me that he thought he might have to actually pay for a room. He dug in his pockets and managed to draw out a few bucks.

I quickly led him to the prostitute room and encouraged him to play with the ghostly vixens. With just a couple of bucks in his hand, we weren't sure how far his good looks and charm would go with these ghosts. He stood bravely inside the dark room, charming the ladies to come for a visit. Camera in hand, we were ready to witness and record the ghostly interaction. Suddenly, the shadowy room was filled with spirit orbs hovering all around Zaffis. Surprised, he exclaimed, "Hey!" as his head was rubbed and his shoulders and face were caressed. These ladies knew that such a prominent man had to be treated right. Stepping out of the room, he immediately deemed the Mid-City Hotel certifiably haunted.

Another room on the third floor, at the front of the hotel, housed a quiet and mysterious dark-haired man. It took years of investigations to find out what little information we could. After numerous psychic interactions, the evidence revealed that his name was Mike; he was somehow related to the

Korean War; and he adored or was attracted to female brunettes. When a dark-haired female entered the room, he would politely touch her hand or face. He was never menacing—except once.

A couple had entered the room to look outside the window and record any paranormal activity. Suddenly, the boyfriend felt an immediate strong shove and found himself outside the room. Meanwhile, his pretty girlfriend was still inside. The energy forced the boyfriend to stay out of the room. Apparently, Mike felt some type of connection with her, and he did not want her to leave. A search of the hotel ledgers revealed no mention of a Mike or Michael. Any additional research on Mike led only to dead ends, until the incident at the Eagles Club in January 2016.

The southeast corner room on the third floor revealed a more sinister spirit. The room was littered with debris and an old iron bed with a tossed mattress. Female tour participants noticed right away that each was either welcomed or pushed out of the room. Judging by the extreme reactions to the ladies, "his" male presence was quite strong. He easily preferred young, pretty and charming women. We had the room number and carefully looked through the hotel ledgers. We could not believe our eyes. Of course he liked the pretty ones, it was good for business. The name was neatly signed in the hotel ledger as Ben Fike. The name's appearance in the ledger showed up for years, right after War World I—time during which he was supposed to be incarcerated at the state penitentiary.

Our historical research continued. We wanted to uncover the truth about Ben Fike. The answers became quite clear when we found Pierson and Hasbrouck's book *McLean County Illinois in the World War, 1917–18*. Our handsome pimp was pictured on page 404 and listed on page 420 as "Ben E. Fike, Bloomington, Col D, 3rd infantry, Camp Del Rio."

Ben's brother Lyle had a memorial on page sixty-two, listing his death on October 20, 1917. He was twenty-one and had served less than a year before his untimely death. His county listing appeared below his brother Ben's on page 420: "Corp. Lyle Fike, Bloomington, 124th M.G. Battalion. Died in France of wounds."

It has been said that, during some of the earlier American wars, if a prisoner was serving time, he could volunteer for the front lines. If he fought honorably and survived, he would be freed of his criminal sentence. The World War I book makes it clear. Sadly, the "good" son, Lyle, served less than a year and died of his wounds. However, his "bad" brother returned home and, according to the hotel ledgers, continued "hotel work" in several rooms for many years.

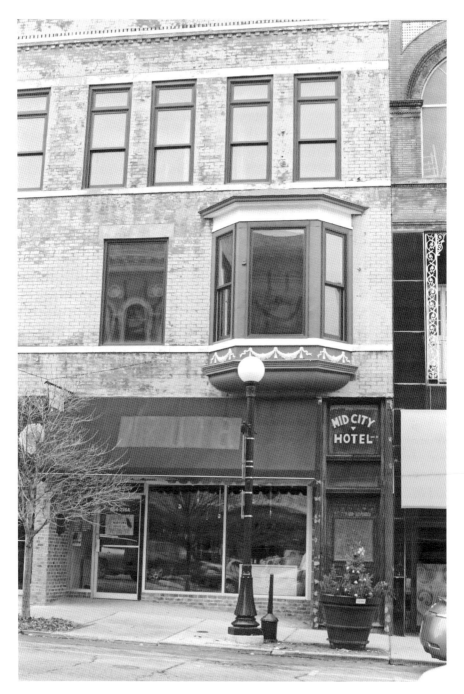

Louis was the first ghost to say hello when the author entered the closed hotel. Condominiums now stand at the site. *Photography by Cari Towery.*

And then there is Louis. Near the end of our "stay" at the haunted site of the Mid-City Hotel, we were fortunate to sit down and interview the two daughters of the last manager, Beulah Green. The daughters were shocked at the horrible conditions inside the hotel building. We assured them that these conditions were only temporary. Their mom had been so meticulous about cleanliness and order, she was coined "Battleship."

Both daughters assured us that their mom cared about the "Men Only" hotel establishment and really tried to help the men. Most were forgotten veterans, but even after the hotel was closed down, their mom continued to care for some of them. It was wonderful to spend an afternoon honoring their compassionate mom. But, then, something horrible happened. I mentioned the name Louis.

Their mom had been married to Louis. He was, they believed, her third husband. Initially, the marriage seemed like a match made in heaven. The daughters brought pictures of their mom and Louis. There they were, a happy couple, she a pretty "light-haired" lady and he a handsome husband. Both were dressed in their Sunday finest. Perhaps it was their wedding day. As the years went by, Louis became a bad drunk; sadly, their marriage became very destructive. In the final days, in drunken despair, he went after her with a butcher knife and she immediately kicked him out. What happened to Louis is not known, but I did find him. He is buried next to his stepsister at Park Hill Cemetery. Hopefully, he is at peace.

There are many other ghost stories to tell from within the walls of the New Phoenix/Mid-City Hotel. The interactions of the ghosts and investigators at the Mid-City will never be forgotten. However, it is special women like Beulah Green and Gaye Beck that managed in their own time to take care of things, including the Mid-City Hotel building. Hard work and dedication keeps history alive in historic downtown Bloomington. The building has now been converted into condominiums, and the only paranormal energy left behind resides within the personal stories of the spirits that once lived at Mid-City Hotel.

SPECS AROUND TOWN

ABE & SPECS ON 66

After turning west onto Monroe Street from Main Street/Route 66, your eye is drawn to some famous faces painted on the wall. Bloomington-Normal's history is represented by those on downtown wall art. Illinois's Lincoln, Jesse Fell, Judge David Davis, James Allin, Georgianna Trotter and Rachel Crothers are depicted. Then, of course, there is the opera singer Minnie Salzman-Stevens, African American war hero Major Julius Witherspoon and Kickapoo's tenaciously independent Chief Machina. Each represents a crucial part of Bloomington-Normal's history. The darling little ghost, Miss Crothers, can wander down and gaze upon her famous playwright sister Rachel. Paranormal activity is plainly seen in this area of Monroe and Center Streets.

SPECS AROUND TOWN

Lincoln walked these same streets when he was practicing law in McLean County. Many of his friends are up on the wall with him. This is a younger Abe. This is the Abe of Bloomington, Illinois. When Lincoln was running for the presidency in the fall of 1860, he received a sweet letter from Grace Bedell, encouraging him to grow a beard. "If you will let your whiskers

How often does Miss Crothers's ghost visit the likeness of her sister or Illinois's Lincoln at the History of Downtown Wall Art? *Photography by Cari Towery.*

grow I will try and get the rest of them [her brothers] to vote for you you would look a great deal better for your face is so thin. All the ladies like whiskers and they would tease their husband's to vote for you and then you would be President."

He grew his beard, and her prediction came true: he became the sixteenth president of the United States.

Young Grace's letter reached out to Lincoln, and her advice may have very well changed the course of history. Not far from Lincoln's wall portrait downtown, a railroad man used to reside; he, too, reached out, attempting to change the course of his own history.

The Downtown Business Association (DBA) is the heart of the revitalization and growth of historic downtown. Vivaciously directed by Tricia Stiller, it is the one-stop shop for what's going on in historic downtown Bloomington and is a few doors down from the wall art of local historical figures. An apartment on a second floor very close to the DBA office houses a legend about a railroad man.

When I first moved to town, a former director of the DBA lived near her office. She loved Bloomington but also missed her family out west. She was vivacious and an integral part of Bloomington's development at the time of my arrival. She asked me to look into an unexplained activity in her apartment. The paranormal energy seemed to appear right around sundown when she returned home from work. She would sit down in a cozy chair, relax with a drink and suddenly feel a dark, tall male energy behind her. She could feel his breath on her neck, yet, for a reason she could not explain, she never felt threatened.

The legend goes that, in the 1800s, a railroad man lived where she was now renting. He was in love with a young, delicate maiden named Margaret. The strong and hard-working railroad man wanted to marry his beloved. They were soon united as husband and wife. She was so frail and thin. Her skin was translucent, as if she could fade away. Her disposition was sweet but

Specs around Town, home of the bespectacled ghost "Thomas." *Photography by Cari Towery.*

weak, and soon, after the marriage, she succumbed to a deadly disease. The railroad man was heartbroken. Many say he mourned her death until the day he died. His last words were his beloved's name: "Margaret, Margaret." And now, after all this time, he was appearing again. As I recalled the legend to the director, her eyes teared up, and she smiled. She explained, "You see, my real name is Margaret, even though I am called Peggy."

A few years later, Peggy returned to her family out west. I happened to be walking by the apartment on her moving day. I waved goodbye as the U-Haul was driving away. I always wondered if the railroad man had hitched a ride out west with Peggy, because he hasn't been heard from since.

Turning south on to Center Street, you come to Specs around Town. Opened by Julie Kubsch in the fall of 2001, the quirky optical shop is located in the beautifully restored Emmett-Scharf Electric Company building. For years, a certain poltergeist has caused some friendly havoc inside Julie's business. Unreliable computer and phone service would often disrupt the staff's business day. And, of course, there was the unexplained rattling in the basement.

After further investigation, it was discovered that "Thomas" dwelled among the living. The structure was built right after the 1900 fire and named after his wife. The historical marker outside confirms it is the 1901 Belle Plumb Building. Further family research showed her husband's name was Thomas. His name was not on the plaque. Once acknowledged, Thomas's technical interference is minimal, but one of the staff members still prefers to not visit the dim basement. Believe it or not, the single ghost photograph of Thomas shows him wearing spectacles. It seems fitting.

In Lincoln's time, Specs around Town was the site of the Pike House. From the second-floor balcony, Lincoln and other politicians, including Stephen Douglas, often delivered speeches. It has been said that in May 1856, at the age of forty-seven, Lincoln bought his first pair of eyeglasses at a nearby jeweler's shop. Eyeglasses or not, looking to the north, one has a clear view of an extremely tall radio tower dominating downtown. Near the site, on the corner of Market and Center, is the site (though unmarked) of the town's only lynching.

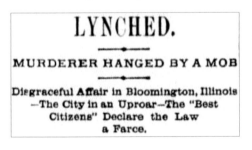

Lynching headlines. *Philadelphia Inquirer, October 3, 1881.*

The story is told that on October 1, 1881, a horse thief

The radio tower is a reminder of the nearby tree-hanging location of 1881. *Photography by Cari Towery.*

by the name of Charles Pierce had been arrested and locked up in McLean County's jail on Market Street. The building is long gone, but the story has never been forgotten of Bloomington's first and only hanging.

Legend says that Pierce was so mean that if he looked deep into your eyes, your blood would go cold. It is also said that, on one particular fall day, Pierce had warned jailer Teddy Frank that by sunset, he would kill Teddy with his own gun. Teddy, a husband, father and Civil War veteran, was known as a cheerful and kindly man. He laughed off Pierce's threat. As the sun was setting, the prisoners were being moved from the public area into their individual cells, when a scuffle occurred. Pierce wrestled Teddy down. A shot rang out, and then another. Kind-hearted Teddy lay dead, and Pierce stood with the gun. The sheriff rushed to the scene and disarmed Pierce and locked him up.

The townspeople heard of the terrible shooting and rushed to the jail. Less than two hours after the incident, a mob surrounded the jail, demanding that justice be done. The angry crowd broke through the jail's entrance, dragged Pierce out and hanged him on an elm tree at the corner of Market and Center. According to the *Philadelphia Inquirer* of October 3, 1881, "Leading business men cheered and encouraged the lynchers, and women waved their handkerchiefs in approbation."

Chicago's the *Daily Inter Ocean* reported on the same date that a placard appeared the following day on Pierce's lynching tree, reading as follows:

> *McLean, Illinois—Ax-man, ax-man, spare this tree, and never touch a single bough; and may God spare this Elm tree forever to grow to mark where the first justice to a murder ever was done in McLean County, and may the good people stand by the boys that did it.*

Charles Pierce's real name was Charles Howlett. His unclaimed body was buried at the Poor Farm Cemetery, just outside of town. His "lynchers" have never been identified or captured, so his open murder case remains a mystery. The adored deputy Henry "Teddy" Frank is listed as the first fallen hero on the McLean County Sheriff's Department website. He was killed by gunfire, but eternally loved by all.

EATON'S STUDIO AND GALLERY

CORNSTALK OFF ROUTE 66

An unusual "selfie" opportunity is located right off of Route 66, down an alley off Monroe Street in the courtyard of Herb Eaton's Studio and Gallery. The *Star-Crossed Pollinators* sculpture allows an up-close and personal look at Herb Eaton's fascinating figurative and narrative art. The alley leads onto North Center Street and the entrance to his studio. The residual energy of art, history and love always lead to a lasting impression.

EATON'S STUDIO AND GALLERY

There is always that next building to investigate, the one that stays in one's mind until the timing is right. Herb Eaton's Studio and Gallery is such a site. It is housed within a historic building born from the rubble of the 1900 Bloomington City fire, and its résumé is quite remarkable. The investigation revealed the most unusual professional and personal paranormal surprises.

For over forty years, Herb has created paintings, sculptures, prints and other forms of art reflecting the architecture of his own imagination. His figurative and narrative art reflects his masculine and feminine side through two characters named "He" and "She." The daughters of memory are the muses of dance, poetry, music, tragedy, comedy, astronomy and history.

The *Star-Crossed Pollinators*, by Herb Eaton, affords the chance for a side alley "selfie" off Route 66. *Photography by Cari Towery.*

His incredible talent is fused with the hospitality of his gifted wife, Pamala, to create a warm and welcoming environment to display and sell his art as well as provide a community venue for musical, theatrical and cultural events.

Before the investigation, the team was not privy to the location or the history of the building. The small private group of investigators carefully maneuvered through the two-story studio and art gallery, each recording their own psychic impressions. After the initial "walk around," the investigators gathered to share notes with Pamala and compare them with history. Odd arrays of impressions were frequent among the investigators, including a fire, cows, horses, cars, carriages and a school building. The amazing building's legacy is found within the residual energy of the site.

The building first operated as a billiards and pool parlor by proprietor and African American Matt Sears. It was later converted into horse stables, a cab company, a creamery (dairy troughs still exist on the north wall), a storage facility and a variety of garages. The Midwest School of Building Trades is still reflected in three brickwork samples downstairs and hardwood floors upstairs. Tim Lee's Shop of Alternative Fuel Research and W.M. Putnam's office supply storage were the two most recent occupants before the Eatons purchased it in 1997 from John Copenhaven. Herb and Pamala Eaton remodeled and officially opened the studio and gallery in 2000. The interior design perfectly blends the building's heritage with a quirky fusion of art and history.

There were several specific psychic impressions that required additional explanation beyond the chronological timetable. The first was an issue with a ladder. Was someone going to be harmed, or had they been harmed by climbing a ladder? Why was the ladder so out of sync and such a worry?

Pamala chuckled as she explained about the yoga instructor. For the longest time, the only entry into Herb's second-floor studio was up a ladder. Yes, up a ladder. Apparently a noteworthy yoga instructor was coming into town and had specifically asked to visit Herb's art studio. The instructor would be dressed in her traditional sari. Pamala could just imagine their special guest climbing the ladder to the second floor in her native dress. She was horrified by the vision. After several conversations, the set of stairs that is in the main entrance today was built practically overnight for the VIP and anyone else wanting to climb the ladder to successfully view Herb's process.

The second impression was very personal. As the psychic impression session was coming to an end, I was walking toward a seat and felt an overall strong sensation. Something or someone literally stopped me in my tracks and I turned back toward the direction I had come. I looked to my right, and there stood a beautiful piano. The entity's energy was warm and inviting, and I clearly heard a man say, "Grandpa." He then corrected himself to say, "No, Dad."

After I shared the story, Pamala asked, "Were you talking about the large piano or the small one on top?" Truthfully I had only noticed the larger one when the spirit stopped me. Then she explained with tears in her eyes. When Herb's father, Jim, was courting Florence, she kept him on his toes. "Jim," she said, "I will only marry you when you buy me a piano." Not wealthy, but so much in love, Jim had to figure out a way to win over his prospective bride and fulfill her desire for a piano. He then came up with a very clever idea. He purchased a very, very small piano, the same petite piano that now sits on top of the larger piano in the gallery. When Jim presented the piano to his beloved, she had no choice except to marry the man with the piano.

The sweetest part of this paranormal love story is that Herb's father had recently passed away. In death, as in life, he will always be a loving "grandpa" and "dad." Dearly departed loved ones often find their own muses and use psychic avenues to simply say "Hello" and to bring back to life a precious story about a man, his piano and his sweetheart. Years ago, Herb had painted the piano for his parents in memory of their love story. The painting still resides with Florence today.

9

LUCCA GRILL

RETURNING TO ROUTE 66

Heading north on Center Street, the next crossroad is Market Street. The "hanging tree" tower is on the left, but the smell of the traditional A La Baldini pizza floats east from Lucca Bar & Grill on Route 66. Contrary to the myth, live Lake Bloomington lobsters never swam in the front window tank, but worker Lois Durbin is still grilling her legendary Lois roast beef sandwich after more than forty years. Traditions and hard-working dedication are still alive on Route 66 at Lucca Bar & Grill.

LUCCA BAR & GRILL

Right after Prohibition, Lucca Bar & Grill was opened in 1936 by immigrant brothers Fred and John Baldini. Lucca was named after their hometown of Lucca, Italy. The two "established a fine eatery in a friendly atmosphere" featuring their A La Baldini, a dime-thin Italian pie loaded with sausage, pepperoni, ham, onion, mushrooms, green peppers and pepperocini.

Lucca, considered the melting pot of Bloomington-Normal, attracts everyone from college students and professors to retired insurance agents. Its slogan is "Where customers always feel 'at home.'" Traditionally, it was a McLean County Democratic hangout, where many celebrities and

Lucca Grill's site may have served as a speakeasy during Prohibition. *Photography by Cari Towery.*

politicians stopped by, most notably John F. Kennedy in 1959.

The delightful former speakeasy has been described as one of the friendliest bars ever found. Managers John Koch and Tony Smith take pride in providing top-notch food and service. Server Marissa Knapp Uselton is a perfect example of the bar's hospitality—she dishes up her sparkling personality with the amazing Baldini pizza pie. The only problem with Lucca Bar & Grill is that John Baldini just won't leave.

My first visit to Lucca Bar & Grill was in the spring of 2008. Business partner Chris Hotz and I were putting together our first historic ghost walk, and we stopped for a late lunch. We sat at the smoothly polished antique bar.

I looked around, taking in the "old-school" vibe of wooden floors, tin ceilings, celebrity photographs and a working dumbwaiter. I felt right at home. Manager Tony Smith was behind the bar and leaned over to say hello. Chris introduced me to Tony and told him about our upcoming ghost walk.

As they talked, I immediately sensed a very hyper male spirit behind the bar. He was anxiously wiping down the countertop. He would pause and sigh, and then continue. Clearly, he was upset about something.

Tony took our order and left. I remarked to "cynic" Chris about my psychic expression, and he kiddingly relayed the information to Tony when he returned with our lunch.

Intrigued, Tony asked, "If I show you a picture of the man, would you be able to recognize him?"

I said, "Yes."

I knew the spirit had a slight build, light hair and an odd part in his hair.

Tony returned with a photo album. I flipped through a few pages, stopped and pointed. "Here he is!"

Tony recognized the ghost right away and immediately identified him as John Baldini, one of the original Baldini brothers. Once acknowledged, the spirit became more agitated. He seemed upset and asked if I knew anything about the missing cha-ching. I immediately relayed John's frustrated behavior to Chris and Tony. I copied the spirit's antic of pulling something down with his hand. Tony was stumped.

Tony recalled the story about John Baldini, hoping that a clue could be found to help explain the ghost's troubled behavior.

John Baldini was obsessed with keeping track of the money from the bar. He wore a money belt home every night with the daily take and deposited it into the bank the next morning. One particular long night at the bar, after the final customer left, John followed his usual routine. He collected the money out of the register, put it inside the money belt and proceeded across the street to his car. Suddenly, out of nowhere a car appeared. John was caught off guard and got hit by the car.

An ambulance was called, and he was rushed to the hospital. His wounds needed to be treated right away, which required the removal of the money belt. It has been said that he refused to relinquish the money until someone he trusted arrived at the hospital. Time was critical; unfortunately, John succumbed to his injuries.

Manager John poses with the author near the site of John Baldini's ghost sightings. *Photography by Cari Towery.*

Chris and I finished our delicious meal as Tony ended the story. He put his two hands on the bar and looked off for a minute, deep in thought. Then a look of wonder appeared on his face. "I got it!" he said. "We just replaced the authentic Baldini register with a newer one."

He further explained that the original register would ring with every sale. The newer model did not sound with the traditional "cha-ching" when a sale was made. Poor John Baldini, obsessed with the bar's money, must have thought the business was no longer prosperous. Once the register situation was clarified to the ghost, he seemed okay. But he still hangs out, keeping a careful watch from behind the bar to be sure that the tradition of quality continues at Lucca Bar & Grill.

10

TROTTER FOUNTAIN

MONUMENTAL ROUTE 66

The iconic Route 66 began in Chicago in 1926. It was established as an interregional highway connecting Chicago to Los Angeles. During the Depression, thousands of unemployed men were put to work as laborers to build Highway 66, or Route 66. John Steinbeck's *The Grapes of Wrath* detailed the opportunity and challenges of those traveling what he called the "Mother Road." The highway quickly became the road to opportunity for truckers, those migrating west to escape the Dust Bowl and tourists. Much of the original Route 66 has been replaced with the major interstates of today, but parts of the hard road are still open right off the highways to provide vacationers an offbeat travel experience of yesteryear.

Route 66 shields, or signs, guide the traveler through the many towns and cities from Chicago to Los Angeles; Bloomington-Normal is no exception. Along the route, attractions, monuments, statues and historic sites dot the countryside, reflecting the timeline of America. In Bloomington, just a step away from Lucca Grill, is Bloomington's Lincoln Park and the Bloomington Center for the Performing Arts. These stops on Route 66 proudly provide an opportunity to experience local history, entertainment and, perhaps, a ghost.

Your selfie stop is at the *Convergence of Purpose* statue. It was commissioned and placed inside Lincoln Park in 2010 by the Twin Cities and the Abraham Lincoln Bicentennial Commission. Local artist Andrew Jumonville's bronze piece features Abraham Lincoln, Jesse Fell and David Davis in a grouping

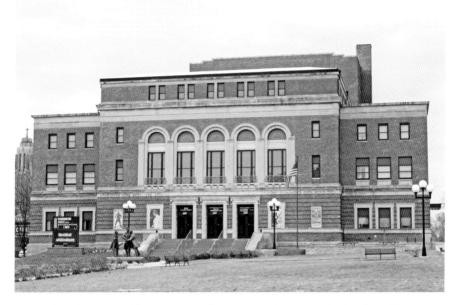

Jumonville's *Convergence of Purpose* statue offers another photo op with Lincoln on Route 66 in front of the BCPA. *Photography by Cari Towery.*

representing the local bonds of friendship and political ties to Lincoln. You can pose among these prestigious men before attending a tour or a performance at the Bloomington Center for the Performing Arts (BCPA).

BCPA was originally built in 1921 as Bloomington's Scottish Rite Temple, a Masonic organization to house the *American Passion Play*, created by grand master and Illinois Wesleyan University professor Delmar Darrah. The hall still maintains its original plush décor, including fancy lighting, ornate painted plaster walls and ceiling and elegant windows and draperies. Seating just over 1,300 people, it provides an intimate, early twentieth-century theater charm.

The *American Passion Play* continues to this day. The portrayal of the authentic life and ministry of Jesus Christ is an elaborate production held during Lent each year. It has become an annual must-see experience for many generations of families and travelers.

The BCPA consistory continues to evolve, featuring comedy, music, magic, children's productions and other special events. Delmar Darrah would be very pleased with the center's continuous run of the *American Passion Play* and ongoing efforts to keep it the center of artistic and social life in downtown Bloomington. In fact, some have said that Delmar Darrah has never left

the building. Often seen and experienced are unexplained noises, flashes of light and perhaps a slight glance of his profile. A lit lamp set on stage can sometimes settle a spirited soul. His deep faith and passion resonates as a vital and living force within the walls of the consistory. The past is often brought back to life by the actions of others today.

Trotter Fountain

The Trotter Fountain has sat prominently in Wither's Park on the northwest corner of Washington and East Streets in downtown Bloomington since 1911. Picnic tables are available during warm weekday lunch hours for people to enjoy watching the water softly cascade from the well-polished statue. Barb Micetic Lancaster's great-great-great-grandfather was John Trotter, a first cousin to the Bloomington Trotters. Up until a few years ago, the fountain had long been forgotten. Recent efforts to restore it by descendant Barb were going nowhere. Then, one afternoon, everything changed. And so the story begins.

The sculpture was designed by renowned artist Lorado Taft. At its establishment, it was praised as the city's most important public artwork. It is a whimsical piece depicting lovely young American Indian maidens and cherubic children. It was willed to the city by the brother of three-term mayor James Trotter and dedicated on May 30, 1911.

The Trotters escaped Ireland's horrible Great Potato Famine in 1850 to find a better life in America. They sailed to America and, after brief stops in New York and Chicago, the family ended up settling in the tiny town of Kappa in Woodford County, Illinois. Most of the family (including Barb's great-great-great-grandfather) settled there. However, it quickly became apparent to some of the cousins that Kappa was a bit too wild for their tastes, and these Trotters moved on to the city of Bloomington. The Bloomington Trotters were Ann and her children John W., James, Georgina, Ann and Maria. Their father, John, had died from cholera while they were in Chicago. He was buried in Chicago's Old City Cemetery, which later became Lincoln Park.

The Bloomington Trotters thrived in business and civil duties. John W. was a popular alderman and three-time mayor of Bloomington. He and his sister Georgina ran a very successful lumber, coal and grain business on Market Street. In those days, women in business were rare, but Georgina

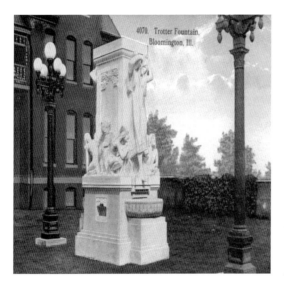

4070. Trotter Fountain, Bloomington, Ill.

A vintage postcard best reflects the amazing details of Taft's whimsical piece. On warm weekday lunch hours, the fountain flows for an enjoyable dining experience. *Courtesy of Barb Micetic Lancaster's private collection.*

was an exception. Businessmen of the day actually went to her for advice! She was also a nurse during the Civil War, serving at the Battle of Shiloh and on hospital boats traveling the Mississippi River.

It is believed that Georgina was the first woman to be an American or naturalized citizen in America. She was the first woman on the Bloomington Board of Education, where she served for eighteen years. Georgina was community-minded and strived to improve educational opportunities in Bloomington. In 1887, she and her friend Sarah Raymond raised $20,000 to build Withers Library on the corner of Washington and East Streets. Brother James was involved in real estate, and sisters Ann and Maria remained at home, where they all lived together in a large house on Market Street. The Mount Pisgah Church now stands on the site.

The Bloomington Trotters remained childless. James was the final member of the Bloomington family; in his will he left money for a fountain or statue to be made in honor of his family, as a gift to the city. Sarah Raymond was able to hire the world-famous sculptor Lorado Taft, and on May 30, 1911, a beautiful fountain was unveiled in Withers Park next to the library. The occasion was a huge celebration. A daylong event included choirs, bands, a parade and visiting dignitaries. The newspapers were full of stories about the Trotters. The fountain would remain as a beautiful reminder of the devoted Bloomington Trotters. Time passed, and the Trotters and their fountain had pretty much been forgotten. Then Barb got involved. And so the story continues.

Meanwhile, the country Trotters flourished in Kappa, including Barb's great-great-great-grandfather John. Soon after landing in New York, he met and married a young Scottish lass named Isabella Coates. They eventually settled onto their farm near Kappa and had two sons, George and William, who both died as babies. In 1854, Isabella gave birth to precious Anna Emily, Barb's great-great-grandma.

The Civil War began in the spring of 1861, and in 1862, at the age of thirty-eight, John felt compelled to join the Union efforts. He enlisted in the Ninety-fourth Regiment of Illinois Infantry Volunteers. His letters home are full of love, gossip, advice and longing to be with his family. He frequently mentions his young daughter Anna Emily with fondness and reminds her to be a "good girl for her Pa." Sadly, in 1864, John died of chronic dysentery in Brownsville, Texas. His body was later moved to the Alexandria National Cemetery in Louisiana.

Anna Emily was only ten years old at the time of her father's death. She was devastated over the loss of her beloved pa. Less than a year later, her mother, Isabella, married a man from Belgium named Albert Smith and quickly signed over guardianship of Anna Emily to George Cox, a local man. This sudden decision has never been understood by Anna Emily's descendants. How could and why would a mother give up her child? It seemed so heartless and needless.

The young abandoned girl grew up with much hardship. She lost two husbands and many children; however, many remembered her sweet, kind and loving nature. Over the generations, Isabella, who so willingly gave her child away, was the relative remembered with disgust. At first, Isabella's new life thrived. She and her new husband had two sons, but, sadly, they lost a daughter named Frances when she was three years old. Relatives felt it fitting that she lost a second "wanted" daughter—a just punishment for abandoning sweet Anna Emily.

Barb's own recollection of what happened next are as follows:

Fast forwarding 140-plus years. . . . I have always loved history, especially that of my own family. I eagerly roam cemeteries and hoard old photo albums—it is well known that I adore my dead people. Except for Isabella. She didn't count.

One day I went to see Deb Senger, a spiritual medium for a private reading. And it seemed that Isabella was coming through. Deborah had no prior knowledge of my family or my feelings towards Isabella. I was stunned and a bit uncomfortable . . . over the years I had been able to think

of her as the evil mother of my great-great-grandmother, but not really my ancestor. Just one of those extra people out there who had interacted with my beloved dead people. But here she was—and she wanted me to know that I didn't understand what had happened. I was flabbergasted. What was there to not understand about immediately marrying some other guy and giving away your daughter??

So Deb explained how things like that were a lot more common 100 years ago. Isabella would have needed to get married again immediately for her own survival. Women had no rights and were treated like property. It would have been almost impossible to make ends meet and raise her child all alone. So she found a trusted person in the community (I haven't found much information about George Cox, except that he was a good person and upstanding citizen and businessman) and gave him guardianship of Anna Emily. Maybe her new husband didn't want to raise her. Maybe they couldn't afford another mouth to feed. I will never know why it happened. But it was time to forgive Isabella.

I went to the El Paso cemetery where Isabella, Albert, their sons and little daughter Frances are buried. I brought flowers, sat down and spent some quality time with my great-great-great-grandma Isabella. I told her I was sorry, and that I forgave her. And I meant it. Generations of her descendants had looked down with scorn and disgust on her memory. And now that was over. She was family, and she was forgiven.

The power of forgiveness is an interesting thing. The day after my visit to the cemetery I was clicking around on Facebook, not searching for anything in particular, when suddenly there in front of me was a page called The Trotter Fountain Project. I had always known about the fountain and knew that in some indirect way it had to do with our ancestors. I had never paid very close attention to it and was just glad that it seemed to have escaped the attention of spray-painting vandals. And now somebody had made a Facebook page about it. And there were pictures of the fountain, and shockingly, of Anna Emily's father John! What in the world was going on?!

I contacted the administrator of the page, Georgie Borchardt, and discovered that she had just made the page earlier THAT day and wanted to find out more about the fountain and possibly get it restored because it seemed to be in rough shape. I have no idea how I found that Facebook page, but I know my people guided me there. And for their sake, and for generations to come, I was going to help save Trotter Fountain.

The rest (of the story) is history. Georgie and Barb teamed up and worked vigorously to bring attention to this treasured fountain hidden in plain sight. Newspaper and television interviews quickly followed about Trotter Fountain. Georgie and Barb hosted a Dedication Day on the 101st anniversary of the fountain's unveiling. Most importantly, the ladies were able to convince the great people at the parks and recreation department to invest in hiring a reputable preservationist to keep the fountain around for another 100 years.

For the 102nd anniversary a grand event was planned! "Georgina" (played by Kathleen Kirk) arrived by carriage and spoke to the crowd. Speakers and prizes were presented, and a permanent plaque was installed to commemorate that day at Trotter Fountain. As Barb has proven, the supernatural can play an integral role in forgiveness. She ends our story by saying, "It continues to be an amazing, loving, spiritual connection between the past and the present . . . between me and my dead people." Isabella and Barb are no longer haunted by the past.

11
EPIPHANY FARMS
RESTAURANT/ANJU ABOVE

AN EDIBLE ENTERTAINMENT STOP OFF ROUTE 66

Just off Route 66 in downtown Bloomington, on the corner of Front and
Roosevelt Streets, there used to sit the Corn Palace Theatre. When I was a
child, I was haunted by this old coliseum. In the mid-1960s, I discovered a
photograph of the cornstalk building while researching for a social studies
report during grammar school in Florida. As a child, I had never heard
of Bloomington, Illinois, and didn't even know where it was located. I was
simply intrigued by the idea of the edible building in the photograph, much
like the one in the story of Hansel and Gretel.

Even though it was originally built from the remains of an old horse
barn in 1898 and known simply as the Coliseum, by 1916, workmen had
transformed it into the "Corn Palace." Bill Kemp's January 19, 2008
Pantagraph article reports:

> *They covered the façade with a wooden framework, which was then garishly
> decorated with thousands of ears of corn, baled alfalfa, pumpkins, corn
> stalks and Sudan grass. Inside, visitors gawked at corn-related exhibits and
> vaudeville performers. Entertainment throughout the years included plays,
> traveling patent medicine shows, and public oratory programs featuring
> politicians, reformers and ministers most notably Clarence Darrow in
> 1910 and Will Rogers in 1928.*

The actual picture of the edible Corn Palace that fascinated the author as a child. *Stevenson-Ives Library Collection.*

It was the photograph that enchanted me. I was unaware that the structure had already been demolished in 1961 and replaced by a car dealership. I didn't have a ghost of a chance to actually experience the Corn Palace, but here I am, some fifty years later, living in Bloomington-Normal. Not far away, in another unusual setting, is a most edible experience: Epiphany Farms, a "farm to fork" haunted restaurant.

EPIPHANY FARMS/ANJU ABOVE

I had a meeting with the manager of Epiphany Farms. The historic location had fascinated me for years. I arrived early to take in the beautiful character of the building. Epiphany Farms was the elegant fine-dining establishment downstairs. Upstairs, the Anju Above provided a charming Asian-fusion, artsy atmosphere for drinks, appetizers and light fare. I decided to walk upstairs so I could sit at the massive bar. It was late afternoon, and the place was sparsely occupied by a few businesspeople nursing their drinks. The long bar was empty, so I sat at the very end and ordered a glass of iced tea. Suddenly, I felt iciness colder than my drink. I shivered.

I could smell her before I "saw" her. A deep reeking smell filled my senses. My nose twitched, and my eyes burned with her intoxicating perfume. As I blinked away tears, I turned my head and saw her in my mind's eye. She was sitting to my left on a barstool. Her long, thin legs were crossed and encased within sagging stockings. Her low-cut, faded black dress loosely clung to her breasts, and her coarse black hair was jelled in a short, blunt cut. She drew on her unfiltered cigarette through a long jeweled holder. She held the smoke deep in her lungs as she carefully examined me.

She suspiciously looked me over. I felt she was evaluating me and perhaps wondering if I was worth her time. Amused by her intensity, I could tell she had made her mind up about something. She released her smoke into expert rings. I turned fully toward her as she became more visible to me. Seductively dressed with refined moves, she waved her cigarette like she was writing in the air. Thick, black makeup lined her deep-set eyes, and bright red lipstick crusted the sides of her mouth. She picked pieces of tobacco off her tongue with her long, polished, chipped nails and flicked them away. I felt she had dismissed me, like I was nothing to her. But she finally spoke, maybe because I was looking right at her or maybe because she was simply bored. "Loretta . . . Loretta is my name and I could tell right away you aren't one of us." She leaned in closer to whisper, "You're kinda sweet and innocent."

I knew immediately, ghost or no ghost, she was quite clever and observant. She was more than likely from the 1920s or '30s. Her disheveled appearance and tired, husky voice indicated she had been up for quite some time. She seemed tired, very tired. Loretta half-closed her eyes, tilted her head back, laughed bitterly and faded away.

Epiphany Farms Restaurant and Anju Above are housed in the Central Fire Station in Bloomington. The 1900 fire originated at a second-story laundry shop early one windy June morning. The fire spread quickly in the high winds, tossing burning cinders through the business and residential sections of the town. At the time, the fire department had only two steamers to fight the great fire. One was thirty-two years old, and the second was twenty-nine years old. The devastation left behind was horrible.

The town vowed to never be caught so ill-prepared again. A modern steamer was soon ordered. Rumor has it that, when the huge hook-and-ladder rig arrived, it was too large for the fire station's existing bays. In 1902, Bloomington built the Central Fire Station at the present site of Epiphany Farms Restaurant. Large enough to house the new rig, it functioned as the main fire station until 1974. After a brief vacancy, many businesses have

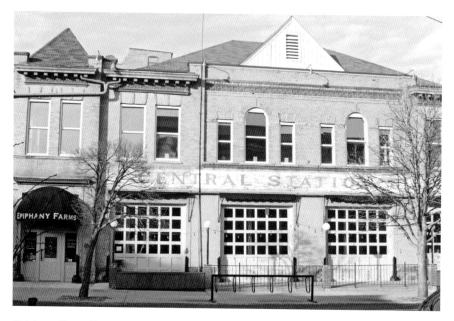

Epiphany Farms Restaurant and Anju Above offer the opportunity to dine or have a cocktail with a ghost in a "farm to fork" experience. *Photography courtesy of Cari Towery.*

quickly opened and closed within the bays of Central Station until Epiphany Farms Restaurant.

The manager had a server direct me downstairs into a private dining room at the Epiphany Farms Restaurant. The manager was busy as usual and had his laptop opened, so I quickly related to him my experience with Loretta. I then advised him that there had also been a stabbing near where we were sitting. A few clicks on his keyboard and the manager was intrigued that he could, in fact, confirm that prior to the restaurant there had been a stabbing, perhaps during the Roaring Twenties. He and I talked about other paranormal possibilities, including the identity of Loretta. As of now, she has not been confirmed, but like so many other spirits of Bloomington, I am confident she will find a way to make her story come back to life.

12

(ORIGINAL) MOSES MONTEFIORE SYNAGOGUE

LINCOLN'S INFLUENCE CONTINUES . . .

A few streets over from Epiphany Farms Restaurant, on the corner of Monroe and Prairie Streets, stands the beautiful former Moses Montefiore Temple, a reminder of the early Jewish community in Bloomington. The B'nai B'rith Lodge, known as Abraham Lincoln Lodge No. 190, served the early Bloomington Jews since 1872, including young Aaron Livingston. The lad had served in the Union army during the Civil War and was inspired by Lincoln's outstanding leadership and passion. And now, one of the very streets that Lincoln had walked prior to his presidency was the site of the original Moses Montefiore Temple, which served its congregation, including young Aaron. Lincoln's spirit continues to live on in Bloomington-Normal.

THE (ORIGINAL) MOSES MONTEFIORE TEMPLE

When young Aaron Livingston returned from the Civil War, he joined his father and uncle, Aaron and Samuel, at their booming Bloomington clothing store. When his father, the elder Aaron, took deathly ill, young Aaron's grandfather Hirsh traveled from Germany to be with the elder Aaron until

his death. During his stay, Hirsh recognized a need for more worship and education for the growing Jewish community. He immediately wrote to his sons in Germany, Meyer and Isaac, and requested that a Torah from Germany be delivered. Meyer arrived with the Torah in 1881.

As you step into the historic temple, an overwhelming sense of peace and belonging surround you. The beautiful stained-glass windows illuminate colorful patterns and dance in the light. If only these walls could talk. Several paranormal investigations were held in this sacred place. History still speaks at the Moses Montefiore Temple.

After the Torah arrived, the Jewish population formed an official congregation in 1882. After several moves to accommodate the growing numbers, member Maik Livingston offered a donation of $100 toward the building of a temple. His only stipulation was that it be named after Sir Moses Montefiore, the great English philanthropist. Fundraising and financing eventually secured the property, and the temple was completed on the southeast corner of Monroe and Prairie in 1889. The temple spoke of history, and our investigation team, Spirits of Bloomington, wanted to know who else may still be residing inside the synagogue. We held several private and public paranormal investigations to help offset the cost of building renovations. It is uncanny how similar psychic impressions were recorded at each event.

More than one psychic has sensed a huge party gathering outside the building. The people were dressed in their finest clothing and appeared to be from the Victorian era. More than likely, given the era and the size of the gathering, this residual haunting could be from the dedication service of the original Moses Montefiore Temple on May 21, 1889. There was also a psychic impression of a missing document. In fact, an official document was presented on that day, describing the history of the local Jewish formation and the names of those present. It included a photograph of the late Hirsch Livingstone, founder of the Jewish congregation in Bloomington. All items were placed inside a box; a cornerstone was placed over the box and set in place. Many have wondered if that box still remains imbedded inside the cornerstone of the building.

Another repeated impression is that of an older man inside the synagogue. He wears a hat and has been seen walking from the pew on the stage area to the altar. He can be more active when recognized by those attuned psychically. Some sensitive people have felt his gentle touch, such as a blessing placed on top of their heads, followed by a tingling sensation. Many believe that the gentleman may be a rabbi because

A mysterious 1890 fire's mystery, solved at the original Moses Montefiore Temple? *Photography courtesy of Cari Towery.*

of his spiritual nature. However, history shows that the young congregation did not have a rabbi for many years; perhaps this man was one of the elder Livingston men, either Hirsh or his son, the elder Aaron. Both men had passed prior to the building of the temple, but they were very influential in creating, building and maintaining the Jewish faith in Bloomington. Either way, the man's gentle energy is quite a divine experience.

The Moorish-style temple was designed by local architect George H. Miller to resemble German Reform Jewish temples of the late 1800s. The work of general contractors J.W. Evans & Son and stone mason August Laufer created one of George Miller's greatest and best-loved achievements. The temple is one of the few surviving nineteenth-century synagogue buildings in the United States. It continued to serve the Jewish community until 1959.

His small voice resonates within his voice, "I didn't mean to do it. It was an accident. I didn't mean to make the altar catch fire."

The paranormal participants were not privy to the history of the temple prior to their investigation. However, their findings were very similar each time. It was recorded that a young boy appears and explains how he is taking full responsibility for the fire. Other times, several loud boys are seen playing and running throughout the building and are often found hiding underneath the altar. Boys will be boys, but sometimes boyish behavior can create a dire situation.

Just over a year after the dedication, tragedy struck—a fire occurred within the temple. It is well documented that on June 7, 1890, the gas jet used to fuel the eternal flame somehow ignited on the altar. The fire spread quickly, and the temple's interior was so badly damaged that it had to be

completely redecorated. The pews were saved and repainted to cover up the scorch marks.

Before the fire, there were many beautiful and ornate designs, perhaps frescoes painted on the ceilings and walls. Unfortunately, they have never been replaced. They can be seen in early photographs of the temple. According to the temple's history, no one knows what caused the fire; perhaps the paranormal impressions revealed the truth. Many believe the poor boy has been granted forgiveness by the touch of the holy man inside the temple.

Other psychic impressions that have not been substantiated include cold spots in the stairway leading to the basement. In addition, there has been the sense of a possible struggle and the appearance of a face, sometimes a profile of someone as they are being pushed into the wall during the struggle. During a public investigation, someone photographed a little girl ghost looking through the basement window from outside the building.

Historical and family research continues to try to identity the stories behind the impressions revealed at each investigation. After the temple's congregation moved to a larger and more modern location in town, the original temple site has housed churches, private residences and, most recently, a community center. Lincoln's presence and presidency continued to live on in those he touched, such as young Aaron Livingston. Holiness and history resonates within the walls of the original Moses Montefiore Temple.

13
OAKS MANSION

CITIZENS OF POWER ON ROUTE 66

Walking south on North Prairie Street, eyes are drawn to the tallest building in downtown Bloomington, displaying an impressive State Farm Insurance sign. This has been the main headquarters for State Farm Insurance since 1928. Today, George Mercherle's original 1922 vision—to provide reasonable car insurance rates for farmers—has grown nationwide to be among the top fifty corporations of the Fortune 500. The original downtown building and nearby Corporate North and Corporate South campuses now house over fifteen thousand local State Farm employees in the Bloomington-Normal area.

The downtown headquarters was home to Mercherle's private executive office. It remains intact since his death in 1951; some say one of his final requests was that the downtown State Farm structure always remain the tallest building in Bloomington. Some also report that his spirit continues to walk the halls of the executive area. An unexplained shadow or cold rush may be Mercherle overseeing his employees' dedication and hard work, keeping watch over his living legacy. "Like a good neighbor, State Farm is there." However, just one street over once resided the meanest husband and richest neighbor in town, Asahel Gridley.

Like a good neighbor, State Farm's building towers over downtown. *Photography courtesy of Cari Towery.*

The Oaks Mansion

Asahel Gridley came into town with just a few dollars in his pocket. No one ever dreamed he would be the first millionaire in Bloomington, except Gridley himself.

When I first arrived in Bloomington, it was December 2007. Chris, my business partner, was showing me the known—and not so known—(haunted) locations downtown. As we were cruising through the snow-covered streets, I saw a somewhat dilapidated mansion through an iron fence. I immediately wanted to stop. I just knew it was haunted; besides, it was creepy cool to look at. Wisely, Chris turned into the mansion's driveway and said, "It's Asahel Gridley's Oaks Mansion."

I replied, "It is very haunted and I am going to live here someday."

Chris quickly shot back, "Does Tom, your husband, know this?"

The mansion was built in the mid-1800s as a single-family residence by Asahel Gridley, but it now serves as multifamily units, including an additional apartment building that oddly blocked the front of the mansion. I immediately fell in love with the eerie manor and was obsessed with its

history. The owner at the time was very accommodating. He loved to share the strange tales of the 1859 mansion to such a captive audience.

I was drawn to this mansion for a reason that I could not explain at the time. I knew the mansion was going to be an integral part of the 2008 spring ghost walk. By December 2008, Tom and I were living in the mansion's men's quarters apartment; however, much was discovered before our arrival.

The youngest of six children, Asahel Gridley was an orphan by the age of fifteen. Once given access to his $1,500 inheritance at the age of twenty-one, he left New York to find his fortune out west. His entrepreneurship began at the age of ten, working as a store clerk. By the age of forty-nine he was the first millionaire in Bloomington. He was clever, driven and the most hated man in Bloomington.

I was obsessed with the nasty Asahel Gridley and his stunning wife, Mary Ann Enos. His tenacious spirit and demonic relationship with everyone around him provided a sinister backdrop for the hauntings at the Oaks Mansion. Mary Enos's apparition had been seen by many, including the owner, workers and residents of the mansion's apartments. She would float into a room, look pleadingly into one's eyes and softly fade away. On the other hand, Asahel's powerful personality resonated through the halls as an uncomfortable force. His heavy footsteps and breathing, along with unidentified moans and groans, caused many to flee the site. Others claimed that they did not experience any unexplained activity at all. It was definitely time to invite Janice Oberding from Nevada so we could do our own paranormal investigation.

Meanwhile, my study of Asahel's accomplishments continued. He successfully owned or organized a wide variety of business ventures in the early days of Bloomington, including a merchandise store, transporting the first printing press, reorganizing the first bank and gas company and providing the first telegraph lines into McLean County. He was an investor, soldier, senator and attorney. Although Gridley had a nasty reputation as a foul-mouthed, ill-mannered opportunist, he maintained a personal and professional friendship with Abraham Lincoln. Friendships were important to both men.

My own friendship and ghost-hunting adventures with Janice have lasted now well over a decade. We had traveled worldwide to seek the paranormal, and now, in my new hometown, she and I were eager to investigate the historic home. Prior to her arrival, she was given no prior knowledge of the mansion. She is familiar and fond of Abraham Lincoln, but was not told of his connection to the mansion. Below are her own notes from her first visit to the mansion:

Janice Oberding
Gridley Mansion Investigation, July 2nd, 2008

We arrive at Gridley Mansion on a sunny and hot afternoon. I mention this to demonstrate that neither the sunshine or the heat dispels the sense of grimness that surrounds this building. It is unsettling and I would say it is one of those buildings in which a certain amount of negative feelings seem to be embedded. It is my belief that we leave an essence of ourselves behind wherever we spend a great deal of time. Those who owned/lived in Gridley Mansion left strong traces of themselves here. They are not positive energies. No one was truly happy in this home. The negative feelings I pick up are sorrow, fear and anger. I sense lies and a sham.

This mansion was not built so much as a residence as a showcase (to show off, pretense) the people who lived here were adept at pretense, or illusion. They were like actors playing their parts. Not much love here. A lot of anger. Usually when you enter a building's entrance, doorway or foyer, you can feel something. The front entrance to the Gridley Mansion is almost stagnant. Devoid of any emotion like this area is flat.

Once Inside I am drawn to the stained glass window on the landing. It looks inviting with the sunlight streaming in. However, this is an illusion, walking up the stairs, I immediately feel a sense of dread. An intense argument took place on the landing. This may have been the norm as this was not a harmonious household. The name Marianne comes to me. I feel that she (or some woman) hovers in the shadows of the hallway.

I walk the length of the hall. Either a suicide or strange murder, or murders, has taken place somewhere in this building. The owner may have conducted some type of experiments or was a scientific type. I hear someone crying, cannot make out if it is a man or a woman. It is not a child.

My own first official paranormal investigation with Janice at the Oaks was also recorded.

DEBORAH SENGER

I have visited this property many times and am amazed how the spirits just seem to "rise" to the occasion. Given the possible "negative" energy, as a Christian spiritual medium I am still drawn to this property. Perhaps sins can be forgiven through recognition and redemption?

Chris and I were allowed to enter the main floor entry way and hall a few months back. I was immediately "met" with many peering ghosts. They were everywhere—the stairway and looking through doors and walls.

A flying parrot lofted the ceiling with his ghostly wings. All had a yearning to be noticed. As justified by the professional investigation spirits seem to follow us up the hallway, in the first and second floor hallway and out the door. Due to the interesting history and events surrounding the Gridley's the 2nd, 3rd and current owners have some what been over looked. Janice's observations introduced the second family of the Humphries and apparently they lived quite a checkered existence: gambling, ladies (only a short distance from "The Line") and eventual loss of money and home. The bank owned the home during the depression and the 3rd owner purchased the property. Plans called for the building of three apartment complexes. The one standing in front of the mansion was the only one built. Did the curse of the Gridley's stop this project? My own throw away camera pictures were mostly blank while using a flash? What energy stopped me? On a sunny day with a flash what prevented development? After carefully reviewing my EVP (Electronic Voice Phenomena) reoccurring energy surges pulsate throughout the tape. No voices just the distant train and road noise among the hum of bats or birds in the upper attic and roof.

On the July 2nd occasion I once again experience a tightness, ache and anxiety outside and inside the home. Due to the privacy of tenants we were only allowed access to the main entrance, the landing and the second floor hallway. At the end of the hall set an antique piano. I was drawn to the piano and knew spirits abound. I was constantly drawn to two doors. One was to the right as you came up the staircase and the second door was down the hall to the right. The upper porch to the left was an area that many paranormal shots had been taken. This day the other doors took my attention. This was one of the first times I witnessed orbs with the naked eye. Along with the heaviness I received the names Abraham and Isaac---sacrifice? I recalled that a minister or man of cloth had been on site with a sense of holiness among the horror. I asked where Lincoln had slept and was told he was not allowed upstairs in the private family quarters but slept in a back room near the back left hand side.

My immediate afterthoughts that day:

Unfortunately time restraints allowed the mediums and staff a short time to record.

Both technically and spiritually much was recorded. I am compelled to think of this home as being cursed. Did the events of the original owners create an atmosphere of doom?

My recommendation as a spiritual medium and paranormal investigation is that this estate is at the Cross roads. The choice of the previous owners recites an undercurrent of creepy and calm.

Little did I know at the time how these insights were the beginnings of bringing Asahel and Mary Gridley, and the mansion, back to life. I continued to learn more about my ghostly obsession.

Asahel Gridley served as a senator in the Illinois state legislature from 1851 until 1854. During his service, he was instrumental in securing two major railroad lines—Illinois Central and Chicago & Alton—directly through the Bloomington area. As a land agent and owner, he earned over $80,000 in one year (close to $2.5 million in today's economy). Even though he had suffered a financial setback in the Panic of 1837, he immediately was the wealthiest and most influential man in Bloomington.

In the spring of 2008, we premiered our first ghost walk in Bloomington. We included a stop at the Oaks Mansion but were not allowed access inside so as not to disturb the living residents. Chris and I presented the walk as the Lincolns, and we were quite surprised at the paranormal activity recorded outside the mansion.

More than once one of our male tour participants experienced short breaths with an alarming paralysis along their shoulder and arm. We would immediately escort them off the property, and all symptoms would disappear. After this happened a few times, it was realized that the affected tour member was built similar to Judge David Davis.

We soon discovered that Asahel Gridley and Judge Davis were not personal friends. Davis was appalled at Gridley's professional and personal misbehavior, even though they were political colleagues traveling on the Eighth County Court Circuit for many years. Personal feelings aside, each man was instrumental in Lincoln's run for the presidency. It has been recently revealed that Gridley advanced $100,000 toward Lincoln's run for the presidency, and Judge Davis was his campaign manager. Political tolerance was maintained, but Judge Davis felt Gridley's conduct was not fitting for any man, much less high society.

With Gridley's newfound wealth, he soon commissioned the ostentatious Oaks Mansion at 301 Grove Street. No expense was spared. "The Oaks" was designed in the Italianate style, with imported Milwaukee bricks, French windows, a stone patio and lacy ironwork. Huge oak trees and an international garden featuring an authentic Japanese koi pond adorned the outside.

The grand entrance to the Oaks Mansion was once surrounded by international gardens and a circular drive. *Photography courtesy of Cari Towery.*

The house itself was built at the cost of $40,000 (equal to $1 million today), not including the furnishings. Inside, imported elaborate furnishings included grandiose tapestries, statues and paintings. It is possible that a Michelangelo completed their extravagant collection. When the house was being completed, Asahel invited Abraham Lincoln on a tour. Afterward, Lincoln simply stated, "Gridley, do you want everyone to hate you?"

The Oaks Mansion's grand open house was planned for March 4, 1861, the same day Abraham Lincoln was being inaugurated as the sixteenth president of the United States, in Washington City. Even though Gridley had been invited to attend and also to work at the White House by Lincoln, he claimed that politics cost him too much money and he was staying in Bloomington to continue to amass his fortune. Given the Gridleys were not quite so welcomed by local high society, such as the Davis family, they wanted everyone to come and admire their fine mansion.

In desperation to attract a large crowd, Gridley contacted showman agent P.T. Barnum about hiring an international star to perform at the special event. Indeed, General Tom Thumb arrived in all his glory, standing not quite three feet tall. He sang, danced and played the piano, and all of society turned out. The housewarming was a complete success. Gridley immensely

enjoyed the entire day, especially General Thumb's appearance. Gridley recalled how he used Webster's Unabridged Dictionary to boost the general's dining room chair.

The ghost walks continued through the fall with some amazing paranormal shots. One photograph in particular caught our attention; there was a dark-haired boy near Lincoln's, rather Chris's, shoulder. The figure was too high from the ground to be an actual boy, given Lincoln's' height. There were many other photos snapped that night, and no boy was found among the participants. We wondered who the boy could be. On that tour, and to this day, many participants feel a fast swish, their knees being tickled and sometimes followed by a low giggle. We did some more research and uncovered the story about Mary and Asahel's son, Charlie.

Although Gridley was very successful in business, his marital relationship with his wife, Mary Ann Enos, has been described as "demonic." His notorious temper often focused on dear Mary. It is said by their neighbor Jonathan Cheney that Asahel had chased Mary out of the mansion on a cold snowy winter evening, she in only a nightgown, and locked her out. Despite such outbursts, they managed to have ten children together, but only four lived to adulthood (Juliette, Albert, Mary and Edward). Five children died in infancy, and then there was Charlie's tragic death.

Many say that Gridley's behavior was somewhat tolerable until the loss of his son Charlie. Asahel had gifted his son a toy gun. As Charlie was playing around with the gun, it accidently discharged and he was shot directly in his eye. It was a serious wound that developed into lockjaw infection (tetanus), a serious bacterial virus that affects the muscles and nerves. Charlie mercifully died, after suffering greatly. Asahel was inconsolable. His grief and guilt for his son's untimely death made him a living tyrant. In fact, he directly confronted and accused his wife of smothering their five infant children who preceded Charlie in death. Neither one ever completely recovered from the accusations and guilt. However, Charlie's ghost seems to enjoy his boyish antics at the mansion.

Interestingly, Charlie was not alive when the mansion was built, but he still chooses to haunt his parents' home, and perhaps a few other places as well. Many times during tours people have reported childish behavior of two ghosts; one a boy and the other a girl. Sniggering and romping along the streets and sidewalks near Kelly's Bakery has been witnessed by more than one perceptive tour guest. Perhaps Charlie has crossed over a few streets to the courthouse square to join a special little girl. One hopes that Charlie visits Miss Crothers and they still play on the streets of historic Bloomington.

While living in the mansion, my relationship with the Gridleys became more intimate. We were given access to most of the mansion and the upstairs ballroom for public investigations and séances. On several occasions communication with Asahel and Mary Enos was recorded. She felt that he had unjustly accused her of murdering her children. He was angry about the condition of his beloved mansion; it was foremost on his mind. He claimed he would continue to haunt the mansion until it was brought back to a respectable condition, and she would as well, until the public became aware of Gridley's torturous behavior toward her, especially the misguided allegations about her dead babies. She was able to bring some justice when he died in 1881.

Asahel died of exhaustion and a lung ailment on January 25, 1881. He had combated a fire at his bank and never completely recovered. Some say that Mary, in retaliation of his lifelong torment toward her, refused to provide him the proper care to nurse him back to life. The effort to wash the extra clothing needed to keep his body temperature warm was too much extra work for her. The coldness of their relationship seeped into his very being until he died.

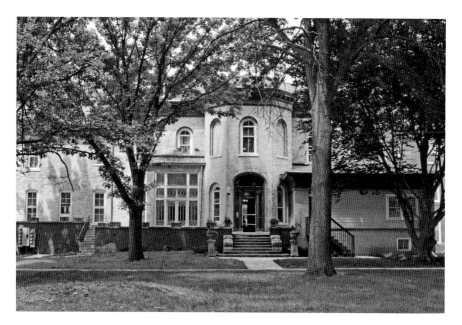

An oak-treed estate surrounds the mansion. Shown is the possible "back door" through which Gridley's coffin was carried in order to not ruin his wife, Mary's, carpet. *Photography courtesy of Cari Towery.*

His funeral was lavish, with thousands in attendance, yet Mary insisted that his casket be carried out the back door instead of the front door, because her "rugs had already taken enough punishment." When they buried Gridley, one of his daughters said, "My father has been a dictator in this city for 40 years."

The Gridley family continued to live in the home until 1905. Howard Humphries and his family resided at the mansion from 1906 until 1935. Eventually, the home was integrated into a large apartment complex known as "The Oaks" that was built in front of Gridley's home. The years were not kind to the mansion, even when Tom and I lived there; peeling paint, rough unfinished floors, inadequate heating and electricity often plagued our everyday life. We soon moved away. My heart was broken by the decaying mansion and Gridley's spirited demands for justice for his once-magnificent manor. Finally, a few years later, a caring couple, Keith and Diane Thompson, was led to bring this splendid property back to life.

Since then, the Thompsons have replaced or updated all the plumbing, heating and electrical in the apartment building and mansion. New central air-conditioning, roofs and gutters have been installed; the chimney, stained glass and residential windows have been restored or replaced. Almost everything inside and outside the apartment and mansion buildings have been repainted, restored and redone. It was an emotional labor of love, and the work continues today, including restoration of the original carriage house and the iron fencing. Even now when I go by, my eyes tear, remembering back to the day when I was first so drawn to this magnificent mansion, its history and haunting.

Asahel received his restoration wish and now perhaps can rest in peace at Evergreen Cemetery with his beloved family, especially his boy Charlie. Mary Enos, on the other hand, may have received her justice in an artistic way. During the 2014 Bloomington Cemetery Walk at Evergreen, the Gridley couple was brought back, represented by actors to recall their prominence in the development of McLean County. He was depicted as his usual cranky self, and she was presented as the tolerable wife seeking justice from her cruel husband. For the first time, her story included his murderous accusation of her possibly smothering their five babies. Through the actress, Mary Enos's enduring agony was expressed, as she tearfully pleaded while gently holding Asahel's hand, "Do you think I could really do that to our babies?"

It has been said that everything takes care of itself eventually, given time to heal and be restored. The Gridley history is part of Bloomington's history, just as much as the history of Bloomington is part of Gridley's legacy. The Thompsons and other residents of the Oaks claim that the only unusual activity is that of the new central air or heating systems.

14

ROSIE'S PUB

LOST ON ROUTE 66

Just down the street from the Oaks Mansion, Main Street/Route 66 has come full circle. The courthouse square is just a block or two over as we cross back to Front Street. Feisty activity often presents itself in order for the truth to be spoken. Such is the case with several spirited opportunists in this section of Route 66.

ROSIE'S PUB

Al demanded that attention be given to him in order for his message to be heard.

In our first couple of years hosting the ghost walk, Chris and I portrayed the Lincolns. We still refer to ourselves as the psychic and the cynic. Little did we know that a spirit was going to challenge our opinions in order that it be found. As the tour group entered the Oaks Mansion estate, a spirit started to be a nuisance to me.

His persistent energy was all around me. I tried to delay my attention to him and finish the tour talk among the oak trees at the mansion. Finally, in desperation, he was dispelling this intense force. I stopped short in my tracks. I must have had this odd look on my face, because Chris looked at me strangely and asked, "Are you okay?"

I quietly whispered, so none of the tour members could hear, "I have this ghost bothering me. You need to take over the tour until I figure out what is going on."

Despite his cynical glance, he followed my wishes. Soon we were outside the mansion property and I stopped the tour in front of a large public building with plenty of available seating. I motioned and asked, "Please, everyone, have a seat."

I continued, "This is the first time Chris has personally witnessed this situation, so please, I ask everyone, including Chris, for your full cooperation."

I went on to describe how sometimes demanding spirits come to me. I learned to acknowledge them and then asked for them to return when someone familiar to them is around me. It was the polite thing to do. I continued, "In this case he will not leave so I believe he is here for someone on this tour."

I gave a detailed description. "I see an older man that tells me he has recently died. He says his name is Al, which is part of his middle name. He walked with a limp in the latter part of his life, and he now wants you to know that he has arrived and heaven is fine."

You could hear a pin drop. No one said a word. Dead silence. Chris, the skeptic, was flabbergasted and admitted later that he thought I had just ruined our entire business. Slowly the group members got up, shaking their heads, and they started walking back. I knew to hang out in the back of the crowd. This had happened before.

A block or two later, a young man approached me and said very quietly, "I think you are talking about my dad. I am sorry I didn't say something sooner but I was too shocked to speak. Everything you said is true; he went by Al, he walked with a limp near the end of his life and he assured my sister and me before he died in March that he would find a way to tell us that he made it to heaven and what it was like."

The young man's confession did not surprise me. I was happy the spiritual connection had been made. I then asked if he would share his story with the rest of the group. He agreed. The participants and Chris were stunned to hear how Al had used the opportunity of a ghost walk to reach out to his family and find a way to convey his heavenly arrival.

Spirit opportunity abounds on Route 66. This heavenly intervention happened right around the location of Rosie's Pub on East Front Street. Rosie's is also the location of a different kind of energy, perhaps, between a father and a son.

Rosie's is a fine tap house located in historic downtown. As its website states, "It is easy to find and hard to forget." Before it was Rosie's, this location on East Front Street had served the Bloomington community since the 1850s as a variety of businesses. It is also attached to the oldest surviving commercial structures in Bloomington. Dating back to 1843, legend says the Miller-Davis Buildings have always housed an attorney, including one of the first, Asahel Gridley. Prior to 1991, the most notable event on this block was held at a community venue across the street called Majors Hall.

It was May 29, 1856, when many historians claim that Lincoln made his greatest speech. The site was Majors Hall, the subject was freedom and

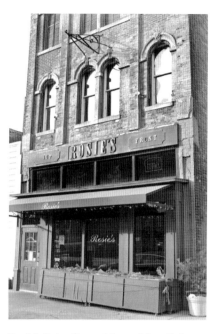

Rosie's Pub offers spirits and fine dining along with a spirited history. *Photography courtesy of Cari Towery.*

the event was the beginnings of the Republican Party in Illinois. For weeks, opposing political sides had been fired up over the slavery issue, recently fueled by the bloody Missouri and Kansas border massacre. The loss of innocent lives and vast property damage over the slavery issue ignited political unrest among Americans; it was time to start speaking up for all men to be free. The convention's purpose was to create the Illinois Republican Party. It was attended by almost three hundred delegates; many distinguished speakers were on the agenda, including Abraham Lincoln. As the evening progressed, the crowd grew more impassioned. Soon they were chanting, "Lincoln! Lincoln!"

Finally, the great orator took center stage, and he immediately captivated the crowd with his powerful speech. At the time, the only way to record a speech was for reporters to write it down word by word. Pencils were poised for the expectant oration. Lincoln talked for nearly ninety minutes and left the crowd stunned and enthralled with his commanding message. Even the reporters were so mesmerized by his words that their pencils dropped and the speech was never officially recorded. The Lost Speech's synopsis was somewhat pieced together by those attending. It was Lincoln's position, that

Twenty Grand Tap doorway
Saturday morning
—O'Connor

Twenty Grand Tap's actual crime scene photograph of the bloody front door. *Stevenson-Ives Library collection.*

unless popular opinion makes itself very strongly felt and a change is made in the nation's present course, "blood will flow and brother's hand will be raised against brother!"

His speech may have been lost, but the truth remains that, on that night in May 1856, Lincoln established himself as a serious Republican candidate for president. America's Lincoln was created that night when the Illinois Republican party was founded. Some truths in history may never be quite that clear, especially at Bill Whalen's Twenty Grand Tap murder scene.

On the morning of April 6, 1991, the body of William "Bill" Whalen was found at Twenty Grand Tap on East Front Street. He had been beaten and stabbed to death in his own bar. The bloody crime scene was gruesome, depicting signs of a mighty struggle between the victim and his assailant or assailants. An investigation began immediately, and police soon arrested Bill's son Donald "Donnie" Whalen. Donnie was charged and convicted of first-degree murder. He is currently serving sixty years for his father's murder.

Before I entered Rosie's for the first time, I had been forewarned of a strange vibration inside, especially around the bar area. I had no knowledge of the 1991 murder at the time. As I cautiously entered, I "saw" a broken barstool among a bloody mess. I was also aware of layers of residual haunting. I did not feel very comfortable and hoped I could find out why.

The court system and many individuals believe Donnie is guilty; however, close family members, including his mother and brother, believe he is innocent. I happened to have met Bill's widow, Coleen, at a Route 66 event just a few years before. At the time, the Mid-City Hotel tour was

102

still available and we were holding an open house to enhance the Route 66 experience.

I and some of my other team members were talking to interested parties as they came up the stairs into the Route 66 site. As I was standing there, a woman walked over to me and asked if I knew who she was. She said she felt a strong feeling to come and talk with me. I did not recognize her. She and I had never met before. She politely introduced herself as Bill Whalen's widow, Coleen. By then I was familiar with the murder and conviction.

For the next hour or so, she talked about how she and her son Steven firmly believed in Donnie's innocence. She made her opinion credible by several key points. They both noted that, on the day after the murder, Donnie was wearing shorts and had no signs of being in a struggle of any kind. If, in fact, he had beaten and stabbed his dad, some type of marks would have been left on his body. She also talked about questionable forensics, including DNA testing.

She reached her conclusion in part on the fact that everyone in the family knew that Bill kept a loaded gun under the bar. If indeed Donnie wanted to murder his dad, why had he not retrieved the easily accessible weapon and shot his dad? At this point, so many of the family's unanswered questions had only led to a solid conviction.

I have no opinion on the matter. I and my friends continue to sit at Rosie's Pub and enjoy the good food. Perhaps one day, Bill himself will find a way, like Al, to reveal the truth. Donnie has asked several times for a retrial, to no avail. But, as in other situations, spirits seem to speak the truth when least expected.

PART IV

BLOOMINGTON:
DRIVING NEAR ROUTE 66

15

VROOMAN MANSION

ROMANCE RIGHT OFF ROUTE 66

Death can be quite romantic, especially if, unlike the Gridleys' demonic relationship, the couple lived a long and happy life together. The devotion between pioneer settlers Isaac Funk and his wife, Cassandra, is legendary. Not four hours after his own death in 1865, she followed. She was buried beside him in the same grave at the old Funks Grove cemetery. One of their granddaughters reminisced about her grandmother: "You all know how she died. Not because she was ill, or suffering, or very old; but because that other one, with whom and for whom she had lived so long, had gone before, and it was easier to close tired eyes and follow him than to face life without him." It was a beautiful earthly ending to a couple's everlasting, unselfish love to their faith, others and each other.

Love affairs often go awry and are sometimes short-lived, like the railroad man and his Margaret. Others include a lifetime of romance enhanced by travel, flowery letters and building a dream or two together. Residuals of romance can also lead to hauntings. Bloomington's mansions and manors, while ostentatious, are fitting sites for a romantic haunting or two.

VROOMAN MANSION

If ever there was a romance, it is that of Julia Scott and Carl Vrooman. They met for the first time in 1894, on the enchanting French Rivera,

a perfect backdrop for the beginning of their fairy tale. She said that love-struck Carl would tell everyone that he proposed to her in every cathedral stop throughout their European travels. Julia admitted that he finally broke her down and she accepted his proposal while they glided in a gondola on a moonlit night through the canals of Venice.

They were married two years later and resided in the Vrooman Mansion until their deaths. It was a match made in heaven, lasting nearly seventy years. Love never dies at Vrooman Mansion.

It all started with Julia's parents, Matthew T. Scott and Julia Green. They were married in Kentucky in 1859. They were some of the first settlers to Chenoa Township, near Bloomington. Matthew was a land speculator. Julia, a young socialite, was devoted to her husband and his pioneer green acreage; however, city living eventually suited their professional and private needs. In 1873, the Scotts purchased their seventeen-room Bloomington home, built in 1869. An eighteen-room addition, designed by Arthur Pillsbury, was constructed in 1900.

The Scotts had two daughters, Letitia and Julia. The Vrooman Manson was home to Julia's second daughter, Julia Scott Vrooman, from her birth in 1876 until her death in 1981.

Guests and visitors alike have reported sightings of several apparitions inside and out on the lawns of the historic mansion. An impressive figure shadows an outdoor monument.

Some have wondered who the tall, thin male apparition is, sporting a stovepipe top hat, appearing among the grove.

On the Vrooman Mansion grounds, a Lincoln Oak Memorial has been placed in remembrance of an oak tree and the possible fiery political debates between Whig Abraham Lincoln and Democrat Stephen A. Douglas. There is no written document verifying such meetings between Lincoln and Douglas at this site, but they just may have happened. The Lincoln/Douglas appearances are still a mystery.

A recent story claims that Carl Vrooman and Adlai Stevenson I, both staunch Democrats, fabricated the entire story and placed the memorial to steal the thunder from the growing Whig Party into a Democrat's own backyard. Democrats were few in a heavy Whig community. Either way, several people have reported the apparition that favors Lincoln, including the stovepipe hat. Lincoln could never tell a lie.

When I first arrived there was a beautiful young Victorian woman with dark hair, with a small boy next to her.

She floats throughout the mansion, often near the upstairs library area. Dark haired, gowned and jewels adorn her hair. Her movement is weightless and her feet never touch the floor.
A husky built bearded man stands in the upper level in his vested proper Victorian suit.

Carl was a writer and debater, and Julia was intelligent and charming. They were deeply religious and devoted to the suffering. He served as the assistant secretary of agriculture under President Woodrow Wilson. Their circle of friends included the likes of President and Mrs. Wilson, Franklin and Eleanor Roosevelt and many others, including prestigious European heads of state. She was the perfect hostess, and he the perfect statesman.

Theirs was a romantic life filled with glamour, travel, politics and prestige. Just prior to their seventieth wedding anniversary, Carl died at the age of 93. Until her death in 1981, Julia's willpower and spirit never faltered. She died in the same room she had been born in. She lived to almost 105.

Her family's history and prominence is kept alive today by their generosity. The couple was childless; when her will was settled, 95 percent of the $5 million estate went to churches and the needy. It would seem appropriate

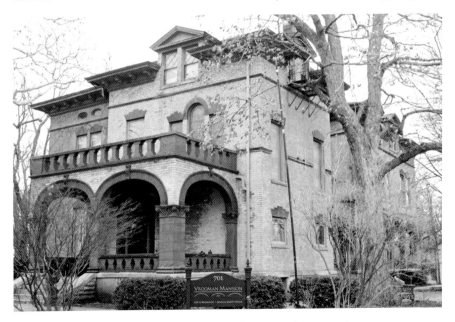

The exquisite Vrooman Mansion bed-and-breakfast attracts history and romance. *Photography by Cari Towery.*

that they both still reside, together, warmly welcoming all who enter their home. A recent guest wrote of her own experience of Vrooman musings:

> *Upon arrival to the beautiful historic Vrooman Mansion, I received a warm welcome by the staff, and the home exuded an aura of peace and happiness. As the staff member led me upstairs to my room, I caught a glimpse of a woman approximately 30-35 years of age, wearing an expensive-looking long black dress.*
>
> *Her demeanor was one of curiosity as she stood in the library at the top of the stairs. She was only visible for a split second, and my guide did not acknowledge her in any way. Later that evening, as I returned from an evening with friends, I entered the side door and once again, caught a glimpse of the same woman in the same dress, standing about 20 feet away, in the music room. As before, her demeanor was one of curiosity, as if she were just checking to see who was coming in as her guest.*
>
> *The following morning, the couple who were staying in "Julia's Room" checked out and I was able to go inside. In the room was a picture of the woman I saw. She was identified as Julia Vrooman, the "second Julia," named after her mother. As I was told that Julia's Room was the room with possible paranormal activity, I requested it on my next visit to Vrooman.*
>
> *Unfortunately, Julia did not make any appearances on that visit, but the manor certainly has no feeling of anything negative, and nothing that should be of concern to a visitor.*

The Vrooman Mansion is an elegant bed-and-breakfast emulating Old World charm in luxurious and charming furnishings and décor, as well as impressive stained-glass windows. The guest rooms and public areas are filled with authentic gilded furniture with thick, velvety curtains. Wall hangings, portraits and woodwork recreate a romantic bygone era. It is a most welcoming home away from home, hosted lovingly by owners Pam and Dana Kowalewski and the timeless romantics, Julia and Carl.

16

EWING MANOR

HEARTBREAKING HAUNTS OFF ROUTE 66

A heart wants what a heart wants, and sometimes, the results can be quite unexpected. And once that love is complete, the bittersweet after-effects can be quite endearing. There are no rules when it comes to heartbreak off Route 66 in Bloomington.

A few streets over from Main Street/Route 66, during Prohibition, there was a little-known thief named Buster Brown. Prohibition was a time when the legal sale or consumption of alcohol was no longer allowed. Depending upon the location, the average dry community began in the early 1900s and ended with the national repeal of the Twenty-first Amendment in 1933. During this time, the nation's mobster and gangster activities exploded. Many men were out of jobs due to Prohibition and desperate to find alternate ways to survive.

Buster Brown would hold up the local grocer on a regular basis. On busy afternoons, he would appear with a loaded gun, demand money, clean out the register and quickly disappear. He never got caught, because it was reported that his accomplice, a beautiful flapper, waited around the corner in a Ford and quickly sped off once Buster jumped into the passenger side.

Buster Brown shoes were very popular at the time. The mascot included a dog and a boy. The boy was always getting into scrapes and was able to escape because of his boyish charm. The shoe icon, Buster Brown, looked

similar to a popular actor at the time by the name of Buster Keaton. So our handsome and charming thief gained movie-star status.

The hold-ups stopped as quickly as they began, over a short period of time. Several believe that the gangster was John Dillinger. Perhaps the dashing duo was, in fact, the infamous criminals Bonnie and Clyde. Either way, Buster Brown broke plenty of hearts of female shoppers when he did not return to rob the store.

Just a couple streets over, on the corner of Emerson and Towanda, stands Ewing Manor, a completely different kind of heartwarming, yet heartbreaking, love story.

THE EWING MANOR

Davis and Hazle Buck Ewing had a love affair like no other. She was a prominent, wealthy heiress, and he was a handsome entrepreneur. They were married in October 1907. Davis owned a concrete business, and she was a born activist. Their life together was promising, not only on a personal level but also in terms of community and world affairs.

The farming community is the foundation of McLean County's successful economic development. In the early 1900s, the rising costs of corn had local farmers searching for alternate ways to effectively store more corn for longer periods of time. Concrete was a new form of sturdy construction material, and Davis soon developed cement materials to fulfill the community's farming and residential needs. Silos, outbuildings, sidewalks, driveways and building foundations quickly modernized construction needs. Concrete replaced wood, just as the automobile had replaced the horse. Davis's business boomed over the next twenty years.

Their marriage and achievements thrived as each pursued their own interests. They adopted a son, Ralph, and also raised Nelson. Married almost twenty years, the couple decided it was time to build their dream home. They planned to travel throughout Europe for a year and be inspired by the many regions' architectural designs in order to create their own special manor and gardens.

It seems appropriate that she still remains at her beloved estate.

I had been drawn to the Ewing Cultural Center for several years. The beautiful Ewing Manor, or residence area, is used for private events, mostly weddings. At the back of the estate is the Theatre at Ewing, which is the

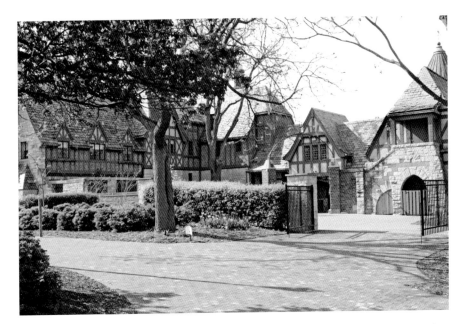

The fairy-tale Ewing Cultural Center beckons you to be entertained, relaxed and amazed by Hazle's dream. *Photography by Cari Towery.*

summer home of the Illinois Shakespeare Festival. The cultural center features the 2007 Genevieve Green Gardens and the 1982 Moriyama Japanese Garden.

It was from the Japanese Garden pagoda that I first saw her standing at the estate's upstairs window; she was surrounded by soft light and had a serene smile on her face. She lifted her hand to me in a cordial wave. I waved back. The elegant ghost of Mrs. Ewing had politely introduced herself to me. She and I psychically spoke. I expressed to her what a lovely estate she had, and she in turned thanked me for visiting and asked me to bring others.

I often walk the gardens and have been inside the manor a few times. Several upcoming tours have been planned, and of course I always bring others, as she had so graciously requested. I do listen to most of the ghosts that I meet.

The gardens are accessible most days and offer a serene stop among the hustle and bustle of the Bloomington traffic. It still surprises me how quiet the back gardens are. Each time I come, I am delighted in the seasonal changes. It is a perfect setting for a picnic, meditation or time to just "be."

Since my first visit, I have brought many others to enjoy the gardens and challenge their psychic skills. I would surprise a workshop group or a friend

Author recharging her energy in the manor's serene Moriyama Japanese Garden. Near this site, she first looked up and met Mrs. Ewing. *Photography by Cari Towery.*

with the location and ask if they felt any type of psychic impressions. Many times, it was the same impression of a formidable woman looking out or walking among the estate. Several specifically referred to a female rider upon a horse.

Recently, a local artist and author, Julie Brooks Meulemans, and her executive husband shared a paranormal experience while enjoying the estate, gardens and the wonderful energy of the Ewing family:

> *For the better part of the last year, I have visited the stately Ewing Manor several times. To walk the beautiful grounds, admire the exterior of the mansion and partake in the annual Shakespeare Festival.*
>
> *Christmas 2015, my husband and I toured the home and stable during the highly anticipated holiday event that brings locals and visitors to the historic mansion to enjoy the festive décor and stories from local historians, who have continued to share the memories of Ewing Manor. For instance, we were told the story of Christmas dinner in the intimate dining room. Promptly at 4 p.m. Christmas came to an end and the celebration of Mrs. Ewing's birthday commenced in the sun porch, which overlooked the spectacular grounds.*
>
> *As we ascended the stairs to the bedrooms, I nervously anticipated the room that sat on the back corner of the manor, as I had once been told that Mrs. Ewing had been seen by some from the corner window. Eventually finding our way to the room that I always fixated my eyes on from the grounds below, I looked for some sign of her. Would she communicate by slightly shifting the tea cup in the corner or maybe dim the light of the original fixture that was perched over the side table?*
>
> *Just as I made my way to the door, I felt something touch my face ever so slightly. It surprised me and I turned to my husband and asked if he had inadvertently brushed his hand over my cheek. He hadn't seen a thing, but I knew Mrs. Ewing was there. Probably pleased that so many people still stand in line to admire her lovely home during the holidays.*

The Ewings returned to Bloomington after the yearlong expedition, with journals filled with ideas for their new estate. They hired Phil Hooton as the architect and soon broke ground to create a charming Channel-Norman house of limestone construction with multiple towers. Local materials, such as stone, hand-hewn cypress timbers and aged repurposed bricks were utilized for the manor, surrounding gardens and

the environment. The manor was completed in 1929 and named Sunset Hill. It served as a private residence until Mrs. Ewing's death in 1969.

The Ewings' love affair somehow ended shortly after the completion of the home. Their beautiful dream together had become bittersweet. He left immediately for Chicago and retired from his concrete business. He then moved and enjoyed a quiet gentleman's retirement with his second wife in Mount Dora, Florida. He died there in 1972 and was returned home to Bloomington to be buried at Park Hill Cemetery.

Mrs. Ewing remained at her beloved estate and continued her own pursuits in charity, the environment, human rights and worldwide peace, along with her lifelong companion, Julia Hodge. When she died in 1969, the manor was given to the Illinois State University Foundation, with the understanding that her estate be used to promote intercultural understanding. The Ewing International Cultural Center was established to utilize all the facilities to showcase her dream.

Hazle and Davis's fairy tale at Sunset Hill sadly ended a long time ago. Despite heartbreak, it seems that the magic still exists. Perhaps Mrs. Ewing is quite pleased to wave or brush a cheek as others visit her beloved estate.

17

DAVID DAVIS MANSION

EVERLASTING LOVE ON THE BYWAYS OF ROUTE 66

Enduring love is quite magical. Home is where the heart is, and the David Davis Mansion is an exceptional example of a living legacy of love off the byways of Route 66 in Bloomington. It was originally built by Judge David Davis and his wife, Sarah, in 1872. To this day, it stands as a lasting reminder of their deep devotion and love for each other.

THE DAVID DAVIS MANSION

David Davis was haunted by Miss Sarah Walker from Lenox, Massachusetts. The first time he met her, some say, it was pure magic. They were introduced through her father, William Walker. At the time, young David Davis was attending law school and working at the local law office of Henry Bishop, one of William's friends in Lenox.

David and Sarah's friendship soon blossomed, and in 1835, Davis asked William Walker for his daughter's hand in marriage. Sarah's father denied his request at the time. The brokenhearted, yet determined, lad set out for Illinois to seek his own fortune, overcome her father's misgivings and earn his beloved's hand in marriage.

David Davis first practiced law in Illinois in the town of Pekin, and by 1836 he had purchased Jesse Fell's law practice and created a home and

thriving practice in Bloomington. His hard work paid off, and he established himself as a promising attorney and future son-in-law. He had accumulated a small fortune.

Once again, he approached Sarah's father for her hand in marriage. This time her father consented, and the couple were joyfully united in marriage on October 30, 1838. He brought his young socialite to the wild west of central Illinois. He was a rising Whig politician and attorney, and she was a cultured, community-minded wife. Their life together wasn't always easy. The Bloomington community was just being established, and East Coast luxuries were difficult to find. With the likes of the Fells, Gridleys and Allins, they established a proper town among the frontier plains and farmland. As the town grew, so did the Davis family.

Sarah and David had seven children; unfortunately, only two, George and Sallie, lived to adulthood. In 1843, the family purchased from Jessie Fell a 190-acre farm, complete with a house, several gardens, livestock and other buildings. They adored their new surroundings and named the estate Clover Lawn. They had plans to build a greater manor when the time was right. Timing is everything, especially when it comes to love and friendships.

David Davis first met Abraham Lincoln in 1835. Together, the attorneys traveled and worked the Eighth County Court Circuit for many years. Lincoln was away from Springfield and Davis from Bloomington, riding the Eighth Judicial Circuit for nearly six months of the year, three months each spring and three months each fall. Davis began as an attorney and soon represented the circuit as a judge until 1862. During this time, Mary Todd Lincoln and Sarah kept the home fires burning, waiting for their husbands' return home from the circuit and other business and political obligations.

As the years passed, both men's prominence grew. With the help of his many Bloomington friends, including Judge Davis, Lincoln was elected to the presidency. The Civil War and the assignment of Davis's judgeship to the Supreme Court put the judge further away from home, but he and Sarah's plans for a dream mansion continued. While the judge served in Washington City, plans and the construction of the manor proceeded under Sarah's supervision.

The Victorian mansion was completed in 1872. Three stories high, it represents the finest in construction, technology and class of the mid-Victorian era. Contemporary amenities such as indoor plumbing, hot and cold running water, central heating, modern gas lighting and several communication systems enhanced the sturdy foundation of the yellow-brick manor. Inside were the grandest furnishings and latest kitchen appliances.

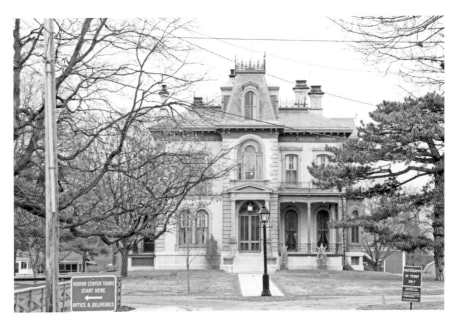

The David Davis Mansion, open to the public, beautifully reflects the everlasting love between Judge Davis and his wife, Sarah. *Photography by Cari Towery.*

The farmhouse was moved aside to transfer the family residential plot into the modern Clover Lawn estate that remains today. It is a true American landmark, to be admired and visited by all.

A few years ago, paranormal associates and friends Janice Oberding and Paula Schermerhorn visited the Bloomington area. Prior to their arrival, Janice and Paula were unaware that permission had been given for a private tour of the David Davis Mansion. The goal of a historic paranormal investigation is to substantiate psychic impressions through historic facts not provided prior to the visit.

Janice and Paula were aware that a site was going to be visited, but they had no prior knowledge of its location. As is the custom of a historic investigation, each participant is encouraged to record their own psychic impressions, not only during the visit, but also prior to their arrival. Janice wrote of the name Edith and how Edith was connected to the site; Paula remarked about a coffin being in the parlor.

The following day, as they entered the mansion Janice and Paula individually walked around the mansion and recorded their own psychic impressions before being advised of the mansion's history. On-site impressions included the changes in the kitchen, more additions to the

119

home, the dislike of trunks and papers scattered about, the last-minute alteration of a bride's dress before her wedding and the color blue being directly associated with the ladies of the home. Collectively, they felt it was a heartwarming home, at one time filled with parties and laughter; of course, there was sadness as well.

Walking down into the basement, a tall, dark, medium-built shadow of a man was seen and later determined not to be anyone on the tour. Once in the basement, a residual energy gave to mind a setup of a single bed and the sound of shoveling near the old furnace area. The scraping sound was quite clear to the mediums present. At the end of the home tour, lingering spirited sounds, feelings and impressions left the investigators with a feeling of home, importance and community. Little did they know that David Davis Mansion and the Davis family were very important not only to the community, but to the nation as well.

The David Davis Mansion, as it stands today, was completed in 1872 and donated to the State of Illinois in 1960. It is carefully maintained as a prime example of Victorian style and taste. The beautifully restored nineteenth-century estate recalls the story of Judge David Davis and his wife, Sarah, during a crucial time in our country's political growth. People lived, worked and died within the walls of this home. After the tour, the investigators were advised by the guides of the mansion's legacy.

Many of the medium impressions were substantiated by the Davis history. Given David's long travels away from home, the idea of traveling trunks and papers scattered about is common for those returning after a long trip. Perhaps the papers were law documents or house plans that should have been kept in order and on the shelves, as Sarah would have preferred. Even technology can sometimes create the perfect atmosphere for a ghost.

The mansion was built with a central heating system that had to be fueled constantly to maintain heat during cold nights. This required a devoted watchman to shovel the needed fuel. In fact, such a man would spend long, long hours in the sparsely furnished basement of the David Davis mansion. His job was to consistently shovel wood or coal into the hot furnace and fireplaces. It seems fitting that his hard work still echoes along with some other traditions within the walls of the estate.

Funerals were often held in the parlors of Victorian homes. The David Davis Mansion was no exception. Sarah had died in Massachusetts in 1879 and was returned home to Bloomington for burial. Judge Davis died in 1886. Both funerals were held in the front parlor of Clover Lawn, and both are buried together at Evergreen Memorial Cemetery.

Even though Lincoln had been assassinated years before the mansion's completion, Davis's friendship with the Lincolns must have continued with Lincoln's oldest son, Robert Todd Lincoln. He was Abraham and Mary Todd Lincoln's sole surviving son, and he respectfully attended Sarah's own funeral in 1879 and was one of the pallbearers at Judge Davis's funeral in 1886. The Lincoln and Davis friendship is immortalized at the David Davis Mansion.

The kitchen, when the mansion was built, did sport the finest in appliances, especially the fancy stove that is still on display today. The torn wedding dress and the color blue are, perhaps, to be kept as a family secret.

Janice had written the name "Edith" in her preliminary expressions of the mansion the night before the arrival. David Davis III's wife was Edith Davis. She resided at the mansion until her death in 1959. In 1960, the David Davis Mansion was bequeathed to the State of Illinois. The estate was listed in 1972 on the National Register of Historic Places and declared a National Historic Landmark in 1975.

The investigators were mesmerized by the magical beauty of the mansion and gardens and the Davis's love story. The David Davis Mansion still speaks of times past. Mishaps, dreams, special occasions and despair are all reflected in the beautiful impressions of the David Davis estate and the enduring legacy of love.

ILLINOIS WESLEYAN UNIVERSITY

ENDURING LOVE NEAR ROUTE 66

Enduring love is quite magical. There are times when a restless soul roams until someone rescues their heart and brings them home. Home is where the haunt is, even off the byways of Route 66.

Illinois Wesleyan University (IWU) was founded in 1850 and began classes in 1851 at Bloomington's Methodist church. It took almost twenty years for a permanent campus to be established in the heart of historic Bloomington, along Main Street/Route 66. The IWU campus is quite impressive and has grown to become one of the nation's leading liberal arts institutions. It continues to provide a powerhouse of graduates and ghost stories.

ILLINOIS WESLEYAN UNIVERSITY

Chris and I decided to have lunch at Lucca Grill a while back. When we walked in, Chris's friend Gary was at the bar with his brother, Tim. As Chris and Gary talked sports, Tim's eyes lit up as he recalled a ghost story from his college days. In the early seventies, he and his buddy were moving into their Illinois Wesleyan's Adams Hall dormitory, right on Route 66. They had been carrying boxes and suitcases up and down the stairs all day and were exhausted.

After the long day, the guys had decided to sit back and drink a couple of beers and take a break. As they were sitting around, the phone from across the room started to ring. One of his friends got up and answered, "Hello?"

"Is Frances there?" asked the male voice on the other end of the line.

"No, there is no Frances here, only us guys moving into the hall," the resident answered.

As the evening progressed, the phone kept ringing. Each time, the same caller asked for Frances, and each time, Tim or one of his friends answered, and over and over again they reassured the caller that no Frances lived there. After a while, and the endless phone calls, the guys were laughing and wondering if in fact they were being pranked. After some time, they quit answering the phone. The phone kept ringing, and they kept drinking until they eventually fell asleep.

The next morning, the boys were suddenly awakened by excessive doorbell ringing, followed by heavy banging at the door. Tim or one of his friends managed to answer the door and were shocked to see it was the local phone company representative. He was there to connect the phone. The phone had never been connected, and the line was dead—and apparently so was Frances.

Legend says that there are actually three Franceses that haunt Adams Hall. The first one was hit by a horse carriage in the mid- or late 1800s. She was carried inside the house and soon died. The other two Franceses are a young girl and an older woman. Their demise could have been caused by a fire. No one knows for sure.

Additional Frances poltergeist activity includes the loud sounds of stereos being turned on and off in empty rooms; guest-bathroom cold spots and breezes so strong one would shiver in the middle of summer; and the loud pounding of heavy footsteps going up and down the stairs. The proverbial rocking chair moving back and forth on the floor above was so loud it could be heard from below, and the random flickering of lights continues to reflect the Frances haunting.

True or not, the paranormal activity has driven away a few residents at Adams Hall and is still witnessed and questioned by residents today. What isn't questionable was Bloomington's founding fathers' determination to create an institution of higher learning. In 1850, a diverse collection of civic- and church-minded people, such as lawyers, doctors, ministers, farmers and mechanics, united to create Illinois Wesleyan University.

IWU's tradition of engaging its students inside and outside the classroom challenged students in all aspects of study, including, most recently, ghost

hunting. The Spirits of Bloomington investigation team was invited to investigate Kemp Hall with the assistance of one of the team members and IWU graduate Phil in 2008.

The best part of this investigation was that I had no prior knowledge of the location. This time I could actually be a medium and not have to be the team leader. The decisions and arrangements were made by Phil and cynical partner Chris. I was also joined by a few other teammates and most of the residents of Kemp Hall. This was my first autumn in the Bloomington area. I had no prior knowledge of the location and was unaware of the hall's history or haunted past.

I and some others waited in a van parked in an obscure parking lot on Main Street, across the street from several homes and campus buildings, while the questionnaire and arrangements were being finalized by the other team members. Until we were escorted across the street to Kemp Hall, I had no idea where we were going. My edited notes follow as I walked up the mansion's steep steps and crossed the veranda-style front porch of the two-story residential hall.

> *Porch: children at play but sadness. No more.*
>
> *First Floor: A locked elevator. Deserted room. Issues with flooring and hanging pictures out of sync. A heavy sweet perfume smell, a drunk, cold wind and something to do with a janitor or gray uniform. Kitchen: dishes and slamming doors with coldness passing. Formal dining room a funeral and I heard, "I am lost." The smell of carnations (indicating death to me) and the side street door I could hear the clump-clump of a horse carriage perhaps a funeral. In the library a father or husband crying.*
>
> *Second Floor: Sharpness in my chest in the hallway. Room 201 and the front sitting area I was immediately drawn to. The sound of a bell tolling (indicating to me Death had come) near the bathroom of room 201. A room in the back not used and shut up. There is a woman that floats yearning.*

Once the psychic impressions were shared, the history was revealed to us about the International House, now referred to as Kemp Hall. According to legend, Kemp Hall was once the residence of A.E. DeMange and his wife. The mansion was finished in 1907 as a gift to Mrs. DeMange from her new husband. The manor featured the finest imported wood, servants' quarters, an impressive library and a grand ballroom on the third floor. It was a proper home for the turn-of-the-century elite, and it has plenty of room for current college students.

Tragically, after living in the home for a only year, Mrs. DeMange died, some say while giving birth. She left her husband grief-stricken and all alone. He immediately vacated the new, luxuriously furnished home and sold it to the university in 1911. For years, reports of a lady in red appearing and floating throughout the halls haunted Kemp Hall. Some say red was her favorite color; others presume it was her gown soaked with blood from the tragic childbirth. It was further revealed that she would appear in the mirror in room 201. Being a spiritual medium, I knew it was time to bring some peace to our beautiful and lovely apparition.

I gathered the team and a few others inside room 201. I asked for God's guidance and invited the spirit's husband to come and greet her from heaven. I invited her to stand in front of the mirror she had appeared in so many times and reach for his hand. As he reached from the higher realms, she took his hand and disappeared into the light of heaven. As surreal as this all sounds, there was an unspeakable energetic sensation that rushed through all those present, and to this day the lady in red is no longer seen.

That evening there was also a frightening incident inside a third-floor closet. As two of us stood inside the closet and had the door closed on us, we did not know that it served as an elevator. As we stood there in the dark, I sensed a gray uniform, or a uniformed attendant messing with the controls. Inside the closet with me, my companion's reaction was quite scary. I watched as her face became a skeleton's skull and then turned green with death. She experienced flashes of red and orange and screamed to get out. That night, we had no answers to our frightening experience. In fact, it was an ongoing investigation until recently.

It has now been said that there was an old elevator that used to be in service in the house and has since been sealed up. Apparently, there was a young man who was stuck in the elevator and died when it suddenly fell. People still claim to hear the squeals of the elevator gears and the bloody screams of the young man as the elevator fell to the bottom floor. No one knows what happened. It was suspected that someone might have accidentally, or purposely, messed with the controls. After his death, the elevator was sealed up. Closets were created, and the incident is rarely mentioned anymore, until someone is shut inside the closet on the third floor. This would certainly explain our terrifying experience and our rush to vacate the death trap.

There is also a rumor of the spirit of a young girl who roams the home and porch. She died in the house; she still wanders as if looking for

something or someone. Perhaps it is the DeManges' baby daughter, lost in childbirth, looking for her mom and dad. We can only hope she has been reunited with her family.

The IWU campus has abounded with the bright, promising future careers of youth since the 1850s, but to this day no answer can be found for the sinkhole or the alleged grave of Eva in the basement of the resident house on Chestnut Street.

The Chestnut Street house was built as a residential home in 1898 for a doctor and his family. It is located inside historic Franklin Square, established as the first city park in 1856. To this day, it houses an amazing array of historical wonders from the Victorian era, featuring Queen Anne and Georgian Revival architecture. Several Funks, Illinois governor Joseph "Private Joe" Fifer and U.S. vice president Adlai E. Stevenson I had impressive homes that still stand. The area encompasses the magnificent tree-laden children's play area and gazebo, still featuring ice-cream socials and concerts in the warmer months. It is an ideal family residential setting, except for poor Eva.

Eva was the doctor's lovely teenage daughter. She fell in love with a young sailor visiting the town, and she soon became pregnant. Her distraught Victorian-minded father quickly performed a procedure on his daughter to remove the unwanted pregnancy. The surgery failed, causing Eva and her unborn child to die. Horrified and deranged for the deed he had done, the father went crazy. He dismembered her body, carried her body parts to the dumbwaiter and lowered them into the basement, where he buried her bloody remains under the house's dirt floor.

According to some, the dead girl appears heavily draped in white, symbolizing her lost wedding. Others declare that a clear sighting has been seen of her sitting on a couch and that her name was revealed during a Ouija board session. All this paranormal activity escalated until a burial service was officially performed around the sinkhole, or her grave, in the basement, followed by a blessing completed with a whitewashed symbol on a nearby door. History itself has revealed a somewhat different version of the story.

The original resident was, in fact, a doctor, and he did have a beautiful daughter born in 1878. She was about twenty, not a teenager, when the house was completed. She was married in 1903, had several children and lived a long and happy life. The sinkhole is known to still exist, but the teenage girl's ghost has not been seen for quite some time; but the stories live on in the basement of the Chestnut Street house.

Enduring love can appear in all forms of the supernatural inside the haunted halls of one of America's finest liberal arts campuses. As IWU states, "a liberal education at Illinois Wesleyan fosters creativity, critical thinking, effective communication, strength of character and a spirit of inquiry." With such aspirations for its graduates, it only seems fitting that some ghosts just want to keep calling the college campus on Route 66 home.

PART V

NORMAL: EXPERIENCING ROUTE 66

19
MONICAL'S PIZZA

HEADING NORTH TO NORMAL ON ROUTE 66

Imagine Al Capone cruising down Route 66 headed south from Chicago in his 1929 bullet-proof, steel-plated V-8 Cadillac sedan to visit some of his cronies along the hard road to St. Louis. Bloomington-Normal is near the halfway point, but, most important, it was the home of the original Steak 'n Shake restaurant on the corner of Virginia Avenue and Main Street.

Today, the site is home to Monical's Pizza, an American pizza chain serving and delivering delicious pizza, pasta and salads all over the Bloomington-Normal and other regions. It is also home to the chicken bacon ranch pizza—the favorite of Tom, my husband, besides the A La Baldini at Lucca's. Who would believe there are two great haunted pizza parlors on Route 66?

MONICAL'S PIZZA

Gus and Edith Belt were operating a restaurant and gas station on the Main and Virginia Streets intersection on Route 66 since 1934. Originally called the Shell Inn, it served gas and food. At first it was fried chicken plates, and then they switched to fish dinners and finally grilled steak hamburgers for a dime. They were proud of their good food and fast service, brought by "curbies"—waiters who delivered the food directly to the cars. Steak 'n

Shake was the beginning of drive-in service. It was a quick stop for busy cruisers on Route 66, and it was one of Al Capone's favorite stops.

It was believed that Capone would use the quick drive-thru service at Steak 'n Shake for a made-to-order steakburger and handmade shake. By staying inside his Cadillac, he had no worries about being a target of a bullet. It was also said that Capone helped to fund the Route 66 project to convert dirt roads into hard-surface roads from Chicago to Los Angeles. It was also good for Capone's business—the smoother the ride, the less spillage of his liquid goods being transported during Prohibition.

Either way, Al Capone often stayed in town, owned a local pool hall, farm and possible gin mill and pool hall. His brother Ralph "Bottles" was the head of his bottling operations in the Chicago area. Locals have told us that they believe Ralph had a second family in town, that their mother, Teresa, once owned a home in Franklin Square and that Ralph was in fact buried in Park Hill Cemetery, right here in Bloomington.

We do know that Al Capone frequently stayed at the Illinois House hotel and owned Fat Jack's pool hall. There is a farmhouse right down the road with a renovated barn and possible gin mill ruins. The house that Teresa supposedly lived in has been demolished, and the lady who had tea with her every afternoon is no longer alive.

The Original Steak 'n Shake offered one of the first drive-in curb services, the predecessor to today's drive-thru service. *Stevenson-Ives Library collection.*

The Mill Route 66 attraction in Lincoln, Illinois. *Courtesy of Geoff Ladd collection.*

Ralph is somewhat associated to a Park Hill location. When he died in 1974, Ralph was cremated at Park Hill Crematorium in Wisconsin and his ashes placed at the Mount Carmel Cemetery in Illinois. There will always be rumors and legends related with Capones in Bloomington-Normal and along Route 66 in Illinois. These are just rumors, mind you; we don't want to have to testify later in a court of law.

Steak 'n Shake's property was near the Sugar Creek riverbank. The local creek flows through most of McLean County along much of Route 66. It could be quite dangerous, especially during heavy rains. Sudden downpours could cause the creek to rise and spill over into the streets and local businesses.

Recently, a story was repeated that in the early 1950s or '60s, when a heavy rain came, locals would flock to the barstools at the Steak 'n Shake and have their lunch with floodwaters rising up their pants. I can't imagine that the local health department would allow such shenanigans, but you never know about the folks in Normal.

Steak 'n Shake continued to operate in the original building, until a fire damaged the structure in the 1960s. The site was repaired and expanded

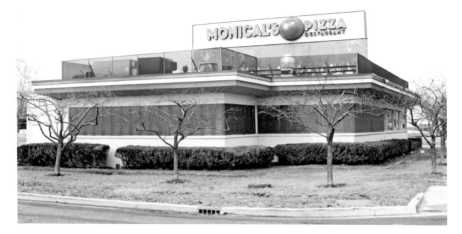

Monical's Pizza on Main Street in Normal. Don't touch the thermostat, especially if it is set on 82 degrees. *Photography by Cari Towery.*

to include a nice dining room. It operated at this location until the 1990s, and then the building was sold to Monical's Pizza. The business transaction made no mention of a ghost.

The Spirits of Bloomington investigation team was recently asked to look into the Monical's Pizza site on Main Street/Route 66. The manager, Tammy Rittenhouse, and some of the other employees had been experiencing paranormal activity for quite some time. Recently, the ruckus had escalated. Since starting as manager in 2000, Tammy immediately noticed some unusual activity.

She vividly recalls, "From the time I arrived at this job, I've noticed unusual noises, unexplained activities, shadows and conversations. A back freezer door constantly opens and closes, lights switch on and off, giggling has been heard and the feeling that someone was always present when I am alone late at night."

Other current and past employees, such as Paige, Sonya and Shelia, relate similar experiences, including having their long hair pulled and hearing unexplained loud racket and banter. All have witnessed a sudden click sound and the associated rise or fall of the temperature setting of the dining room and kitchen thermostats. Even in the summer heat, the temperature rises to 80 degrees for no apparent reason.

In desperation, Tammy asked the spirit to identify itself. "I heard and have since referred to the ghost as Sammy."

Tammy had been told that Sammy may have been a victim of Sugar Creek's flash flood in the 1990s. It took several days of preliminary research to come up empty-handed in regards to the Sugar Creek flooding and deaths in the 1990s. When I had the chance, I reached out to the McLean County Museum of History's library and was provided a file about the Sugar Creek flood. There were many flash floods in the area along Sugar Creek, but none specifically in Normal in 1997. No names or deaths were mentioned for that time period in the file.

I then visited the Normal Library, which in turn referred us to the Bloomington Library, where card catalogs were loaded with history and research possibilities. I encouraged Sammy's spirit to help me with the process as I carefully studied card after card. I suddenly saw the headlines: "Flood Death in Normal an Accident"; "Search Abandoned for Drowning Victim." And the year was not in the 1990s, but 1982. I had found not one, but two, possible drowning victims; perhaps the ghost at Monical's could be identified.

I quickly wrote down the *Pantagraph* newspaper information so I could pull the microfilm and locate the specific articles to do with the tragic Sugar Creek flash flood on December 3, 1982. William Godfrey and his passenger, Laura Peterson, were driving down Main Street/Route 66 during a sudden rainstorm. More than six inches of rain were dumped, causing sudden havoc on Route 66.

William, according to several *Pantagraph* reports, while driving north had encountered several stalled vehicles on the flooded street. He tried to maneuver around the cars, but the truck became stuck each time. The water on the road kept rising. He then tried to back the truck across a bridge just south of the intersection. By this time, the water was three feet deep. The truck left the road and slid directly into the forceful, deep-running creek. The floodwaters were so powerful that the driver lost all control of his truck.

Several people courageously leaped into the creek to try to pull the occupants out of the truck. The vehicle quickly pulled away, and the good citizens barely made it ashore to save their own lives.

Laura's body was found right away, along the riverbank. Her death was later ruled an accidental drowning. The search for William's body continued for many weeks. The cold weather and soft ground made the searches difficult. Additional debris along the creek bed often was piled ten feet high and at least seventy feet long, making it nearly impossible to see a dead

Searching for William Godfrey along Sugar Creek. *Stevenson-Ives Library collection.*

body. Eventually the search was completely called off; the body of William Godfrey has never been found.

When spirits pass, they often attempt to reach out for family or friends. Could Sammy be a family or friend's name? William may be calling out Tammy's name, and she was thinking he said Sammy instead of Tammy. The spirit world doesn't always make it easy to find answers. Remember the constant moving thermostat going to 80 degrees? Well, perhaps it is going to 82 to commentate the year he died. A flash flood may have swept William Godfrey away, but his spirit may very well remain alive at Monical's Pizza. Perhaps more answers will be found some day on Route 66 in Normal.

20

Illinois State University, Milner Library

Into the Heart of Normal on Route 66

Route 66/Main Street travels right into the heart of downtown Bloomington's twin city of Normal. The Twin Cities are fondly referred to as Downtown Bloomington and Uptown Normal. Jesse Fell was the founder of Normal in 1865. In 1867, the Town of Normal was officially incorporated by state charter. Uptown trustees were elected, sidewalks built and the sale of alcohol was prohibited until 1970s.

Normal is best known for Illinois State University, established in 1857, and the once state-supported Soldiers' and Sailors' Children's School. Both are on or near Route 66. Along with some other locations, they offer much to those seeking ghosts in the Uptown.

Illinois State University, Milner Library

Illinois State University's original classes were held at Major's Hall in Bloomington, site of Lincoln's famous Lost Speech. The ISU campus now spreads well over one thousand acres, with a current student body of over eighteen thousand in Normal. The university began as a "Normal" teaching college and has now grown to include dozens of degrees in major fields, such as business, education, social sciences and humanities. ISU

offers a perfect opportunity for higher learning and paranormal activities in uptown Normal.

The most famous ghost at ISU's campus is that of the beloved librarian Angeline Vernon Milner. According to Michael Kleen's book, *Ghostlore of Illinois Colleges and Universities*, she was born in Bloomington in 1856. She was destined to become a librarian. By the age of four, she was reading; by 1891, at the age of thirty-five, she was the head librarian at the university. "Aunt Ange," so fondly named by the student body, was dedicated to helping the students with their research.

Ange never married. Her entire life was devoted to her library books. She maintained a strict and proper organization of the materials and books in the Old Main Building and then North Hall. She collapsed while organizing a section of biology books and died in 1928. It would seem fitting that she still wants to get her job done.

North Hall served as the campus library until 1940, when a new structure was built and christened Milner Library, to honor the university's beloved librarian. In 1976, the old Milner Library was renamed Williams Hall, and most of the books were moved into the newer library, located on the north side of the campus. Many of Ange's books remained on the third floor of Williams Hall.

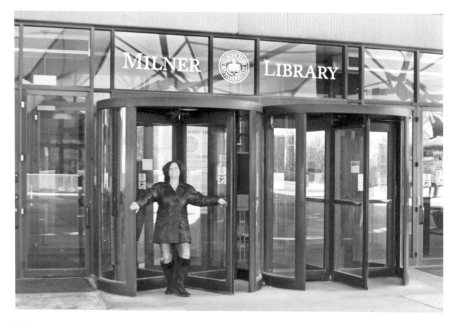

The author visiting the Milner Library on the ISU campus. *Photography by Cari Towery.*

Faculty, staff, students and visitors, as well as students working in the Williams Hall archives since the 1980s, have reported spirited encounters with who they believe is Ange Milner. Among the sensations felt among the books have been the following: a creeping feeling along the arms or neck; a chill that permeates the body and makes every hair stand on end; the feeling that someone is standing nearby, despite no one being there; sudden temperature drops; mist or fog; and untouched books flying from the shelves.

Kleen's book describes a former employee reporting that she had actually witnessed a full-torso apparition of Ange in 1995, describing the spirit as "a five-foot-tall elderly woman in a floor-length dress wearing her hair in a bun."

Miss Milner's haunting seems to follow the location of her beloved books. The books were recently moved into an airtight storage area to better preserve them. Has Ange followed them, or is she content that her books have finally been stored properly?

Recently, a well known para-celeb visited and conducted a paranormal investigation. One of my team members, Steffanie, reported what happened. This is what she recalls about that special evening:

Several years ago, a famous TV medium came to town. He was to do a meet and greet, gallery reading and ghost investigation at a "famously haunted" building at the local university. Of course I had to go! While meeting him and witnessing the gallery reading were fun, the investigation was the exciting part of the evening I looked forward to.

When we arrived at the building, everyone was waiting to be led to the room where we would start the investigation. I happened to see a penny on the floor, and the medium told me that I should flip it head's up and take it for luck. So I did! Then, we were taken to the haunted location, most known for being haunted by a former librarian.

Once we arrived in the part of the building that is notoriously haunted, the medium began to talk about previous experiences with haunted buildings. He had an app on his phone that spirits could use to communicate with the living. The device did report some words. Also, the medium used flashlights for communication.

The medium informed us that when he uses flashlights to communicate, his friends' deceased son often comes forward to help spirits communicate. He seemed to have a longstanding relationship with this sprit. Before long, the flashlights did respond to questions. The friends' son, who was a spirit, made the flashlights blink very fast. This was this young man's form of

communicating. While the famous ghost of the library did not seem to make her appearance, there were other sprits turning the flashlights on and off to communicate with our group.

After we concluded our flashlight session, we proceeded to explore the building. We were able to walk through the old library racks in the basement. While the area appeared "spooky," we did not encounter any other sprits for the rest of the evening. While we did not communicate with the librarian, it did seem as though we had made contact with people from the beyond, and it was a fun night!

I am still informed of others witnessing Miss Milner in her spirited state, but apparently it is now a rare occasion. Perhaps she is content to finally retire among her properly preserved reference books. Modern technology has been known to calm the spirits in the proper environment.

21

RYBURN PLACE/SPRAGUE'S SUPER SERVICE

CRUISING ROUTE 66 IN NORMAL

Route 66 takes a few interesting turns around Normal before heading north to Ryburn Place, formerly known as Sprague's Super Service. A stop in the Uptown area is a must before or after the visit. The heart of Normal offers easy walking access to coffee shops, ice-cream parlors, fine restaurants, eateries, retail shops, Bill's Key Shop and the modern Uptown Amtrak Station and Government Center.

Impressive highlights of this technological uptown community are the Marriott Hotel and Hyatt Place high-rise hotels and the beautifully restored Normal Theater. It was originally opened in 1937 as the first stand-alone, commercial movie theater in Normal: "A new thrill in theater beauty."

The theater's interior and exterior have recently been completely restored to its Art Moderne architectural style. It is the ideal location for a movie-star selfie, complete with striking lighted marquee as the backdrop. Classic movies, theater productions, comedy shows and other entertainment attractions light up this nostalgic theater.

I have visited the theater several times and witnessed some unexplained ghostly activity. The movement of shadowed couples among the seats in a practically empty theater, the running of feet and silly giggling often can be heard in the distance. Just as I am tuning into the more residual haunting, my attention is drawn to the stage or screen. I am soon transported from the spirit world. Now, it is the magic of the shows that upstages the quiet presence of the paranormal community at the Normal Theater.

The historic Normal Theater in Uptown Normal features movies, comedy and other shows and special events. *Photography by Cari Towery.*

Ryburn Place, formerly Sprague's Super Service

Heading north from Uptown Normal on Route 66, the next stop is Ryburn Place, formerly Sprague's Super Service on Pine Street. Years ago, Pine Street was the Northern Gateway to and from Bloomington/Normal. The haunted location is alive with Normal's spirited Route 66 history.

In the late 1920s, according to owner Terri Ryburn in a 2013–14 *Route 66* magazine article, "The Place at 305 East Pine Street":

> *Contractor William W. Sprague constructed a two story Tudor Revival building at this location and opened "Sprague's Super Service." The first floor included a restaurant, gas station and garage. A spacious owner's apartment and a small attendant's apartment occupied the upstairs. A gas station, restaurant and garage were on street level and upstairs were the owner's roomy apartment with a compact residence for an attendant.*

I had visited Terri's place several years back with business partner Chris Hotz. She was very welcoming and passionate about her renovation dreams at her Route 66 destination. I, on the other hand, was just dying to

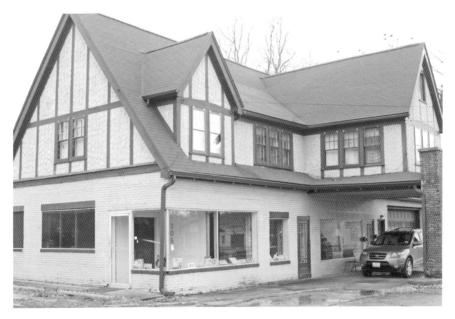

The Ryburn Place is layered with Route 66 history and haunts. *Photography by Cari Towery.*

find out about her ghosts. It was several years later when the opportunity presented itself.

I saw Terri at a Bloomington Normal Area Convention and Visitors Bureau's event and asked about visiting her iconic attraction. She gave me her business card so we could set up a time to meet at Ryburn Place and talk further about the possible ghost investigation.

Soon after, a meeting was arranged and we met at Ryburn Place. She warmly welcomed me into her roomy upstairs apartment, offered me a cup of hot tea and sat down to discuss the Spirits of Bloomington's investigation agenda. I informed her that our investigation usually lasted about an hour or two and that we would have at least five or more team members present.

During our conversation, I kept feeling the tug of a ghost dog. The dog kept grabbing at the bottom of one of my pant legs and playing tug-of-war. I kept ignoring it and hoped it would settle down until our conversation was finished. The dog was very persistent, and I finally mentioned the dog to Terri. Once I acknowledged the dog, it immediately ran into her bedroom and started jumping on and off the bed. She said she had no idea whose dog it could be.

As we concluded our conversation, Terri graciously agreed to the investigation of Ryburn Place and offered to have the history present so we could compare it with the medium impressions. I thanked her again for the opportunity to investigate Ryburn Place and hoped someone else on the investigation team could perhaps give us more clues to help find the ghost dog's owner. I left excited not only about the ghost dog but what other spirits may be found at Ryburn Place on Route 66.

Even after my second visit, I had very little knowledge of the building's history, except that it served as a gas station, garage and nice living quarters for Terri. The paranormal team had no knowledge of our location until we arrived on a Saturday morning.

The team had recorded in their notebooks their preliminary psychic impressions prior to their arrival at the unknown destination. We introduced ourselves and individually walked around outside, throughout the downstairs and in Terri's nice upstairs apartment. Just like the Eaton Studio and Gallery, the building was layered with residual energy.

The team recorded a wide range of intuitive impressions.

Downstairs, one member sensed a lively church service or some other type of religious service. Praying or gazing at the sky was felt by another in the backyard. Several mediums felt the presence of a very unlikable strong

willed woman. Many talked about a man in the garage addition area. The mechanical smell of grease, oil and the sound of dropping tools were felt in the garage addition area. A strong male presence was pacing and worried. Several felt one male spirit did not want the garage to be removed and others felt it was an impatient customer.

Upstairs several talked of a tall man's shadow in her spare bedrooms, hallway and one of her guest rooms giving most of us a sense of sickness, sadness and crying. Others talked about encouragement from several spirits especially a kind-hearted man for Terri. The man lovingly insisted with encouraging words for Terri to keep going with her project. His presence was also felt in the kitchen entry area.

Both times I visited, I was greeted by and watched the hyper antics of a small dog. He was happily jumping all over the bed in the master bedroom. Out on the street I felt a strong conspiracy or mishap to do with a crime. The impressions of the ghost dog and the crime left Terri baffled.

The psychic impressions were quite a variety, and not all are listed here. Terri graciously served hot tea as the team gathered. The team eagerly waited for Terri to explain the history of Ryburn Place (Sprague's Super Service).

Ryburn was amazed at the team's diverse, yet accurate, impressions of the place. She is quite a master of storytelling, so we all sat spellbound as she talked. She quickly acknowledged the building's original use as a service station and garage and the 1937 tourist cabins located behind the building for Route 66 travelers.

In just a few years, a highway bypass was finished, and the need diminished for overnight tourists. The cabins were removed, a concrete block addition was built on the south side and a one-bay garage was added to the west side in 1967. The local traffic and businesses still supported the need for gas and garage service.

Through the years, businesses changed with the ownership of the building. Gas stations, restaurants, rental space, insulation and roofing companies were common usages. Transportation companies included the Yellow Cab Company and Avis Rent-a-Car, and it served as a Greyhound Bus stop.

The gas tanks were safely removed in the mid-1970s, and the building was then used by a catering company, a bridal shop and a wedding-cake bakery. A previous female business owner was known for her cantankerous behavior and poor business behavior, or perhaps her behavior had something to do with a crime. This was all prior to Terri Ryburn's purchase in 2006.

Terri also shared that her husband had recently died after a long illness. She believes the kind and loving man was in fact her husband, Bill. It was heartwarming how he was able to reach out to her and wanted to let her know to keep going on *her* Route 66 project.

You see, the purchase of the building was a complete surprise to him and her. She had driven by the site for many years and had often remarked to her husband, "I wish someone would buy that building and do something with it."

Recently retired, she and Bill were content in their nearby remodeled home. A "For sale" sign went up in the parking lot of Sprague's Super Service. Terri still can't explain what led her to call the realtor and go inside the building. "I wasn't in the market for a house, much less a decrepit old building, but I was curious to see the interior."

To her surprise, she immediately made an offer, without talking to Bill. As they say, the rest is history. This building had chosen Terri to bring it back to life, and she renamed it Ryburn Place.

She also confirmed that an independent, fundamentalist church group had rented space downstairs, and that lively services and praying would be expected. There was no confirmation of the ghost dog identity or about a crime mishap, but, as always, we stay alert on Route 66 for the spirits to speak when the timing is right.

Terri further explained how she was a comedian besides being retired from Illinois State University. She had an upcoming comedy fundraiser that she was headlining, featuring comedian Robin Brayfield. Those funds would then be used to bring in the singing duo Hank and Rita to produce a film featuring their travels on Route 66.

She then asked if any one of us wanted to be extras for the 1980s audience at the Eagles Club. You see, ghosts have a way of arranging things. Terri explained that the renovation plans include the removal of the garage addition—perhaps one particular ghost would not be happy.

Since the investigation, an interesting news story was uncovered by one of our team members. It seems that in 1933, the sister of the owner of Sprague's Super Service had been acquitted of a charge of killing her husband, L.D. Daley. According to the November 29, 1933 *Pantagraph*, her husband had been shot and killed in Champaign, and she was the prime suspect. A sole witness's testimony was discredited by character witnesses for Mrs. Daley. Her niece, Miss Pansy Sprague of Normal, was so relieved at the acquittal that she fainted on the spot in the courtroom.

Mrs. Daley, the story stated, was recovering in Normal. There is no absolute proof that this was *the* psychic impression of a crime conspiracy

Artist's depiction of the future Ryburn Place on Route 66. *Courtesy of Terri Ryburn's collection.*

to find Mrs. Daley guilty of her husband's death. However, her mishap was corrected, and justice had been served to the innocent Mrs. Daley. We do find it interesting that it was connected to Sprague, the original owner of the Ryburn Place.

The Ryburn Place continues to come alive under Terri's direction. She has received several grants and help from others, including the Town of Normal, the National Park Service/Route 66 Corridor Preservations Program and the Route 66 Association of Illinois Preservation Committee.

Bill Kelly, executive director of the Illinois Route 66 Scenic Byway, facilitated the installation of a Route 66 wayside exhibit. The Ryburn Place has been placed in the National Register of Historic Places, inducted into the Route 66 Association of Illinois Hall of Fame and is a Town of Normal Local Landmark. Terri plans to open a gift shop in the spring of 2016. It seems that perfect timing continues for spirited intervention while cruising on Route 66.

22
SOLDIERS' AND SAILORS' HOME

SPOOKY ROUTE 66

Heading north on Route 66 from the Ryburn Place, one encounters the crossroads of Pine and Beech Streets on Route 66. There is a large campus of cottages, homes and an epic, spooky, dilapidated building. Most buildings are now independently owned and operated as residences and businesses.

The history of the orphan home dates to 1865 and provides a bevy of stories and haunts on spooky Route 66.

SOLDIERS' AND SAILORS' HOME

The Soldiers' and Sailors' Home, or the Soldiers' and Sailors' Children's School (ISSCS), opened as the Civil War Orphans' Home in 1865. It provided a boarding school for Civil War veterans' children. Through the years, the facility continued to operate it, providing care for children of veterans from other wars and eventually admitting all orphans until its closure in 1979.

The school building barely stands up on Beech Street. The rickety structure exudes creepiness. Unkempt and left to rot, the building creates an eerie and sad state of what was once the town's pride of helping needy children. Many sensitive people are drawn to the depressing condition of the building and the desperate cries of the spirit children as they call out for their missing parents.

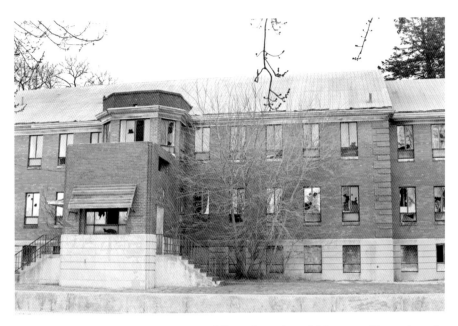

The creepy front entrance to the closed building, where ghost children are still experienced. *Photography by Cari Towery.*

It has been said that, early on, when disease and filth were widespread, it was policy for the children to be put into isolation upon arrival. They were kept separate to be properly cleaned, fed and found disease-free before entering the general population. Unfortunately, some children were not well and died. It has been said that they were buried on the grounds and later moved to a proper cemetery plot in Bloomington. Their heartache and death saturates the residual sadness and despair of the school building.

Feelings of misery, immense head pressure, stomachaches and an overall sense of hopelessness is felt by many who drive or walk by. The building itself is not safe and not open to the public. People often see children peering out of the windows. They are pale, with sunken eyes and thin bodies. In the past, people would mistake them for living children and try to rescue them. Now all know they are permanently imprisoned and the building is off limits to the public, whether they are seeking the living or the dead.

As the school grew, some of the older buildings were torn down and more modern facilities built. The children were housed comfortably within a system of cottages and homes. A gymnasium, a new heating plant and new hospital were added to properly care for the orphans.

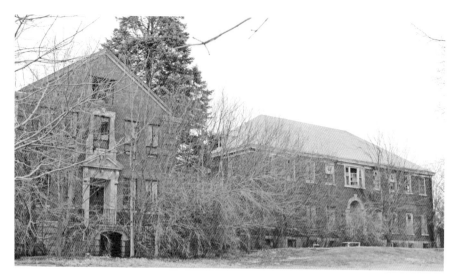

A side view of the old structure, decrepit and dangerous. *Photography by Cari Towery.*

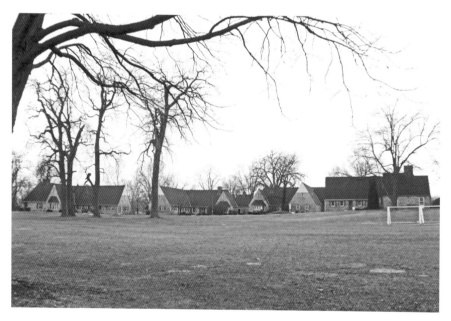

Normandy Village reflects a positive usage and energy of the former site. *Photography by Cari Towery.*

Since the closure of ISSCS in 1979, many of the existing buildings have been completely renovated and remodeled into businesses or homes and renamed Normandy Village.

The town of Normal served the needy children all those years ago. At the time, "residents sent a memorial to the legislature calling attention to the need of an institution to care for the dependent children of the Civil War soldiers." Some people say the Soldiers' and Sailors' Children's School is haunted.

I've had several offices within Normandy Village and enjoyed the beautiful energy of the campus. In my opinion, there is no gloom or negativity, but peace and tranquility among the beautiful tree-shaded Normandy Village campus on Route 66.

What haunts the facility is the neglect of the old school building. Perhaps someday, the creepy structure on Beech Street will receive the same love and care that the community provided for the needy children all those years ago.

CONCLUSION

ROUTE 66 ENDS IN BLOOMINGTON-NORMAL

It has been almost nine years now, and it never gets easy.

Each time I am asked to portray Mary Todd Lincoln, I follow a precise protocol. She is, after all, the one in charge. The universe somehow thought it was time for us to come together and do good work in Bloomington-Normal.

I must always be prepared.

Mary possessed a clever feistiness that attracted Lincoln. With this same energy, she has channeled herself directly into me.

Each audience is special, and I carefully plan the presentation to suit the listeners.

As I put together each production, I imagine Mary and Abe literally putting their heads together in a quiet home setting. They talk passionately about politics and strategy for his latest speech or courtroom appearance.

Just like them, a plan is put into place to provide the best performance.

Once the dialogue is ready, Abraham Lincoln scribbles a few notes and carefully places them inside the brim of his tall hat. He is fired up like no other man in history has ever been.

I carefully lay out the essentials; proper undergarments, shoes, dress, gloves, pearls to adorn the neck and fresh flowers to enhance the beautiful bonnet. As I carefully dress, Mary comes alive within me and carefully tilts her head to the side to let me know we are ready.

The psychic and the cynic, the author and Chris Hotz, appear as the Lincolns at a red carpet event in Lincoln, Illinois, premiering the *Lincoln* movie in 2012. *Courtesy of Geoff Ladd collection.*

Is it possible that in the universal plan each of us is exactly where we need to be? With the proper tutorage, anything can be achieved through education and practice. Mary may have brought me to Bloomington-Normal, but she isn't the only character or spirit that has come alive since my arrival.

Haunted Bloomington-Normal is my own testament that the paranormal investigator and lover of history can be combined with mediumship to integrate history with haunted entertainment.

It is a journey not traveled alone. A family, a team, other citizens, customers, historians, entrepreneurs and home owners must be on board to allow such magic to happen.

This is a tale of a spiritual medium that landed in the wonderful world of Oz, not knowing that Dorothy was buried here. It was just left up to me to believe that there is no place like home in Bloomington-Normal on Route 66.

Mary Todd Lincoln may have brought me here, but it was all the other spirits, alive or not, that were waiting to be discovered on Route 66 in Bloomington-Normal. Timing is everything. History and haunts all began here on Route 66 in Bloomington-Normal.

BIBLIOGRAPHY

Craig, Eloise B., Frances R. Johnson and Bertha R. Hudelson. *Souvenirs of History: Normal*. Normal, IL: Normalite, 1965.

Duis, Etzard. *Good Old Times in McLean County*. McKnight & McKnight Publishing Company Sesquicentennial Issue, 1968.

Fehrenbacher, Don E. *Lincoln: Speeches, Letters, Miscellaneous Writings; The Lincoln-Douglas Debates*. New York: Library of America, 1989.

Fraker, Guy C. *Lincoln's Ladder to the Presidency: The Eighth Judicial Circuit*. Carbondale: Southern Illinois University Press, 2012.

Henry, Chester D. *Route 66: My Home Away from Home*. Charleston, SC: CreateSpace, 2014.

Jones, Morris W. *Stories of the Past & Poetry*. N.p., n.d.

Kay, Betty Carlson. *Illinois from A to Z*. Urbana: University of Illinois Press, 2005.

Kleen, Michael. *Ghostlore of Illinois Colleges and Universities*. Hertford, NC: Crossroad Press, 2015.

Light, Ivan. *This Bloomington Town: A Sketch of Bloomington, Illinois*. Shirley, IL: Range Line Farm, 1956.

Munson, Don. *Don Munson's WJBC Sesquicentennial Stories: Glimpses of McLean County's 150 Years*. Bloomington, IL, 1980.

———. *More of Don Munson's WJBC Sesquicentennial Stores: Glimpses of McLean County's 150 Years*. Bloomington, IL, 1980.

———. *The Illustrated History of McLean County*. Edited by Greg Koos and Martin Wyckoff. Bloomington, IL: Transactions of the McLean County Historical Society, VIII, 1982.

Munson, Don, and Greg Koos. *WJBC's History You Can See: Fifty Historic Journeys into McLean County's Past.* Bloomington, IL: McLean County Historical Society, 1991.

Neece, Orville. *Historic McLean.* Bloomington, IL: Transactions of the McLean County Historical Society, VVI, 1944.

Reinking, Donna. *Lincoln in Bloomington-Normal.* Bloomington, IL: McLean County Historical Society, 1998.

USEFUL WEBSITES

www.becksfamilyflorist.com
www.bloomingtonlibrary.org
www.daviddavismansion.org
www.epiphanyfarms.com
www.evergreen-cemetery.com
www.ewingmanor.illinoisstate.edu
www.facebook.com/EatonStudioGallery
www.funksgrove.org
www.funksmaplesirup.com
www.historic66.com
www.il66assoc.org
www.illinoisbyways.org
www.illinoisroute66.org
www.illinoisstate.edu
www.iwu.edu
www.kellysbakery.com
www.library.illinoisstate.edu
www.lincolncollege.edu
www.luccagrill.com
www.mchistory.org
www.monicals.com
www.mosesmontefioretemple.org
www.mpzs.org
www.normaltheater.com
www.rosies-pub.com
www.ryburnplace.com
www.savethemill.org
www.specsaroundtown.com
www.spiritsofbloomington.com
www.steaknshake.com
www.sugargrovenaturecenter.org

BIBLIOGRAPHY

www.trotterfountain.wix.com
www.visitbn.org
www.vroomanmansion.comv

ABOUT THE AUTHOR

Intuitively gifted from birth, Deborah Carr Senger is a spiritual medium and mystic. Her psychic, spiritual and humanitarian work has taken her to all corners of the world. She has recently returned from India, Italy, Germany, South Korea and Hawaii.

Deborah's private metaphysical practice is in Normal, Illinois. Her innate knowledge and easy humor allow her to balance the serious and humorous side of her private metaphysical practice and public entertainment business. Her private practice offers private readings, healing sessions, classes and workshops, as well as Gypsy Girl Parties and séances.

Deborah Carr-Senger is always ready for a new metaphysical, paranormal or historical adventure.

She co-owns and operates Spirits of Bloomington, which offers step-on and walking tours, as well as presentations of historic and haunted Route 66 and Lincoln sites in the Bloomington-Normal area. Through channeling and extensive research, she is honored to portray many ladies in history, such as Mary Todd Lincoln and Helen Keller. She loves integrating history, haunts and personal experiences to bring spirits alive.

She lives with her husband, Tom, and their rescued animals, Maggie, Tabitha and Pete. They are members of Lions Clubs International and embrace its motto: "We Serve."

And the Band
Stopped Playing

And the Band Stopped Playing

The Rise and Fall

of the San Jose Symphony

DR. THOMAS WOLF

NANCY GLAZE

Wolf, Keens & Company

Cambridge, Massachusetts

And the Band Stopped Playing

The Rise and Fall of the San Jose Symphony

Research for this book and its publication were supported

by the David and Lucile Packard Foundation.

This book is also available online at www.wolfkeens.com.

Additional copies are available ($15 postpaid) from:

WOLF, KEENS & COMPANY

10 Rogers Street

Cambridge, Massachusetts 02142

617-494-9300

info@wolfkeens.com

Library of Congress Control Number: 2005904665

ISBN # 0-9769704-0-6

DESIGN: THE LAUGHING BEAR ASSOCIATES, MONTPELIER, VERMONT

About the Authors

Dr. Thomas Wolf is Chairman and CEO of Wolf, Keens & Company, an international consulting firm with a focus on arts and culture. His lifelong association with symphony orchestras began with his debut as flute soloist with the Philadelphia Orchestra at the age of sixteen. Since that time he has provided guidance to orchestras throughout the United States and advised grantmakers that fund orchestras. For a decade he was consultant to the John S. and James L. Knight Foundation's Magic of Music program, helping to allocate millions of dollars toward innovation in the orchestra field. He is the author of *The Financial Condition of Symphony Orchestras* and an editor of *Americanizing the American Orchestra*, both publications of the American Symphony Orchestra League. His other books include *Presenting Performances* and *Managing a Nonprofit Organization in the 21st Century*.

Nancy Glaze is Director of Arts at the David and Lucile Packard Foundation. Prior to joining the Foundation in 1983, she was executive director of the Community School of Music and Arts in Silicon Valley. She has been active at the local, state, and national levels on issues of cultural policy, arts education, and leadership development. She was a founding member of the Silicon Valley Arts Fund, a program of the Community Foundation Silicon Valley; and she co-chaired the arts education task force for Cultural Initiatives Silicon Valley. She is currently on the board of Americans for the Arts and the Classics for Kids Foundation, and also serves on the advisory committee for the Nonprofit Finance Fund. Nancy Glaze is a 2001 recipient of the California Arts Council award for exemplary contributions to the arts in California.

CONTENTS

FOREWORD

In keeping with a strong belief in the inherent value of symphony orchestras, the David and Lucile Packard Foundation supported the San Jose Symphony Orchestra for more than twenty-five years. The Foundation saw the symphony as a fundamental part of the cultural landscape of the local area and, along with other similarly committed funders and patrons, worked diligently to preserve it.

From 1973 through 2000, grants from the Foundation supported the symphony's general operations, facilitated a broadening of the symphony's donor base, provided emergency funding to help avert projected deficits, and enabled the organization to seek expert advice and consultation aimed at strengthening its operational infrastructure and effectiveness. In addition to financial support, the Foundation often assumed a convening role, bringing together a cross-section of regional leaders to meet with symphony trustees, staff, and patrons to explore ways all might work together on behalf of the organization.

Although the Foundation made every effort to help the symphony to be successful, in the end, this support was not enough. It is the Foundation's hope that this book will serve to inform and enlighten those who share an ongoing commitment to furthering the arts in their communities.

The David and Lucile Packard Foundation
May 2005

EXECUTIVE SUMMARY

This is a cautionary tale for other cities,
for other symphony orchestras, for those in
the entertainment industry, and for anyone
connected with a nonprofit organization.

This book tells the story of a symphony orchestra in a particular city that went out of business in 2002. Such a local story might seem to be of only parochial interest to a small group of individuals who lived in and around that city (San Jose, California) at about that time. This was their orchestra, after all, and when it declared bankruptcy after 125 years of existence, it represented the community's loss.

But this is also a cautionary tale for other cities, for other symphony orchestras, for those in the entertainment industry, and for anyone connected with a nonprofit organization. For each, there are lessons to be learned, mistakes to be avoided, and opportunities to be investigated. This book also raises some fundamental questions about when and under what circumstances it is appropriate to terminate the life of a symphony orchestra or any nonprofit organization.

Why did the San Jose Symphony fail? Some of the reasons are familiar:

- Its operation was based on an unachievable and overly ambitious vision that grew well beyond what the community could sustain.
- It had weak leadership—board, staff, and musical.
- It spent money it did not have and misallocated the money it did have.
- It ignored sound advice from national experts even when that advice was provided free of charge thanks to the assistance of local funders.
- It had insufficient marketing and fund-raising capacities.

- It offered too much of the same product in the same way long after it was clear that there was inadequate demand.
- Its programming, said by some to be "unexciting," did not address the realities of changing demographics and local taste.
- It ignored obvious competition locally and regionally.
- It performed in poor venues.
- It operated in a collective bargaining environment that led to too many guaranteed services for musicians, services that did not reflect the realities of the marketplace.
- It ignored obvious opportunities for partnerships in the areas of education and technology—partnerships that likely would have been met with widespread community enthusiasm and support.
- It got diverted by the fantasy of an overly expensive new concert hall even when its day-to-day operations were failing.
- Its inadequacies were tolerated for too long by local funders, thereby exacerbating the problems it faced.

All of these problems and missed opportunities are documented extensively in the following pages. But the most interesting and provocative question may not be, What went wrong? It may be, How much did it really matter?

It has long been axiomatic in the United States that a great city needs a great symphony orchestra. San Jose is a great city. But did it need a great orchestra—one with high-caliber musicians playing symphony orchestra concerts in a large downtown venue week after week? Did it need a great concert hall? Did it need a European-born music director with a fancy pedigree? Did it need all the accoutrements that go with symphony orchestra organizations—organizations established in the nineteenth-century European mold and later modeled on a very few successful institutions in select U.S. cities?

As we begin a new century and the full implications of having a great symphony orchestra are played out in city after city, it is important to raise these questions and others. Have changes in the demographics of our communities and in the entertainment marketplace changed funda-

mental assumptions about the need for professional orchestras in the traditional mold? Are rising costs and falling demand clear indications that many professional orchestras simply will be unable to thrive in the twenty-first century?

Asking who really needs professional symphony orchestras and who is willing to pay for them suggests that similar questions can be asked about nonprofit organizations in other fields. When an organization's mission, program, and operations are no longer sustainable, we ignore such questions at our peril.

INTRODUCTION

The Background

In March of 1877, Rutherford B. Hayes was inaugurated as the nineteenth president of the United States, succeeding the Civil War hero, Ulysses S. Grant. The "War Between the States" was little more than a decade in the past. That same year (1877) marked the final surrender of Crazy Horse, the Native American leader who helped immortalize the Battle of Little Big Horn. Thomas Edison was in the throes of experimentation, having just announced the invention of the "talking machine," but his extraordinary light bulb was still a couple of years in the future.

In sleepy San Jose, California, a flourishing agricultural region was becoming well known for its fruit, especially its prunes. The community had served as the first capital of the state of California in the 1850s, but its accommodations were reportedly so poor that it did not retain that distinction for long. Indeed, an old photograph from the 1860s providing a view from San Jose's courthouse does not depict a promising metropolis—it shows a vast plain broken up by perhaps two dozen ramshackle dwellings. This was not the place one would have imagined a state capital . . . or a symphony orchestra.

Yet it was in this unlikely locale and era that a symphony orchestra was born. The first concert was played in 1877, and within two years the San Jose Symphony Orchestra organization was established, one of the first ensembles of its kind in the West, and indeed in the country. It would be another two years before Henry Higginson established the Boston Symphony, twelve years before the founding of the Chicago Symphony, and more than twenty years before the Philadelphia Orchestra was established. Indeed, of the so-called "big five" orchestras, only New York's predated the

formation of the San Jose Symphony Orchestra. Neighboring San Francisco would not form its orchestra until 1911, almost thirty-five years later.

One hundred and twenty-five years after the first orchestra concert in San Jose, the music stopped. On December 16, 2002, the San Jose Symphony filed for bankruptcy. Some had hoped for a reprieve for the organization—more time to raise money to get the organization back on track. But for them, the news was as bad as they could imagine. Unlike some orchestras that had filed for bankruptcy only to reorganize as newer, stronger organizations, the SJS bankruptcy ended the organization permanently. The assets were sold, and the organization ceased to exist.[1] The orchestra that had once been the pride of a growing city went quietly, with minor press coverage and with little hue and cry from the community.

Understanding what happened and why it happened may serve as a wake-up call for other orchestras and other communities.

- How could this have happened?
- Who was to blame?
- Where was the community support?
- What did this portend for the future of classical music in San Jose or orchestras in America?
- What does this tell us about the management and governance of a nonprofit organization and when it might be appropriate to close it down?

The answers to these questions are not simple. No single group was to blame for the demise of the SJS, and many good people tried hard to save it. Nor was there any single factor that can explain the symphony's demise. But understanding what happened and why it happened may help other communities understand how a major artistic resource can be lost. Such an understanding may also serve as a wake-up call for other orchestras—or other nonprofits—in other places.

The Symphony Orchestra
as an American Institution

The history of the symphony orchestra in America can be divided into four distinct periods.

By mid-century, nearly every major and moderate-sized city in America had an orchestra, and some had more than one.

EARLY ORIGINS: Before 1900, symphony orchestra activity was sporadic and dispersed with almost no professional ensembles except in a few major urban centers. Though the phenomenon of the European-style symphony orchestra was based primarily in the East, a few orchestra institutions made their way into the West. The first concert of San Jose's orchestra in 1877 is quite extraordinary considering that the most important symphonic works of such major orchestral composers as Brahms, Dvořák, and Tchaikovsky had yet to be written.

THE DELUGE: At the turn of the century, orchestras began to spread throughout the land, and the formation of new institutions was unprecedented for the next half century. Americans desiring classical music no longer had to depend primarily on Europe. With European immigration at an all-time high, the available pool of European-born American musicians was growing. That same influx of Europeans brought audiences with a taste for classical music that itself was primarily European in origin. As the wealth of these immigrants increased, so did their support for the American orchestra. By mid-century, nearly every major and moderate-sized city in America had an orchestra, and some had more than one. These orchestras employed musicians primarily on a freelance (per service) basis, and most had other jobs. Indeed, the idea of a salaried workforce of musicians playing for an orchestra year-round was practically unheard of. At the same time, because costs were relatively low by today's standards (even adjusted

for inflation), typically, a handful of donors was able to cover the small shortfall between earned income (primarily from ticket sales) and expenses.

PROFESSIONALIZATION AND INSTITUTIONALIZATION: Just after the middle of the twentieth century, there was a fundamental reassessment of what the country had managed to create. From many quarters, the issue was the same — there were many orchestras but not enough of them were musically great or institutionally stable. The result was a rush to build year-round, high-level professional orchestra institutions that would become the envy of the world. Offering musicians predictable employment at higher wages, professionalizing staffs, building endowments — all of these were seen as important strategies to achieving the goal. After an investment of hundreds of millions of dollars, the goal was achieved in a large number of cities. American orchestras did become preeminent in the world, a development aided by enhanced pay for musicians (major orchestras went to full-time, year-round salaries beginning in the 1960s), larger and better-trained staffs (especially in marketing and development), and a strong feeder system of homegrown, conservatory-trained musicians of the highest caliber. Endowments and budgets grew exponentially. So did audiences.

> American orchestras did become preeminent in the world, but then, in the final quarter of the twentieth century, some fault lines began to appear.

CHALLENGES: Then, in the final quarter of the twentieth century, some fault lines began to appear. Orchestra expenses were growing faster than revenues.[2] The number of concerts continued to grow — initially to satisfy audience demand, but later to satisfy the employment terms of musicians who now depended on orchestras as a prime source of income. As immigration shifted away from Europe, that sector of the audience, so loyal in its support, began to age. At the same time, the costs of tickets escalated, frequency of attendance declined (as did subscription buying), and empty seats became an increasingly noticeable problem in concert halls. Another contributor to the audience decline was a major disinvestment

in public school music education that began in the 1970s. With less exposure to classical music and instrumental lessons,[3] fewer members of the younger generation showed an interest in orchestra concerts. The development of new technologies was also a factor. Ironically, technology had once been a boon to orchestras, contributing a new income stream through the sale of recordings. Now technology was drawing people away from the live concert hall performance experience. Well before the century's end, many orchestras were in trouble—some in serious trouble—and a series of bankruptcies, which began with the failure of the fifty-three-year-old Oakland Symphony in 1986, shook the industry.

•

To some extent, the history of the San Jose Symphony mirrors that of the orchestra industry as a whole. From its nineteenth-century roots, it remained primarily a small, nonprofessional community orchestra for most of the first hundred years of its existence. Its budgets were modest. But after 1972, with the hiring of Music Director George Cleve and the national trend toward growth, it rapidly expanded into a professional orchestra. With that professionalization came a better-trained corps of musicians and, ultimately, the creation of a professional staff and a separate foundation with an endowment to ensure long-term viability.

There is no question that the musical product of the San Jose Symphony improved during this time. Unfortunately, few people foresaw just what it would take to sustain the new larger institution. Deficits grew and audiences were insufficient to consume the added supply of product. Appeals to the community to "save the symphony" became more frequent. In the final years, after several last-ditch efforts to keep the symphony afloat—many led by high-profile leaders such as the mayor and the publisher of San Jose's major newspaper—the will to keep the organization going simply was not there.

There is no question that the musical product of the San Jose Symphony improved during this time. Unfortunately, few people foresaw just what it would take to sustain the new larger institution.

PART I
THE MARKET

Demand

The Classical Music Audience

By national standards, the classical music audience in the San Jose Symphony's prime market was large during the 1990s, the final decade for the SJS. Both in San Jose City (where rates of participation in classical music approached 25 percent) and the balance of Santa Clara County (where they stood at 27 percent), the rates exceeded the national average (16 percent) by a considerable degree.[4] This is hardly surprising in an area (Silicon Valley) in which one third of all people over the age of twenty-five held a bachelor's degree or better and in which the average household income was $72,000.[5]

Among the broad population, 25 percent of respondents to a 2002 survey conducted by Cultural Initiatives Silicon Valley said that if they had an opportunity to learn a new form of creative expression, it would be playing a musical instrument.[6] This rated considerably higher than painting, photography, acting, creative writing, gardening, and carpentry. From a demand perspective, this seemed to be an ideal marketplace for a symphony orchestra.

Spheres of Influence

Yet in looking at the demand in a more nuanced way, San Jose and the SJS represented only one sphere of geographic influence for classical music consumers in Silicon Valley. Other spheres directed demand away from San Jose. Palo Alto and Stanford University, less than an hour away and with a world-class presenting series ("Lively Arts"), served a highly educated audience and controlled much of the demand for classical

music in its local area. Montalvo and the Flint Center were two additional Silicon Valley anchor venues with their own established spheres of influence. Then there was San Francisco. The primary market area for the major San Francisco performing arts organizations encompassed the northern part of Silicon Valley, which overlapped the SJS's market area.

The draw of San Francisco on SJS audiences was typical of a problem encountered by many cultural institutions that find themselves within the shadow of large and culturally important cities. Such cities often boast internationally acclaimed cultural institutions, which are often able to allocate large marketing budgets to an ever-expanding geographic base. In the orchestra industry in recent years, these large institutions have been facing declining audiences and thus have been searching ever more widely for people to fill seats.

A survey of Silicon Valley audiences conducted in 1997[7] revealed that almost as many people attended events outside of Santa Clara County as in San Jose. Fully one third of all attendances by Santa Clara County residents were either in Bay Area locations other than Silicon Valley or beyond. Seventeen percent of large entertainment program ticket buyers for San Francisco–based attractions came from the SJS's market area. For classical music organizations, the impact may have been somewhat more modest—more like 5 to 10 percent of their ticket sales.[8] Yet given the size of their audiences, this represented a lot of ticket activity.

Using conservative figures, the combined draw of the San Francisco Symphony, Opera, and Ballet would have amounted to as much as $5 million in ticket sales from the SJS's market area. The San Francisco Opera, in using a broad definition of Silicon Valley that included parts of San Mateo County in 1998, drew 18 percent of its subscriber base and 14 percent of its single-ticket sales from Silicon Valley. That amounted to $3.2 million in ticket sales for the opera alone in a year when the SJS's ticket sales were only $2 million.

A survey of Silicon Valley audiences conducted in 1997 revealed that almost as many people attended events outside of Santa Clara County as in San Jose.

Cocooning Behavior and
Avoidance of the Concert Hall

Recent research reveals both good news and bad news for symphony orchestras trying to attract classical music lovers. Roughly 10 to 15 percent of Americans have what might be termed a close or moderately close relationship with classical music, and again as many have weaker ties. This is a great deal higher than previous estimates. Yet only half of those who express the very highest levels of preference for attending classical music concerts actually attend live concerts, even infrequently.[9] This huge potential market for classical music and symphony orchestra concerts is maddeningly difficult to attract to the concert hall for the following reasons:

The huge potential market for classical music and symphony orchestra concerts in the United States is maddeningly difficult to attract to the concert hall.

- Radio is the dominant mode of consumption of the art form.
- Recordings constitute the second most frequent mode of consumption.
- Live concerts rate a distant third.

In terms of settings for the consumption of classical music, the patterns are strikingly similar:

- The automobile is the most common setting for experiencing the art form.
- The home is next.
- Informal venues (schools, churches, private homes) constitute the third most popular setting.
- The concert hall rates a distant fourth.

In Silicon Valley in the 1990s, these preferences were reflected and amplified. Commuting was a way of life, and the car's tape deck, CD player, or radio could offer high-quality music and sound twenty-four hours a day. The intense pattern of work for those whose demographic profiles fit the potential classical patron (high education, high income) put significant pressure on discretionary free time, making it difficult for arts

organizations to capture some of that free time. The prefer-
ence for technology as the primary purveyor of classical music
in this geographic center of technological innovation was high,
as was the value placed on entertainment options in the home
or close to home. In this environment, the SJS's challenges
were daunting.

Supply and Competition

Silicon Valley

In the fertile classical music environment of Silicon Valley,
there was a rich array of classical music organizations and
programs. The classical music enthusiast in Silicon Valley had
many options, often several each week and many close to
home (see Appendix A: The Competitive Marketplace for
Classical Music in Silicon Valley). Thus, despite clear demand
for the classical music product, there was a great deal of com-
petition for the SJS. It was far from the only game in town.

Research carried out for this project during the season follow-
ing the demise of the SJS indicated that at least fifty-four
organizations were offering 387 classical music events in
Silicon Valley. This was, of course, only a small fraction of the
total events available in the entire Bay Area.

Of the fifty-four organizations offering classical music
concerts, a surprisingly high number (twenty-eight) were
orchestras providing 190 performances during the season.
The orchestras were comprised of:

- Five professional symphony orchestras

- Nine community orchestras

- Four professional chamber orchestras

Despite clear demand for the classical music product, there was a great deal of competition for the San Jose Symphony. It was far from the only game in town.

- One amateur chamber orchestra
- Nine youth orchestras

Additionally, Silicon Valley offered another twenty-six organizations providing 197 performances of classical music:

- Four opera companies
- Nine choral groups
- Ten performing arts series
- Three classical music festivals

With the exception of July, at virtually any time of year, people were able to take in a classical music performance in Silicon Valley several times a week. Furthermore, most people did not have to travel far to hear a classical music concert, as the distribution of performances by geography was very broad:

- Palo Alto/Menlo Park/Los Altos/Mountain View: 151 performances
- San Jose/Santa Clara: 121 performances
- Saratoga/Cupertino: 32 performances
- Santa Cruz/Gilroy/San Juan Bautista/Salinas: 31 performances
- Fremont/Hayward/Livermore: 27 performances
- San Mateo/Redwood City: 25 performances

Some have argued that this seemingly vast supply of product is irrelevant because the SJS's offerings were generally of much higher quality than those of most of the competition. But admissions data indicate that regardless of quality, these other organizations were drawing audiences (close to 100,000 admissions per season). Whether or not the quality approached that of the SJS (a subjective question at best), people were still buying tickets.

In addition to the many opportunities to attend live classical music events in Silicon Valley, for those willing to travel to San Francisco, the opportunities expanded exponentially.

Given the many organizations and programs being offered, it was imperative for the SJS to differentiate itself and make a case for why it was unique and indispensable to the community. This was one of many areas in which the organization fell short.

San Francisco's Supply of Product

If Silicon Valley offered a dense array of classical music events, the picture became even more competitive when San Francisco and the balance of the Bay Area were thrown into the mix. For many in Silicon Valley, the drive to San Francisco took an hour or less. For those patrons for whom quality was the hallmark of their concertgoing decision, the San Francisco Symphony represented an undisputed premier option. For others, whose preferences might be quite specific concerning subforms of classical genres or classical music superstars, a variety of venues offered an array of artists and ensembles of the highest quality.

The sheer volume of San Francisco–based organizations, and their variety, was daunting. In 1981 and 1986, the San Francisco Foundation conducted two surveys (entitled "ArtsFax") of nonprofit arts organizations in the Bay Area.[10] One of the findings of this work was that the number of nonprofit arts organizations in this region had grown from about thirty in 1960 to nine hundred in 1980, a growth rate that is probably unprecedented in almost any other city in the United States during that thirty-year period. After 1980, the growth continued. It is easy to see why the attraction of San Francisco was so strong for many people in the SJS's market given the array of choices.

And strong it was. An economic demand analysis conducted in 2002 estimated that San Jose–based organizations were losing about half of the total audience for classical music, opera, and

The sheer volume of competing San Francisco–based organizations, and their variety, was daunting.

ballet to organizations elsewhere (mostly in San Francisco).[11] The problems for the San Jose Symphony escalated as its own volume of product increased and the organization had more tickets to sell. More organizations offering more entertainment "product" in more places turned out to be a recipe for big problems.

The conclusion to be drawn is that the SJS could not sustain the level of audience it required given the extremely competitive marketplace. It failed to fit neatly into the Bay Area infrastructure with a clear and differentiated mission, program, and audience-development strategy. It was unable to make the case for why it, among many other options, was worthy of greater attendance and financial and community support.

A conclusion to be drawn is that the San Jose Symphony could not sustain the level of audience it required given the extremely competitive marketplace.

Consumer Preferences

Silicon Valley on the surface appeared to offer a strong classical music audience, as do many communities with similar income and education statistics. But it is important to look more deeply to understand what these potential ticket buyers actually wanted. Like many orchestras, the SJS did not bother to ask. Two studies conducted after the demise of the SJS did ask, and they shed light on local classical music consumers and their preferences.

Overall, the findings confirmed the high interest in classical music, the prevalence of electronic delivery systems and non-concert-hall settings in people's lives, and the preponderance of San Francisco as a competitive marketplace. But they also revealed new information such as consumers' dissatisfaction with the SJS programming, dislike of its venues, and the tremendous diversity of alternative musical tastes even

among serious classical music lovers. Much of this information could have helped the SJS redirect its priorities in the final years.

The first study was an online survey in which 641 individuals participated. The other was a focus group effort. Both were intended to further an understanding of how Silicon Valley audiences experienced classical music.[12] Neither worked with a representative sample of respondents, yet the geographic distribution of the online survey results matched pretty closely the distribution of ticket buyers for the SJS in its final years, and the focus group participants were taken from the online respondents.

Surveys revealed consumers' dissatisfaction with the San Jose Symphony's programming, dislike of its venues, and a diversity of alternative musical tastes.

Findings from the Online Survey

Respondents to the online survey were, as a group, very involved with classical music, most describing themselves as "critical" listeners. They were, predictably, very well educated. Almost all had played an instrument at some time in their lives. A high percentage had attended the SJS at some point, with 24 percent having attended one of the concerts in the final season.

Diversity of taste: Even among this highly motivated group of classical participators, preference for many other genres of music was strong, especially jazz and classic rock. This indicates that the SJS was competing not only with classical music organizations but also with a myriad of other purveyors of music. It also indicates that potential patrons may well have welcomed greater diversity of programming (which is confirmed by additional findings below).

Draw of San Francisco: About half of those surveyed indicated attendance at San Francisco concerts, confirming statistics given earlier from other surveys.

Dislike of venues: The data suggest a low level of satisfaction with the performance venues most frequently used in the area for orchestra concerts. Seven venues were preferred as favored halls for classical music over the auditorium most frequently used by the SJS, the Center for the Performing Arts (CPA) in San Jose. In fact, looking at the data in terms of negative preference, the CPA rises to the top of venues rated "poor or fair" (35 percent).

Preference for electronic media: In the area of electronic media, the survey found the following:

– Of those who described themselves as critical listeners, three quarters listened to classical music on the radio several times a week (roughly half listened daily). Pretty much the same percentage listened to classical recordings several times a week (about a third daily).

– Even those who described themselves as casual listeners had high rates of regular listening to radio and recordings (one third listened several times a week to each).

– The average critical listener owned over 250 classical recordings.

– Ownership of classical recordings was high even among those who had never attended an SJS concert (82 recordings).

Focus Group Findings

Two focus groups were conducted—one devoted to self-described critical listeners, the other to self-described casual listeners.

Emotional connection to classical music: It was no surprise to hear that critical listeners were passionate about classical music. Surprisingly, so-called casual listen-

> The Center for the Performing Arts, the San Jose Symphony's main auditorium, rose to the top of the venues rated "poor or fair."

ers were no less so. Their connection tended to be emotional, not intellectual, and they used classical music as a means of channeling emotions and enhancing experiences. Many recounted milestone experiences in their lives that were connected to classical music. These individuals tended to be suspicious of their more knowledgeable peers—those they would meet in a concert hall who they said tended to "listen for mistakes." Clearly, the concert hall needed to be friendlier to their style of emotional listening to attract this group.

Didactic nature of programming: Respondents expressed some frustration with the didactic nature of the programming of the former SJS, complaining that they were being force-fed music that others thought was good for them. Traditional programming did not capture the imagination of many of them.

Informal presentation and settings: For many people, the concert hall and the concert experience were neither friendly nor welcoming. People were looking for more informality, with music provided in natural settings such as public parks and amphitheaters. Authenticity of setting was the underlying construct—music that relates thematically or emotionally to the setting.

An emphasis on learning: Several participants—both critical listeners and casual listeners—suggested that an organization that helped both children and adults appreciate music would be good for the community. Although the SJS had had an active education program, most seemed unaware of it.

> Casual listeners' connection to music tended to be emotional, not intellectual, and they used classical music as a means of channeling emotions and enhancing experiences.

Ticket Sales

Comparisons with National Data

How was the SJS doing in its competitive marketplace? The answer to this question depends on one's point of view. The majority of orchestras have seen declines in overall tickets sold over the past decade, though in most cases, these declines are masked by increases in ticket price.[13] Nevertheless, by an actual measurable comparison to other orchestras in other markets, the SJS was not doing especially well. Surveys indicate that on average an orchestra can expect to capture approximately $2,500 per thousand adults in ticket sales per year in the market area (generally defined as a thirty-mile radius). The San Jose Symphony was capturing only $1,738 per thousand.[14] Given the competitive realities of the marketplace, perhaps it is no worse than what might have been expected. Nevertheless, it does help explain why the SJS was struggling to fill its houses.

Highlights

Appendix B summarizes ticket sales from the 2000/2001 season, the last full season of the SJS. Following are some highlights of the ticket sales data.

- For most of the concerts, one third to one half of the tickets were unsold. For some, the number of unsold seats exceeded 50 percent. One wonders why this data alone was not sufficient grounds for reducing significantly the number of concerts.

- Of the seats that were sold, the vast majority went to subscribers, many of whom did not show up. This resulted in houses that often had more seats unfilled than filled, exacerbating the empty house syndrome.

- Although no demographic data on the audiences exist, it is well known that orchestra subscribers (who made up the vast majority of SJS audiences) are more likely to be older, wealthier, and white than are single-ticket buyers. With houses often consisting of as few as 10 percent single-ticket buyers, audiences were skewed away from the population with the greatest potential for future growth.

The Signature Series

- The core series, called the Signature Series (with twelve concerts), sold at an average capacity of 56 percent, or just over half the house. Of this 56 percent, three quarters of the sold seats went to subscribers, many of whom attended only occasionally. Thus, empty seats were often more plentiful than filled seats, making it difficult to create the illusion of success.

- The Signature Series concerts ran on Fridays at the Center for the Performing Arts (CPA), Saturdays at the CPA, and for most of the concerts, Sundays at the Flint Center in Cupertino. Fridays sold least well, at 45 percent capacity; Saturdays sold at 61 percent capacity; and Sundays at 63 percent capacity (Flint was a slightly smaller space at 2,427 rather than 2,673).

> With houses often consisting of as few as 10 percent single-ticket buyers, audiences were skewed away from the population with the greatest potential for future growth.

Other Concerts

- The three-concert Family Series (held on Sundays at the CPA) sold at an average of 66 percent capacity. Again, almost 71 percent of the seats were sold to subscribers with fewer than 20 percent of the seats occupied by single-ticket buyers.

- The four-concert Familiar Classics Series (held on Saturdays at Flint) sold at 52 percent of capacity. Of this 52 percent, 66 percent were seats sold to subscribers.

- The six-concert SuperPops! Series sold at an average capacity of 68 percent (at Flint). Of this 68 percent, 84 percent

were seats sold to subscribers. This means that around 10 percent of the seats in the hall were occupied by single-ticket buyers, and roughly a third of the seats were unsold.

- The two special concerts held at the CPA sold at 47 percent of capacity. Neither of these events had subscribers. They were both held on Saturdays.

- The fullest house was a Saturday night pops concert with Lou Rawls. That sold 75 percent of the house (at Flint).

- The least-well-attended houses were two Friday night Signature Series concerts (September 22, 2000 — the first of the season, and March 22, 2001), which were only at 37 percent of capacity. These were both held at the CPA.

The consequences of empty seats are many. The most obvious is lost income in the form of tickets not sold and also in the form of donations since ticket buyers are most likely to contribute. Empty seats also have a psychological impact on an institution. An empty house creates the illusion of failure and makes those who are in attendance wonder what is wrong and, in some cases, whether they made a mistake in coming. Over the long term, an institution cannot sustain itself when its audience begins to doubt the wisdom of their support.

An empty house creates the illusion of failure and makes those who are in attendance wonder what is wrong.

PART II
FINANCIAL AND
ORGANIZATIONAL
ISSUES

Budgets
and Financial Controls

In interviews, many people close to the San Jose Symphony in its final years identified financial and organizational issues that they believed were contributing factors to its demise— mismanagement of the finances, unchecked musician compensation, and inadequate leadership. In this section, we will assess the first assertion; in the next two sections, we will look at the others.

There was wide agreement among those interviewed that financial mismanagement at the San Jose Symphony contributed to the organization's downfall.

Annual Operations

There was wide agreement among those interviewed that financial mismanagement at the San Jose Symphony contributed to the organization's downfall. An analysis of the financial history of the SJS over its final six years confirms this view.

The following pages present a reconstruction of the financial history of the final six years of the San Jose Symphony based on public documents. Figure I shows annual operations, including revenue, expenses, and net income for 1997/1998 through 2002/2003.

Declining Revenues

Key declines in revenue, as indicated in Figure I, occurred during the final six years of the orchestra.

- Overall revenue declined from $6.5 million to $5.2 million between 1997/1998 and 2000/2001 (the last full season of the SJS). In percentage terms, the decline was over 20 percent.

- Ticket sales were healthy through 1999/2000. Thereafter, they fell (almost $300,000 in 2000/2001 alone or 12 percent in a single year). In 2001/2002, the season was not completed. Ticket sales stood at $675,000 (as compared with $2.13 million the year before) by year's end.

- Services sold to other organizations declined. With the local ballet company experiencing its own problems, SJS services sold to the ballet decreased. Sold services, which had stood at over $450,000 in 1997/1998, declined to $90,000 in 1999/2000. There was a slight increase the next year and a decline again in 2001/2002.

- Perhaps most significant in dollar terms was the fact that private sector support declined a whopping 51 percent ($2 million) in the years between 1997/1998 and 2001/2002, from $3.9 million to $1.9 million. The decline was steepest between 1999/2000 and 2000/2001, when it went from $3.4 million to $2.2 million.

Expenses grew by 37 percent in the same years that revenue was declining by 21 percent.

Increasing Expenses

- Expenses grew by more than a third, from $5.6 million to $7.7 million during the period 1997/1998 to 2000/2001 (the final complete season). In percentage terms, this was a growth of 37 percent in the same years that revenue was declining by 21 percent.

- Salaries and wages increased 11 percent overall in the three years between 1997/1998 and 2000/2001, as indicated in Figure I. When payment for substitute players is factored into the total compensation, the increase was almost 20 percent.

- The line item for guest artists more than doubled during this same period, from $313,000 to $680,000.

- Expenses for telemarketing and advertising increased almost 50 percent during this period, in spite of the fact that ticket sales declined.

Figure I:
San Jose Symphony Financial History (based on Forms 990)

Revenue	1997/1998	1998/1999	1999/2000	2000/2001	2001/2002	2002/2003
EARNED REVENUE						
Ticket sales	1,606,361	2,079,681	2,411,715	2,128,482	674,934	81,035
Sold services	456,220	239,030	89,461	170,828	79,544	0
Orchestra camp	0	0	0	0	78,501	0
Orchestra tuition	0	0	0	11,750	11,404	0
Other revenue	62,738	35,622	40,957	128,591	39,626	1,500
Interest	1,301	16,667	42,080	50,407	33,264	73
Sale of assets	0	60,466	(4,437)	0	78,440	0
Contributed support						
Private sector support	3,939,632	3,760,037	3,354,831	2,243,890	1,908,967	161,032
Government support	487,936	420,353	408,295	438,717	415,587	0
Total Revenue	6,554,188	6,611,856	6,342,902	5,172,665	3,320,267	243,640
EXPENSES						
Salaries and wages	3,033,622	3,131,144	2,665,034	3,386,622	1,197,387	49,821
Employee benefits	318,829	389,573	334,310	190,811	202,690	24,771
Payroll taxes	277,625	292,699	347,757	309,859	193,173	6,493
Guest artists	312,955	442,145	711,732	679,976	152,460	0
Substitutes	0	0	204,652	234,975	139,033	0
Accounting fees	5,036	10,291	16,175	18,825	79,250	5,050
Legal fees	22,941	11,603	225	0	17,260	45,115
Supplies	19,287	21,930	18,951	24,859	12,982	0
Telephone	16,714	19,788	23,172	19,098	16,789	3,623
Postage/shipping	31,901	22,545	24,637	25,192	30,667	1,243
Occupancy	329,950	288,526	425,195	688,257	282,473	9,795
Equipment rental/purchase	166,024	197,852	232,224	185,771	47,196	0
Printing/publications	87,704	90,759	226,712	37,035	34,709	0
Travel	0	11,365	7,781	1,460	8,081	0
Interest	82,388	77,991	96,228	134,502	52,680	3,837
Depreciation	34,671	28,039	43,774	54,181	44,016	0
Insurance	25,807	32,756	31,252	32,169	40,519	5,382
Consultants	28,424	51,563	138,222	191,478	131,348	68,989
Telemarketing/advertising	466,236	471,244	508,428	694,493	145,966	0
Other	329,175	329,635	698,372	748,130	206,562	26,366
Total Expenses	5,589,289	5,921,448	6,754,833	7,657,693	3,035,241	250,485
Net income	964,899	690,408	(411,931)	(2,485,028)	285,026	(6,845)

Adjustment made 2000/2001*	(631,000)
Adjusted net income	59,408

*FY 2000/2001 Form 990 indicated an adjustment for a loan from Silicon Valley Arts Fund prior to 6/30/99 that was allocated inappropriately as revenue. The adjustment is entered in the appropriate year for this analysis. Accordingly, fund balance numbers for 1998/1999 and 1999/2000 are different from those reported on those years' Form 990s.

- The allocation for administrative costs more than doubled during this period, from $840,000 to $1.8 million, as indicated on the third line of Figure II below. In dollar terms, this was more damaging than the increases in other categories, including orchestra player costs.

Figure II: San Jose Symphony Operating Expense Program Allocation (based on Forms 990)

	1997/1998	1998/1999	1999/2000	2000/2001	2001/2002	2002/2003
Concert services	4,745,844	4,943,851	4,966,770	5,675,096	2,047,295	119,385
Youth orchestra	0	76,122	154,354	153,119	37,782	0
Administration	843,445	901,475	1,633,709	1,829,478	950,164	131,100
Total expenses	5,589,289	5,921,448	6,754,833	7,657,693	3,035,241	250,485

Surpluses, Deficits, and Fund Balances

- Both the 1997/1998 year and the 1998/1999 year show surpluses, as indicated on the second line of Figure III below. Thereafter, deficits grew at an alarming rate. In 1999/2000 the deficit was $412,000, and in 2000/2001 it was $2.5 million on a total expense budget of $7.7 million. The next year the season was not completed.

- As a result of these deficits, the ending fund balance (net worth) of the organization declined dramatically from an already unhealthy negative $278,600 in 1997/1998 to negative $3.1 million in 2000/2001, as indicated on the bottom line of Figure III below.

Figure III: San Jose Symphony Fund Balances (based on Forms 990)

	1997/1998	1998/1999	1999/2000	2000/2001	2001/2002	2002/2003
Opening fund balance	(1,243,508)	(278,609)	(219,201)	(626,695)	(3,111,723)	(2,826,697)
Surplus (deficit)	964,899	59,408	(411,931)	(2,485,028)	285,026	(6,845)
Adjustment	0	0	4,437	0	0	0
Ending fund balance	(278,609)	(219,201)	(626,695)	(3,111,723)	(2,826,697)	(2,833,542)

Lack of Financial Controls

Oversight of financial activity at the San Jose Symphony was lax, and as the pressures of day-to-day cash needs mounted, there were uncontrollable temptations to draw from whatever funds were available to pay current expenses.

Like many performing arts organizations, ticket sales revenue that came in prior to the beginning of a season was not escrowed but spent immediately. Ticket holders had no protections, and when the final season was cancelled midway through, the organization had no way to refund money on tickets for which no concerts were provided.

Misallocation of Funds

Much more serious from a fiduciary point of view was the misallocation of restricted funds. Indeed, the financial straits of the SJS were actually significantly worse than the budget numbers indicated. This is because funds raised for capital projects actually got used for operations, and other funds designated for the youth symphony were similarly redirected. This information was revealed only when a transition board was appointed after the SJS ceased operations.

A January 10, 2002, press release from the transition board indicated that unspecified symphony officials had "improperly" used $1.7 million donated by four sources whose identities were also not released. The funds had been intended for a proposed new symphony hall, but rather had been used to cover operating costs. Similarly, a subsequent disclosure indicated that symphony officials had used $77,000 belonging to the San Jose Youth Symphony to cover operations. "Indeed, it seems quite likely that had these actions not been taken, the symphony would have been forced to suspend operations months or even years earlier," according to the press statement.

As the pressures of day-to-day cash needs mounted, there were uncontrollable temptations to draw from whatever funds were available to pay current expenses.

Summary

Overall, the track record in the financial area appears dismal. From a financial planning point of view, one wonders how an organization can approve significant increases in expenses when its revenues are in free fall. It is also puzzling that there weren't at least minimal financial controls to prevent such a substantial misallocation of funds. Who was in charge, and why did they let things spin out of control?

The question of financial accountability will be dealt with in the subsequent section about leadership. However, before doing so, we need to examine one additional specific component of the finances—musician compensation—because it relates critically to the overall picture.

> From a financial planning point of view, one wonders how an organization can approve significant increases in expenses when its revenues are in free fall.

Musician Compensation

Many people in the San Jose community have cited musician compensation as a primary cause of the SJS's failure. Growth in musician pay was described as "unsustainable" by some. Others simply felt that the musicians were paid too much.

It is difficult to argue that a musician with many years of specialized training is earning too much when he or she is paid as little as $18,000 a year (as was true for many section players of the SJS). This is especially the case in a community that in the 1990s had enjoyed exponential growth in incomes with accompanying rises in real estate costs and overall living costs. On average, most SJS musicians earned less than clerical workers despite their proficiency, education, and costs for instruments and other employment-related necessities. It is not unreasonable to argue, as many musicians did, that they were unable to earn a decent living based on their pay from

the SJS in the Silicon Valley of the late twentieth century. It is also not unreasonable to argue that it is not the responsibility of an orchestra to provide a living wage. If it is to survive, it must pay no more than it can afford.

The question of how much to pay musicians has plagued the orchestra industry for the last half century and has led to bitter labor disputes and strikes. It is not our intent to try to resolve this issue. Rather, framing the issue in a way specific to the SJS's case may be constructive.

Appendix C provides an analysis of the number of musicians playing for the SJS in 2000/2001, the number of guaranteed services, the pay rate, and the growth in that pay over time. From the highlights of this information, summarized in this section, several patterns begin to emerge.

On average, most San Jose Symphony musicians earned less than clerical workers despite their proficiency, education, and costs for instruments and other employment-related necessities.

Service Counts

A fundamental dilemma encountered by the SJS has been faced by many American orchestras attempting to secure a stable, high-quality musician workforce. To attract good musicians, an orchestra must pay adequately, which often translates into providing sufficient guaranteed work (called services). But if the demand for those services (either rehearsals or concerts) is not evident, an orchestra either has to create the demand, pay for unused services, or offer more programs than the marketplace wants.

This dilemma assumes that to form a good orchestra, the SJS had to offer all of its musicians guaranteed and predictable work from year to year with an adequately salaried contract. The question for communities such as San Jose may be whether this assumption is actually true or certainly whether it is viable. Other communities have avoided the problems of excessive work guarantees by hiring some or all of the musicians on a "per service" basis—that is, only when they are

needed. An axiom of the industry has been that these "per service" orchestras are of inferior quality. The best musicians, so it is claimed, will not accept work on this basis, and if they do, they will not play often enough as an ensemble to produce high-level results.

In California's San Francisco Bay Area, it is fairly evident that these arguments are specious. The area boasts an active, plentiful pool of very high-quality freelance musicians, and many successful orchestras operate there on a freelance basis.

In a sense, then, the question of whether the SJS paid individual musicians too much may be the wrong question. Of course, it didn't, given their level of skill and experience. The question more properly should be: Were the musicians hired on the right basis in the first place, and could the SJS sustain the level of guaranteed employment it was offering? Here the answer turned out to be no.

In 2000/2001, the last full, completed season of the SJS, there were eighty-nine players in the orchestra, of which seventy-nine were tenured, eight were probationary, one had an audition pending, and one had an individual contract. The musicians were divided into three classes depending on the number of services they were guaranteed.

As one looks at each category of musician and the service guarantees, one notices that larger numbers of musicians were guaranteed more services over time. For example, the number of guaranteed services for all musicians collectively during the period from 1989/1990 until 2001/2002 increased from 13,946 to 16,397 (an increase of 18 percent).[15] The problem was exacerbated by the lack of flexibility in terms of how many of these services had to be delivered in a "full orchestra" format, limiting the options for using the musicians in other ways, such as popular small ensemble programs that can be booked in a seemingly infinite number of locations for all types of organizations and individuals.

> The question of whether the San Jose Symphony paid musicians too much may be the wrong question. The proper question is whether the musicians were hired on the right basis in the first place.

The gradual increase in guaranteed services to musicians was occurring in an environment in which fewer guaranteed services would have been more appropriate. Houses were often half full, indicating that there were simply too many concerts for the demand. Furthermore, the ballet, which at its high point had been hiring the orchestra for as many as fifty-seven services per year (per musician), reduced that number to 17.[16]

Range of Pay

Overall Salary

The lowest contracted salary in 2000/2001 was $18,008 (including vacation). Following industry norms, principals earned roughly double the base ($35,113), and the concert-master earned close to triple ($51,453). Some musicians had played for the symphony for thirty years or more (the longest was forty-seven years), but there was virtually no recognition for this loyalty of service in the compensation scales.

Service Compensation and Wage Scale History

Looking more deeply into the compensation question, the pay level becomes starker considering how much each musician was paid for a service. By 2000/2001, section players were being paid only a base of $122 per service, up from $69 three years before. Some would consider this inadequate given the amount of time devoted to commuting to and performing a service.

The wage scale did improve for all players in the critical years 1989/1990 to 2001/2002. For principals, assistant principals, and section players, wages grew by 78 percent (on a per service basis, this was from $86.25 to $153.13 for principals, from $79.35 to $140.88 for assistant principals, and from $69 to $122.50 for section players).

Yet, while the effort was going on to provide a living wage, the SJS was sinking faster and faster into debt. Even in the last three years when deficits were growing exponentially, wages grew by 7 percent per year in 1999/2000, 2000/2001, and 2001/2002. While the total number of musicians did not expand significantly during the period from 1989/1990 to 2001/2002, a number of musicians did move from Group C (which had fewer guaranteed services) to Group B (with the highest level of guaranteed services). This resulted in an increase in guaranteed services from 13,946 in 1989/1990 to 16,397 in 2001/2002 (an increase of 18 percent, as noted earlier).

Finally, during this period the cost to the SJS per musician for medical insurance increased by 221 percent (from $515.46 per musician in 1989/1990 to $1,655.17 in 2001/2002). During this same time, the cost to the SJS per musician for pension went from 0 percent of salary (1989/1990) to 8 percent (2001/2002).

> Yet, while the effort was going on to provide a living wage, the San Jose Symphony was sinking faster and faster into debt.

Another Way?

One could argue that the tragedy of the San Jose Symphony was that the musicians were underpaid and that the organization couldn't afford what it was paying them. But there is a bigger tragedy, which is that it might have been possible to solve the problem. Following the lead of so many orchestras in the second half of the twentieth century, the SJS moved to a form of compensation that forced the organization to provide more guaranteed work than was merited. Perhaps the SJS would be in existence today and the musicians happier if it had chosen to pay the musicians more each time they worked but had geared the amount of work to a more realistic and sustainable level.

Many alternative models would have been possible:

- At the most extreme, a fully "per service" orchestra with no guarantees
- Alternatively, an orchestra with many fewer salaried players (with guaranteed services) and many more without such guarantees[17]

Either way, the SJS would have been able to lower its service counts and its obligation to pay for services it did not need.

Perhaps the San Jose Symphony would be in existence today and the musicians happier if it had chosen to pay the musicians more each time they worked but had geared the amount of work to a more realistic and sustainable level.

Leadership

Almost universally, those interviewed for this project pointed to failed leadership as a contributing factor in the demise of the San Jose Symphony. Some pointed to the board of trustees, others to staff, and still others to the music director. Some pointed to two or all three as failing in their responsibilities.

Board

A standard textbook on nonprofit organizations[18] lists the following six critical functions for boards of trustees:

- Establish fiscal policy and boundaries with prudent budgets and financial controls
- Provide adequate resources for the activities of the organization through direct financial contributions and fundraising
- Select a competent chief executive and then evaluate the person's performance, terminating if necessary
- Develop and maintain a communication link with the community, promoting the work of the organization

- Set a responsible program from year to year and engage in longer-range planning
- Set sound policies for the organization's operation

Despite some talented and hardworking trustees, the board of the San Jose Symphony fell short in virtually every area of trustee responsibility. Finances were out of control and no reasonable boundaries were set given the realities of anticipated revenue (the annual deficit reached $2.5 million in 2000/2001 on a total expense budget of $7.7 million). No financial controls were established to prevent the misallocation of restricted funds. Fund-raising continued to decline (by more than 50 percent) over four years.[19] Unseasoned CEOs with no orchestra experience were hired. Because no adequate communication link was maintained with the broader community, when the final crisis came, the SJS found itself with few champions. Program planning was totally inadequate (as indicated by the decline in audience response), and there was little evidence of serious and objective long-range planning. Operational policies turned out to be totally ineffectual.

The forty-five-member SJS board was divided between long-time members and newer members from the high-tech businesses in San Jose. In part as a result of the influence of these newer board members, annual deficits (to cover increases in the collective bargaining agreement, staff hires, and new office rental costs) were budgeted as they might be for an entrepreneurial business—as a form of "investment" in the organization. With little experience with the nonprofit sector, these board members seemed unaware that they were urging a disastrous strategy for an organization with no hope of recouping the so-called "investments."

Several interviewees commented that the board problems of the SJS were not unique to the orchestra. The boards of nonprofit organizations, especially arts organizations, in San Jose and Silicon Valley, did not have particularly strong track records. One reason for this, so it was claimed, may have been

> Despite some talented and hardworking trustees, the board of the San Jose Symphony fell short in virtually every area of trustee responsibility.

that some of the best trustee prospects in the Valley preferred to associate themselves with the most prestigious cultural institutions in San Francisco. Another may be that there had simply not been a strong tradition of board service on which to build. Finally, the very nature of the leadership in the Valley—newer, younger, not bound by tradition, tied to very demanding jobs—may have worked against the level of commitment required for an orchestra board, especially one addressing crises.

Staff

Several people registered surprise that such a well-established organization could be so lacking in qualified and experienced staff leadership for such a long period of time. Running a symphony orchestra is a complex business. Today, most orchestras with budgets in the $5 to $10 million range are run by people with considerable proven work experience in the orchestra field. During most of the final decade of the SJS, this was not the case. As consultant Bruce Coppock remarked in a 1997 report, "There is a virtual music management vacuum in senior positions on staff, which is at the root of many of the organization's woes."[20]

From 1988 to 1992, the SJS's executive director was a former local banker. A former San Jose City Council member was appointed in 1992. Strongly supported by some in city government despite her lack of substantive orchestra management experience, her connection to sources of local public funding was seen as an important advantage. This feeling was sparked in part by emerging discussions about a new symphony hall that might be funded partially with city redevelopment dollars. By the time Coppock issued his 1997 report, he was urging that the SJS hire an executive director with field knowledge: "The pathologies of the current situation are those of an organization whose management lacks an understanding of the dynamics of the business This is a matter of being able to make balanced

Several people registered surprise that such a well-established organization could be so lacking in qualified and experienced staff leadership for such a long period of time.

judgments regarding repertoire choices, choices of soloists and conductors, issues concerning the performance of individual musicians, workload balance for musicians, programming balance for the community and balancing the financial and artistic imperatives of the institution." [21]

For six years, the staff leadership of the SJS remained unchanged in spite of warnings from outsiders. Then, with plans for a new hall gaining ground and the need to raise considerable private matching funds, the executive director announced that she would step aside and move into a fund-raising role. A national search for her replacement turned up some qualified candidates (according to those close to the process), many with strong orchestra experience at the executive director level from other communities. In the end, however, the position was filled by someone whose staff experience at two major orchestras did not translate into an ability to solve the mounting challenges in San Jose. Finally, in 2001, with the SJS in free fall, a board member with experience as a business consultant was appointed as interim (and as it turned out, final) executive director.

> For six years, the staff leadership of the San Jose Symphony remained unchanged in spite of warnings from outsiders.

In thinking about this series of events, it is important to distinguish between knowledge of the orchestra field and good leadership. Many executive directors with plenty of orchestra experience have demonstrated similarly poor leadership skills in their institutions. What is true is that without knowledge and experience of the orchestra field, a staff leader is severely hampered. In San Jose, a combination of inexperience and lack of leadership was a continual problem.

Musical Leadership

In September 1992, the new music director of the San Jose Symphony conducted his first concert. He had come to the SJS with impeccable credentials. Born in the Ukraine and a graduate of the Moscow Conservatory in both conducting

and composition, he had conducted and toured with a number of Soviet ensembles before emigrating to the United States in 1981. Chosen by Leonard Bernstein for the first Los Angeles Philharmonic Institute, he won a prestigious Exxon Endowment Conductors Fellowship and became a professor of conducting at the University of Houston. He did much conducting in Europe and also traveled to South America, New Zealand, and Canada. By 1999 he was sufficiently respected in the field to be invited as a last-minute replacement at a concert by the Los Angeles Philharmonic and was reengaged by that ensemble the following year to conduct at the Hollywood Bowl.

With such a pedigree and with such apparent respect from those in the field, how could there be any question about whether this was the right musical leader for the SJS? But posing the question in this way suggests a basic weakness in the way music directors are often chosen in the United States. It assumes that the candidate's musical credentials are the sole criterion of importance, when in fact most American orchestras today need much more than a superb musician on the podium. Looking at the musical excellence of a conductor, his respect by colleagues, and his conducting experience in world capitals is certainly crucial. But not considering equally carefully an individual's ability to relate to the community and be a spokesperson for the orchestra in a variety of community settings—from schools to city council chambers to service clubs—is a mistake.

This one-size-fits-all approach to choosing a music director was resoundingly rejected by a group of field leaders at a symposium on the 21st-century music director hosted by the Boston Symphony Orchestra at the Tanglewood Music Center in August 2001. Participants argued that orchestras must develop profiles for their music directors that include an ability to be responsive to their communities and to understand the vision, needs, and capacities of their organizations:

> It would have been important to consider the individual's ability to relate to the community and be a spokesperson for the orchestra in a variety of community settings.

An individual is ideal only in relation to a specific orchestra in a specific community. The cult and prestige of a star personality is alluring. But orchestras should ask themselves the key questions: Who are we? Who do we want to be? What can we realistically achieve?[22]

The group was very specific about the role that a conductor may need to play in an orchestra such as San Jose's, which was not only well below the top tier of orchestras nationally but within easy driving distance of an orchestra that was in the top tier (San Francisco's).

> In a smaller orchestra, building musical excellence is important. But the music director of a smaller orchestra must be involved in such activities as building community connections, meeting with the city council or the Rotary Club, or taking a role in educational activities.[23]

What kind of community was San Jose in the 1990s, and what kind of person might have been best at making those all-important community connections when the orchestra was in crisis? San Jose and the surrounding market area was a melting pot of cultures—especially Hispanic and Asian—with much of the local leadership drawn from these groups. If symphony leaders at the time had established primary criteria for the selection of a music director in San Jose, an ability to connect with the diverse population and the leadership of the community would have been near the top of the list.

Connecting with a specific constituency can come in many forms. It can come on the concert stage through the choice of repertoire or guest artists. It can come in the form of community programming in neighborhoods and schools. And it can come at local government meetings where the music director is seen as a crucial community leader. In each of these cases, a great deal more might have been accomplished by the SJS and its musical leader.

San Jose was a melting pot of cultures. An ability to connect with this diverse population should have been a consideration in choosing a music director.

Concerns about musical leadership are often difficult to discern from the usual disgruntlement of musicians or selected audience members. However, in this case, the problem was well documented in an important analysis of the SJS in 1997 conducted by consultant Bruce Coppock, who registered serious concerns with the musical leadership of the orchestra. The music director, he said, "needs much guidance regarding programming, communication with the orchestra and the building of programs that will engage the community more broadly. The choice of repertoire, soloists and guest conductors is overly narrow. While [the maestro] clearly has responsibility for the artistic development and direction of the orchestra, this activity must happen in the broader context of the institution's circumstances, capacity and the community in which it operates."[24] Coppock's recommendation that the symphony form an artistic advisory committee was one of many that were never implemented.

PART III
OTHER FACTORS

Economic Issues

Like many orchestras, the San Jose Symphony misread the economic trends. When the economic bust came at the end of the 1990s, it hit hard.

In 1992, when the American Symphony Orchestra League published a benchmark study of the financial condition of symphony orchestras,[25] the prediction was that by the year 2000, the orchestra industry and individual orchestras would be in financial crisis if they did not significantly change the way they did business. Subsequently, the United States experienced one of the most vigorous and sustained economic booms in its history, with Silicon Valley especially well positioned. The combined growth in income and assets during this period was significant, especially in places such as Silicon Valley where the increase in so-called "paper" wealth was staggering. Many misread the trends as harbingers of a new economic order leading to unending vistas of permanent prosperity. Orchestras for the most part did not heed the warnings of the 1992 report.

Like many orchestras, the San Jose Symphony misread the economic trends. In the mid-1990s, Silicon Valley was booming. With only 10 percent of the state of California's population, it accounted for 34 percent of California's export sales. In one year alone (between 1993 and 1994), those sales climbed from $22 billion to $27 billion. In the three-year period between 1992 and 1995, the number of jobs in the Valley increased by 46,000 (4.5 percent). Ten percent of the jobs were in the software industry, in which the average salary was $70,000.[26]

When the economic bust came at the end of the 1990s, it hit hard. The dot-com collapse and weak technology sector performance that accompanied the bust culminated in 2002 with an exodus of 40,000 people from Silicon Valley as employment fell by 87,000.[27] Although the decline was felt throughout the country, in Silicon Valley it was described as

catastrophic. Many of the fortunes created so rapidly in the 1990s disappeared just as quickly.

Yet indications of trouble for the SJS should have been evident well before the bust, even in the years of prosperity. The SJS was not reaping the kind of support that should have accompanied a new economic order. A 1994 survey by the Chronicle of Philanthropy indicated that Silicon Valley, despite its extraordinary wealth, was not a particularly philanthropic place. It maintained a remarkably low ranking in per capita giving (39th among the nation's 50 largest metropolitan areas). With its income rank at 3 and its philanthropic rank at 39, it received one of the worst philanthropic index scores (−36) of any of the top 50 cities.

> The San Jose Symphony was simply not reaping the kind of philanthropic support that should have accompanied a new economic order.

While the economy was going through its boom and bust cycle during the SJS's final decade, some things remained constant. San Jose's downtown continued to be regarded by many as unexciting, with little to recommend it as a destination. Silicon Valley lacked a vibrant tourist industry that might have fueled interest in cultural organization programming. Once again, the contrast with San Francisco was stark: San Francisco offered a vibrant urban center, it spawned one of the most significant cultural tourism industries in the nation, and it could boast some of the most significant charitable giving in the United States.

Venues

Every orchestra is at the mercy of the hall it plays in. For some, the hall is part of an orchestra's greatness. The Boston Symphony has been associated with Boston's legendary Symphony Hall for a century. In Cleveland, Severence Hall is as renowned as the orchestra that plays there. More recently,

the completion of Disney Hall in Los Angeles has given new spark and vitality to the Los Angeles Philharmonic.

Acoustics are key to a great hall, and the best halls are purpose-built and designed exclusively for the orchestras that use them, as opposed to those halls that must accommodate other types of performing arts organizations as well. Even inexperienced concertgoers tend to react enthusiastically to the sound of a great hall, even when they may not be aware of what makes them feel the way they do. Similarly, they often are less enthusiastic about concerts in mediocre halls even if they cannot specifically point to acoustics as a factor.

In addition to acoustics, other aspects of a hall contribute to its suitability and desirability: its ambiance, convenience (including parking), amenities, and safety. Patrons are discerning, vocal, and specific when they are dissatisfied with these other aspects.

In the matter of halls, the San Jose Symphony was unlucky. The halls it played in were undesirable and disliked. As mentioned earlier, they were the most disliked halls in Silicon Valley,[28] an area generally not known for distinguished performance spaces. The hall used most frequently by the SJS was the Center for the Performing Arts (CPA), a municipally owned and operated facility in San Jose. Designed by the Frank Lloyd Wright Foundation and originally built in 1972 as a community theater space, it was renovated in 1987 and a new acoustic shell was installed. With 2,673 seats (including 1,908 on the floor and 765 in the balcony), its 2,400-square-foot proscenium stage was built as a multipurpose space to accommodate not only orchestra concerts, but also ballet, opera, and musical theater. Because the SJS shared the space with other local companies, any attempt to reconfigure the facility as a purpose-built orchestra hall would have been resisted.

The other facility used by the SJS was another multipurpose hall, the Flint Center in Cupertino. Opened in 1971, the Flint

Center is located at De Anza College and hosts a variety of local and touring performing arts events, as well as lectures, Broadway shows, and rock and popular music concerts. A bit smaller than the CPA (2,427 seats) and with a slightly larger stage (2,860 square feet), it too had a shell available for orchestra concerts but suffered from the fact that it served many users and uses.

The quality of a hall is subjective, but clearly neither of these options was excellent from the point of view of acoustics or ambiance. Both were multipurpose, which is always a compromise. When the halls were half full (as was generally the case with SJS performances), they were particularly undesirable. Nor were there good alternatives at the time for the SJS. A survey of Silicon Valley halls completed in early 2003 concluded that "no first-rate (acoustic & physical conditions) halls exist for symphonic music in Silicon Valley" and stated that although there were some other facilities that could host symphonic music, few had open dates for extended rental.[29]

A survey of Silicon Valley halls completed in early 2003 concluded that "no first-rate (acoustic & physical conditions) halls exist for symphonic music in Silicon Valley."

Many community leaders in San Jose in the 1990s, including an arts-friendly mayor, recognized that the SJS suffered for lack of a good hall. Serious initiatives were put forward, including the renovation of the Fox Theatre (an old abandoned movie house) by the city[30] or the building of an entirely new hall in conjunction with a City Hall development. Both projects were pursued by the San Jose Redevelopment Agency, and plans moved forward to the point that the SJS initiated a capital campaign to raise private matching dollars as required by the city. Unfortunately, by the time these plans materialized, the SJS was in free fall, and the hall projects served as a dangerous distraction to the more critical need of addressing survival issues. Indeed, some (including a consultant brought in to study the situation) claimed that the focus on a new hall contributed to the crisis that eventually ended the SJS.

Missed Opportunities

Despite the fact that the SJS was a wounded organization in the 1990s, the inevitability of its demise was far from certain. It had many opportunities to repair itself in such obvious areas as governance, management, programming, marketing, and employment agreements. But there were other missed opportunities that could have provided the SJS with what it needed most—a new vision and image of what a symphony orchestra in Silicon Valley might be.

Despite the fact that the San Jose Symphony was a wounded organization in the 1990s, the inevitability of its demise was far from certain. It had many opportunities to repair itself.

Celebrating Community Diversity

In the mid-1990s, the population of Santa Clara County, the SJS's primary market, was about 1.6 million, with just over half of its residents living in San Jose. Roughly a quarter of the population was Hispanic in origin, with about the same percentage of Asian or Pacific Islander descent. Significantly, the community celebrated this diversity, and political power and leadership were clearly dispersed among people of these different ethnic backgrounds. Many of the community's most interesting arts groups were culturally specific in their artists, their programming, their audiences, or all three.

Other symphony orchestras faced with this kind of demographic challenge have turned it into an opportunity and have made significant efforts to reach people who have not traditionally been symphony goers. The Saint Louis Symphony developed its In Unison program in conjunction with black churches and reached out with other programs throughout the greater Saint Louis region to serve minority populations. Its musicians agreed to a new contract that made it possible to trade a certain number of traditional concert and rehearsal

services for an equal number of community-related services to strengthen the orchestra's presence outside the concert hall. The Louisiana Philharmonic has commissioned works especially to celebrate the black heritage of New Orleans and has included African Americans in its composer and soloist pool. In Long Beach, California, which has a very large Hispanic population, outreach has been coordinated through a large Hispanic museum and other Hispanic community organizations. In 2001, the Long Beach Symphony Orchestra hired a Mexican music director who would be able to speak directly to the local Spanish-language population. The orchestra in Charlotte, North Carolina, extended its outreach program to various culturally specific communities, completely redesigning its program once it realized that minority populations were geographically disparate and had to be reached in ways that did not depend on geographic centers of activity.

If ever a community seemed hospitable to culturally specific outreach efforts, it was San Jose, one of the few major cities with large minority populations that has never experienced significant civil strife around issues of race and culture. With enlightened city and county government officials in the 1990s sensitive to and proud of this cultural diversity, the opportunity for the SJS to design programs and outreach efforts would have been positively received and, no doubt, generously funded. The fact that the SJS stubbornly reinforced a Western European image in its programming, leadership, marketing, and outreach, resulted in a kind of wall between itself and the larger community it could have served.

Arts Education

A survey conducted by AMS Planning & Research and published as part of a cultural plan for Silicon Valley in 1997 indicated that residents of the area believed overwhelmingly that the arts should be for everyone. Ninety-five percent of them also believed that more arts education should be offered in

> If ever a community seemed hospitable to culturally specific outreach efforts, it was San Jose.

school. Arts education programs were rated highly as a top priority for a tax increase for the arts; two thirds of respondents said they would pay an additional $5 in taxes to augment such programs.[31]

Although one might quibble about whether this strong interest in arts education would actually hold up if put to the test, the larger point is that the responses the consultants received from the Silicon Valley survey were some of the strongest they had ever seen compared to similar studies in other places. Quite clearly, this was a region that cared about arts education even as such programs were being cut locally by cash-strapped schools still suffering from the effects of a hostile property tax measure—Proposition 13—and its aftermath. It was also a region that did not care for an elitist approach to the arts.

As the largest performing arts organization in the Silicon Valley, the San Jose Symphony should have seen the findings about arts education as an opportunity, and the findings about elitism and the arts as a warning. Yet neither of these insights seemed to have occurred to the leadership of the SJS. When the cultural plan was completed, local funders, led by the David and Lucile Packard Foundation, stepped up and invested several million dollars in expanded arts education programs. Yet the SJS was not a participant in any of the programs or the foundation funding. Though it did offer some education programs, these were not deemed significant enough or broad enough in their reach to be supported.

Perhaps the saddest part of this missed opportunity is the fact that the San Francisco Symphony had, over a period of years, honed one of the most effective music education programs sponsored by a symphony anywhere in the United States. Interviews with the leadership of the SFS indicate that that orchestra would have been willing to work with the SJS in developing a version of the program in Silicon Valley just as it had with orchestras in Houston, Baltimore, Cleveland, Saint Paul, and Milwaukee.

Quite clearly, this was a region that cared about arts education and did not care for an elitist approach to the arts.

The SFS's Adventures in Music program provided a sequential and comprehensive curriculum-related music experience for all third-, fourth-, and fifth-grade students in San Francisco's public elementary schools and a small number of parochial and private schools. It had begun in 1988 and was reaching some sixteen thousand students annually in over ninety-three schools by the end of the 1990s. Program components included in-school performances by specially trained ensembles; a music-centered interdisciplinary curriculum; professional development sessions for teachers and principals; supplementary resources for teachers (such as rhythm instruments, compact discs, books, maps, and videos); and a journal for each student. The program culminated in a field trip to Davies Symphony Hall for a concert by the San Francisco Symphony. A similar program was later developed for first- and second-graders in 1993 and was reaching an additional ten thousand students in more than seventy-five schools.

Here was something that the community said clearly that it wanted. Arguably, funding would have been available for something so comprehensive and with such nationally verifiable positive outcomes, even though funding for the SJS's own education programs was being cut. The SJS's inability to read the community's desires and needs was a consistent shortcoming throughout its final decade.

Though the San Jose Symphony did offer some education programs, these were not deemed significant enough or broad enough in their reach to be supported.

Technology

Ask people what they think of when they hear the words Silicon Valley, and they will likely say, "high tech." Residents of the communities that make up Silicon Valley like to think of themselves as living and working in the high-technology capital of the world, and they take pride in a tradition of innovation and entrepreneurship. As Silicon Valley's major city, San Jose enjoys this image and history and has invested a great deal of public funding into a cultural infrastructure that celebrates it.

Perhaps the prime example of that investment is San Jose's Tech Museum of Innovation, which began as a dream in 1978, when members of the Junior League of Palo Alto, later joined by the San Jose League, envisioned an exciting learning center devoted to science and technology in the heart of Silicon Valley. The vision for The Tech was realized in 1990 when a 20,000-square-foot temporary test facility was opened in the old convention center in San Jose. Since then, The Tech has become a landmark for visitors seeking a glimpse of the most inventive place on Earth and a showcase of the latest high-tech gizmos and gadgets that put Silicon Valley on the map. Since it opened, approximately 3 million visitors from all over the world have passed through its doors, and it has become the dominant cultural institution in the area. The lead donors in the $113 million project were the city of San Jose and its redevelopment agency.

Here then was an area in which the San Jose Symphony might have ridden a bandwagon of local support and interest and at the same time distinguished itself from every other orchestra in the world. Partnership possibilities with The Tech as it was being developed or with other high-tech institutions (public and private) and high-tech entrepreneurs were especially possible during the late 1990s when the local economy was booming and the SJS was beginning to flounder. Although the SJS was in the business of producing and disseminating music, that business had itself become technology-intensive in the late twentieth century, with many orchestras experimenting with technological innovations of all kinds.

Experimentation in high-technology applications for orchestras ranged widely from the use of special lighting and video in concert presentations to new forms of concert dissemination via the Internet to innovations with acoustics to special compositional techniques using computers. Even education and audience-development programs were being influenced by high technology with the introduction by some orchestras

of handheld PDAs that allowed for the simultaneous presentation of program notes during a concert. Development of this latter device, called the Concert Companion (or CoCo), was supported by two Silicon Valley–based foundations (the David and Lucile Packard Foundation and The William and Flora Hewlett Foundation) among many others, and was written up in the *Wall Street Journal*, the *New York Times*, and other major publications.

Technology offered a pathway through which a wide swath of the local community might have taken special pride in its symphony and supported it regardless of whether they liked or attended classical music concerts. It offered a window through which the world could look at the SJS and regard it as unique and special regardless of whether it played at the level of the San Francisco Symphony or toured to Carnegie Hall or Europe. It offered an opportunity for partnerships and funding and broad exposure. What was lacking was the imagination to see these connections and make them real.

> Technology offered a pathway through which a wide swath of the local community might have taken special pride in its symphony and supported it regardless of whether they liked or attended classical music concerts.

The New Hall

That the San Jose Symphony was disadvantaged by its performance venues, there is little doubt, as discussed earlier. In the 1990s, the SJS began a serious consideration of how it might rectify this situation, and the San Jose Redevelopment Agency had an answer—the long-neglected Fox Theatre.

The Fox had originally been designed in 1927 by architects Weeks and Day (architects of San Jose's magnificent Sainte Claire Hotel, Oakland's Fox Theatre, and San Francisco's Mark Hopkins Hotel). Said to be the finest theater in California on its opening day, it was one of the best-preserved examples of late 1920s motion picture houses in the country. Over the years the theater housed vaudeville shows and featured 3D and Cinemascope. In the 1960s and 1970s, the building passed

through several owners and closed in 1973. In 1985 it was purchased by the redevelopment agency to preserve the city's largest remaining downtown movie palace.

The redevelopment agency's proposal to the symphony was flawed from the start and put the SJS at risk (as noted by consultant Bruce Coppock in his analysis summarized later in this report). It required a significant matching contribution from the cash-strapped symphony. Later, the redevelopment agency proposed an alternative project, a dedicated symphony hall to be built as part of a new City Hall complex. The price tag for the SJS for this project would require an $85 million capital campaign—at a time when the organization needed to focus on fundamental governance, management, and fund-raising issues.

Perhaps if the SJS had taken the time to study the history 0of other orchestras in other communities, it would not have been so hasty in jumping at the redevelopment agency's offer. At about the same time that it was considering the Fox, the mayor of Philadelphia was leading a broad-based community effort to create a new concert hall for the Philadelphia Orchestra when the orchestra's own efforts fell short. The lesson there should have been clear: New or renovated halls are ambitious projects and often are beyond the capacity of a local orchestra—even a large, internationally acclaimed one—to pull off. Sadly, the SJS saw the renovated Fox as such a good opportunity that it diverted much of its fund-raising energy to an ill-fated capital campaign. The effort ultimately fizzled, having used up much energy and goodwill in the process.

The great irony is that had the SJS passed on the opportunity of the partnership with the redevelopment agency, it would have gotten to use the venue anyway, in a beautifully restored condition. After the failure of the SJS's effort, the Packard Humanities Institute stepped in to fund the private portion of a public–private partnership with the redevelopment agency. The result was a $75 million project initiated in 2001 and

> The great irony is that had the San Jose Symphony passed on the opportunity of the partnership with the redevelopment agency, it would have gotten to use the venue anyway, in a beautifully restored condition.

completed in 2004 that has provided the city with a state-of-the-art hall and local arts groups, including a new local symphony, with a wonderful place to perform.

Indeed, on December 13, 2004, Mark de la Vina reported in the *San Jose Mercury News* on the success of the Fox — renamed the California Theatre. He described it as a "restored 1,146-seat performance palace" that had become the new home of the local symphony, opera, and others. "Interest in the restoration has been a boon for the theater's tenants . . . the symphony expects to sell about 2,000 tickets . . . for its two performances of an orchestral-choral concert this weekend. Last season, the symphony sold an average 1,677 seats per concert, or 64 percent capacity at its old digs, the 2,595-seat Center for the Performing Arts."

PART IV
ANALYSIS
AND ADVICE

Wisdom Squandered

Given the amount of talent and knowledge in the Bay Area and in the orchestra field, one might wonder why the SJS did not receive better direction. If the organization itself did not seek it out, why wouldn't some of its funders have insisted on outside counsel when things seemed to be going off track?

In fact, much sound direction was provided—to the community in general and to the symphony in particular—and much of it came as a result of the efforts of concerned funders, both public and private. The problem was not lack of good advice; it was that the advice was, for the most part, ignored.

The problem was not lack of good advice; it was that the advice was, for the most part, ignored.

Of the many efforts to provide direction, four will be reviewed in this section. The first two occurred during the years that the SJS was experiencing stress and was still operating. The latter two occurred after the SJS suspended operations and when there were hopes that some kind of new organization might emerge from a formalized community process.

The Cultural Plan

In the spring of 1996, the city of San Jose and the Arts Council of Santa Clara County embarked on a comprehensive cultural planning project for Silicon Valley.[32] The yearlong process involved over one thousand participants—community leaders, ordinary citizens, arts organizations, corporations, foundations, and many others. Although not directed specifically at the SJS, many of its recommendations appeared to speak to the organization's needs, including the following:

- The development of two new state-of-the-art performance spaces

- The creation of a major new $60 million stabilization/capacity building initiative to provide adequate capitalization for local cultural organizations
- The development of a coordinated marketing program to assist arts organizations
- The development of productive partnerships between cultural organizations and neighborhood institutions, including an incentive program for providing cultural education opportunities in the neighborhoods
- The formation of a leadership group to promote increased funding for the arts and implementation of the plan

Any of these initiatives—and many of the others recommended in the cultural plan—would have benefited the SJS. Yet the organization's attitude toward the planning process was strangely unsupportive. The leadership of the SJS seemed skeptical that collective action would benefit the orchestra directly. As one of the larger and better-known cultural organizations in Silicon Valley, the feeling seemed to be that it would be better off pursuing its own ends.

Many of the recommendations of the cultural plan were implemented. Some of the more substantial ones—such as new halls and a financial stabilization program—were set aside. To some extent, the SJS played a role in this because its lack of support divided community leadership. Ironically, the SJS sought both a new hall and financial stabilization on its own and failed on both counts.

Of all the initiatives of the cultural plan, the ones that received the most substantial financial support were in arts education. This was one area that would have benefited the SJS since these dollars began to flow at just the time when the symphony needed to find additional services for its musicians and continuing support dollars for its own music education initiatives. In the end, as we have seen, the money went elsewhere.

> The leadership of the San Jose Symphony seemed skeptical that collective action would benefit the orchestra directly.

The Coppock Consultancy

Of more direct relevance to the SJS was the work of consult-ant Bruce Coppock. Coppock's work with the SJS began in 1997, when he was executive director of the Saint Louis Symphony and considered one of the leading experts in the symphony orchestra field. His involvement with the SJS extended through 1999. It had been made possible through the efforts of community leaders who had grave concerns about the SJS. These included the mayor and representatives from four foundations—The William and Flora Hewlett Foundation, the David and Lucile Packard Foundation, the John S. and James L. Knight Foundation, and Community Foundation Silicon Valley.

Coppock's assessment was dire: a financial situation that could only be described as "a deep crisis," unachievable and unsus-tainable budgets, a musical vacuum in senior staff positions, an ineffective board that lacked cohesiveness and needed to be strengthened dramatically for the organization to survive, serious concerns about artistic leadership, questionable programming choices, volatile labor relations, an inflexible labor contract, a lack of high-quality and sustainable education programs, a dysfunctional fund-raising operation that was neither cohesive nor strategic, poor marketing and nonexist-ent public relations, inadequate community engagement, and a complete failure to address the needs of multiethnic communities.

Perhaps the most damning finding was that the SJS still was trying to function as a "would-be big five orchestra," reaching well beyond its potential with a vision that was totally inappropriate given the community, the organizational capac-ity, and the quality of the ensemble. According to Coppock, a previous long-range plan

> would have attempted to recreate a version of the San Francisco Symphony in San Jose. This vision included

Perhaps the most damning finding was that the San Jose Symphony still was trying to function as a "would-be big five orchestra," reaching well beyond its potential with a vision that was totally inappropriate.

national and international touring, full-time salaried musicians, recordings and radio broadcasts, and all of the other traditional hallmarks of a "world-class" orchestra....The inability to replace this vision with another, bolstered by programmatic content, is perhaps at the heart of the current crisis.[33]

The Coppock report made a number of recommendations, including developing a new and more appropriate vision, strengthening the board and management, addressing and improving labor relations, eliminating the deficit, and improving programming.

The report then analyzed the SJS's desire to take on a project that would provide it with a new home. The proposed joint project with the city to renovate the Fox Theatre would focus the SJS on a capital campaign that Coppock believed (accurately, as it turned out) could contribute to the downfall of the orchestra by diverting its attention from its more immediate problems:

> The future of the San Jose Symphony will be far more determined by the ability of the organization to cope with its many pathologies than by whether or not the Fox Theatre becomes its home.[34]

Coppock offered a step-by-step plan for reviving the organization and reengaging the community, and, if these steps were achieved, a plan to tackle a facility project. But by 1999, when he returned to determine what the SJS had achieved and how it might move forward, he found that little had changed for the better and that the focus was now on raising $85 million as the SJS's share of a public–private funding partnership for a new symphony hall to be constructed as part of the new City Hall building project. To a large extent, the window of opportunity had been lost. The SJS had gone too far down the wrong path to be able to return.

But by 1999, when the consultant returned to determine what the San Jose Symphony had achieved and how it might move forward, he found that little had changed for the better.

After the Fall

The Advisory Panel Report

To a large extent, the window of opportunity had been lost. The San Jose Symphony had gone too far down the wrong path to be able to return.

Two years after Coppock's visit, things began to unravel quickly. On October 18, 2001, with insurmountable problems looming, the interim chief executive officer of the SJS suspended the orchestra's fifty-six-concert season and asked the board of directors to resign. On October 27, 2001, he and the former board chair laid off the SJS's eighty-nine musicians, its thirty-person staff, and its music director. A nine-member executive transition board, led by Jay Harris (the well-respected former *San Jose Mercury News* publisher), formed to act as an interim governing structure, holding its first meeting on December 8 to figure out what went wrong and reconstitute the symphony.

The board then turned to Nancy Glaze, program director at the David and Lucile Packard Foundation, to chair an advisory panel to advise the transition board. This sixteen-member group deliberated for four months, interviewing experts locally and nationally, and issuing its report on May 1, 2002.

The advisory panel report[35] was consistent with Coppock's call for a new vision and many of his other recommendations. But it was radical in at least one respect. In calling for the new vision, it said that the existing organization had to be abandoned completely. Its unanimous conclusion was that attempts to resurrect the San Jose Symphony could only fail, even if money could be raised to pay its debts. It recommended a complete break with the past. "Go dark," the panel recommended. "Stop planning programs for next season. Stop making brochures. Stop writing letters to the constituency asking for interim funding. Discontinue concerts under the old SJS name."

Instead (following Coppock's advice), it recommended that Silicon Valley explore a model that had evidence of broad community support, with strong board and staff leadership, an artistic vision well matched to the community, adequate capitalization based on a realistic business plan, a supply of program offerings geared to demand, an effective communication strategy, a mission that incorporated education in a significant way, musician involvement in governance, and a plan to use many different venues (both traditional and nontraditional) throughout Silicon Valley.

It should be observed that many cities faced with the same situation have looked for ways to repair what was broken with recurring "save the symphony" campaigns. The advisory panel was unwavering in its conclusion that what existed was unfixable and that efforts to repair the SJS should end. Only by taking the time to develop something entirely new could an orchestral venture hope to succeed.

> The advisory panel was unwavering in its conclusion that what existed was unfixable and that efforts to repair the San Jose Symphony should end.

The report called for the transition board to take a number of steps that would lead to the formation of a new organization, including the following:

1. Form a start-up steering committee.
2. Develop a communications plan to create public awareness and support for a new effort.
3. Hire a visionary to lead a planning process.
4. Design an implementation plan.
5. Secure funding.
6. Identify leaders and form a new board.

The advisory panel's recommendation of "a process for constructing a new vision for the future that will engage the community and break with the past" required high-level leadership to galvanize (and fund) the new vision. However, as the bankruptcy of the SJS dragged on, it was unclear how quickly such a group could be assembled, as there was little enthusiasm for stepping into what was a messy situation. There was

still confusion about whether the SJS would be reorganized (Chapter 11 bankruptcy) or disbanded completely (Chapter 7 bankruptcy). Once again, a series of sound recommendations was put on hold.

The Symphonic Music Working Group

There was still confusion about whether the San Jose Symphony would be reorganized or disbanded completely. Once again, a series of sound recommendations was put on hold.

With the community unable to implement the advisory panel's recommendations immediately, it was agreed that a process with a lower profile should be initiated that might provide the necessary data to begin afresh when the appropriate time came. Consequently, a group of community representatives (including, initially, the chair of the advisory panel, other interested community members, and two musicians from the SJS) was appointed to work with consultants and deliberate about the future of symphonic music in San Jose. The group was called the Symphonic Music Working Group (SMWG), and much of the research cited in this volume was conducted under its auspices between September 2002 and May 2003.

From the start, there was internal disagreement about the mission and even the legitimacy of the SMWG. Its formation had been organic, and its charge self-designed. Some members felt that its purpose was to get a symphony orchestra up and running in San Jose as quickly as possible. Others were not even sure that a resident symphony orchestra in San Jose was appropriate and wanted to begin by looking at demand, competition, venues, and alternative organizational structures. This latter direction was the one ultimately followed.

About midway through the process and quite independent of it, a new orchestra did start up in San Jose—Symphony Silicon Valley—so the urgency to form a new orchestra organization was substantially reduced and several members

of the SMWG resigned. The SMWG evolved into a forum for people interested in issues related to classical music in Silicon Valley. The group met regularly to discuss research findings but not to produce any official recommendations, and eventually disbanded.

In the end, the community may have been left in a state of limbo. Some would say that the case is now closed. Silicon Valley has a new orchestra. Symphony Silicon Valley, which was formed by the local ballet company and then was subsequently spun off in its second season to be a freestanding organization, became active and established its own following. In many ways, it appeared to have learned lessons from the SJS's demise. As of this writing, it gives most of its concerts in the beautifully restored 1,100-seat Fox (now called the California Theatre), a substantial improvement over the cavernous and inhospitable CPA. The number of concerts has been much reduced from that of the SJS, presumably to match supply more closely with demand. Its programming seems more diverse with the potential for much wider appeal.

Yet, others wonder whether an opportunity may have been lost to create something totally fresh and new—a model that could provide an inspiration for many other communities facing similar challenges in the twenty-first century. The Symphonic Music Working Group was exploring that question. But now we will probably never know the answer.

Some wonder whether an opportunity may have been lost to create something totally fresh and new—a model that could provide an inspiration for many other communities

PART V:
BROADER QUESTIONS
AND
LESSONS LEARNED

Broader Questions

Imagine you are running a business. For a hundred years, it has been a relatively small and successful business. You have shareholders who have been content with a loyal handful of customers and a modest return on investment. Many generations of employees have helped the business to prosper and have received minimal (but many would say "adequate") wages for doing so. After your first century, you decide to expand. You do so in the face of mounting evidence that there is new competition and changing demand for your product. Based on past success, you succeed in finding new investors. But now your employees want significantly better wages and benefits at the same time that your loyal customer base is on the decline. Management seems unable to cope with the new realities. You start losing money. Your shareholders start to complain.

At this point, before it is too late, wouldn't you consider selling out to your competition, taking whatever equity you could from your assets before dissolving the business, or reinventing yourself in a manner consistent with profitability? Even if you didn't, wouldn't your shareholders make sure you made decent decisions before running the business into the ground and declaring bankruptcy?

The San Jose Symphony was such a business. Once modestly successful, it was unable to adjust to a changing environment, and it made many decisions that seemed to defy reality. As John Kreidler remarked, the SJS "had ample funder-initiated interventions that could have saved it, and without lifting a finger, the symphony could have occupied the new California Theatre. . . . But it suffered from the same unfortunate hubris as the Oakland Symphony, which similarly committed itself to a course of head-to-head competition

with the San Francisco Symphony. Oakland had been an outstanding regional orchestra with a unique musical perspective focused on twentieth-century music, but when it decided to take on San Francisco, it changed its repertoire, jettisoned a highly popular conductor, developed a too-large performance hall, expanded its season and musician services, and soon passed into history."[36]

Part of the problem may have been that these orchestras were nonprofit corporations. As such, they did not have equity investors whose personal wealth was at stake every time a business decision was made. The trustees may have believed, quite correctly, that the mission of a nonprofit corporation is public service, not profit; but this belief somehow resulted in poor decisions with dire financial consequences.

Could any combination of interventions have saved the SJS in the long term? Had the environment become so infertile that it made no sense to continue? Again, to quote Kreidler, "You can grow palm trees in the arctic if you are willing to build hot houses with appropriate warmth, soil, and light, but why? From my limited but long (twenty years) observations of the San Jose Symphony, the organization seemed to be in a long slide, due not only to its mistakes, but more profoundly to the increasingly 'arctic' demand environment of the South Bay. The population was becoming younger, more culturally diverse, and less musically literate, especially in the classical forms of music."[37]

> And so one has to ask the inevitable question: Are there times when it is prudent to plan carefully for the end of a symphony orchestra?

And so one has to ask the inevitable question: Are there times when it is prudent to plan carefully for the end of a symphony orchestra? Suppose in the 1990s, when Silicon Valley was booming and the San Jose Symphony was not, the board had convened and reached the conclusion that the SJS had become Kreidler's proverbial "palm tree in the arctic." No reasonable amount of marketing was going to attract the contemporary population, and there was no retreat possible to a shorter season without incurring divisive strikes.

What if the board had elected to dissolve with honor, a course that would have engendered some level of criticism, but would have acknowledged that the organization was only of marginal benefit to its community, however long its history? The symphony could have reinvented itself to become more relevant to the postmodern environment of the South Bay, but only a very few organizations (especially those with unionized workforces) have the capacity to implement wholesale reforms that make them viable in a changed environment. The early recognition of this growing obsolescence and a decisive closure would have been preferable to the prolonged and messy death that ate up the SJS's remaining resources, including goodwill.

Finally, this leads to the ultimate question: Does a great city really need a great orchestra or one with "great orchestra" aspirations? San Jose is a great city. But did it really need a full-season professional orchestra—one with high-caliber musicians playing symphony orchestra concerts in a large downtown venue week after week? Did it need a great concert hall? Did it need a European-born music director with a fancy pedigree? Did it need all the accoutrements that go with the symphony orchestra organizations—organizations established in the nineteenth-century European mold and later modeled on a very few successful institutions in select U.S. cities?

As we begin a new century and the full implications of having a great symphony orchestra are played out in city after city, it may be appropriate to raise certain questions. Have changes in the demographics of our communities and in the entertainment marketplace changed fundamental assumptions about the need for professional orchestras in the traditional mold? Are rising costs and falling demand clear indications that many professional orchestras simply will be unable to thrive in the twenty-first century?

Indeed, one might ask, Who needs professional symphony orchestras, and who is willing to pay for them? Speculating

> Finally, this leads to the ultimate question: Does a great city really need a great orchestra or one with "great orchestra" aspirations?

on this, however interesting, turns out to be anathema in the orchestra field today. But as we look ahead in the present century to inevitable changes in demographics, taste, and the delivery of entertainment product, the issue and the questions will not go away.

Lessons Learned

The demise of the San Jose Symphony occurred to a unique institution in a particular time and place. Yet what occurred has resonance for other organizations in other places and in other times. Some of the lessons to take away from the experience in San Jose are specific to symphony orchestras; others are broader.

The demise of the San Jose Symphony occurred to a unique institution in a particular time and place. Yet what occurred has resonance for other organizations in other places and in other times.

Lessons for Symphony Orchestras

1. Musical leadership must respond to local realities. There is no such thing as a great music director who will be equally successful in Berlin, San Jose, or Peoria. A music director's success is specific to a time and place. Local demographics, community imperatives (such as the need for expanded music education), local taste—these and other considerations should guide the choice of musical leader. In San Jose, an unfortunate mismatch was partially responsible for the organization's demise.

2. Hiring policies must reflect the scale of sustainable programming. The level of musician employment must be carefully calibrated with the demand for services. This means laying out a season first and then hiring to that reality. Doing the inverse—starting with a guaranteed service count and

then looking for work to fill it—may lead to the downfall of an orchestra, as it did with the SJS. A collective bargaining environment may make the proper approach more challenging, but the board leadership of an orchestra must be willing to close it down temporarily until it is able to develop a plan that its musicians can accept and that the institution can afford.

3. A respectful and high-quality work environment for musicians is crucial. The life of a musician is a stressful one. The expectation is for a consistent high level of performance in an environment in which making a living is often a constant challenge. Orchestras can ease some of the burden, not by providing more employment than they can afford, but by developing a predictable and high-quality working situation that respects the professionalism and dedication of its musicians. Such an environment was not present at the SJS.

4. Audience members must have a quality experience. Because an orchestra is in the entertainment business, satisfying the consumer must be among its primary goals. This means everything from performances in high-quality halls that are the proper size and have good acoustics and ambiance to appropriate programming. It means having educational opportunities for those who want them and amenities that speak to the desires of an increasingly demanding public. The SJS was unable to provide this experience for many, and as a result, they refused to attend.

Broader Lessons

Beyond these industry-specific lessons, other lessons from the SJS's experience can and should be applied to any nonprofit organization anywhere:

5. The organization's vision must be achievable and sustainable as well as appropriate to the community.

Orchestras should provide employment situations that respect the professionalism and dedication of their musicians.

First and foremost, an orchestra (or any nonprofit organization) must develop a vision that is based in the realities of its community—a vision that is achievable in the short run and sustainable in the long run. The San Jose Symphony was never going to be a major orchestra on the scale or artistic caliber of the San Francisco Symphony. But it could have been valued and respected in its own right had it developed a profile that matched what the community wanted and could support.

6. The organization must have responsible governance and oversight. The failure of any nonprofit organization must ultimately be laid at the feet of its board, which has legal authority to oversee its operations, programming, and financial health. Although some trustees made a valiant effort on behalf of the SJS, the group was not cohesive and did not work in harmony toward a common set of goals. Also, not enough trustees provided the kind of personal financial support through direct contributions and fund-raising that the ambitious vision demanded.

Running an orchestra demands knowledge of music, orchestra operations, collective bargaining, marketing and fund raising, and personnel management.

7. Staff leadership must be skilled in the business of running the organization. Running most organizations takes specialized knowledge and skill. Running an orchestra is a particularly complex activity demanding knowledge of music, orchestra operations, collective bargaining, marketing and fund raising, and personnel management. For long periods of time, the SJS lacked people with these skill sets, and the organization suffered accordingly.

8. Responsible and reliable systems for budgeting and financial controls must be in place. Budgeting and fiduciary oversight are critical to the success of any nonprofit organization. But especially in a field in which contractual commitments must be made as much as three years in advance, budget forecasting and review require special techniques and approaches. What are especially necessary—and what were lacking at the SJS—are systems, controls, and

contingencies to correct for the inevitable miscalculations, as well as the discipline to make tough decisions when the financial realities demand them.

9. The organization must have an open-minded consideration of market realities. Again, any nonprofit organization must understand and respond to its market. In the case of an orchestra, audience demand and competition within an entertainment marketplace are considerations that will largely determine what the orchestra can do programmatically. Scaling the activities of the organization beyond what the market will bear is a recipe for trouble. The SJS misread its market and did not pay attention to the competition. The result was half-empty halls and a precipitous decline in earned income.

> The funders' traditional mantra "do no harm" may sometimes lead to timidity in the face of opportunities to do some good.

10. Funders must be willing to be tough. Sometimes funders must take a very high-profile role in getting a nonprofit organization on track. This includes withholding funding and insisting on specific changes to be implemented or benchmarks to be met. The funders' traditional mantra "do no harm" may sometimes lead to timidity in the face of opportunities to do some good. When an organization is off track, as the SJS was for some time, the funding community may be the last best hope to rectify the situation before it is too late.

11. The organization must be willing to say "enough is enough." Finally, there is the biggest lesson of all, the one that can be applied to any organization—for-profit or nonprofit—anywhere and at any time. There comes a moment in the life of many organizations when continued operation simply does not make sense. In the case of the SJS, that moment probably came well before bankruptcy was declared, but the specter of a "great city" losing its large professional symphony may have prevented clear-sighted reality testing. Much anguish might have been avoided had the signs been read earlier. Even so, the leadership group that finally made

the decision to disband the SJS may deserve more approbation than it ultimately received. Unlike orchestras in other communities that struggle along unsuccessfully year after year from crisis to crisis, the SJS was able to challenge the conventional norms in its industry and call it quits.

The San Jose Symphony, like so many orchestras around the country, had been a precious community resource with a proud history. Its demise was a loss, regardless of whether in the end it made perfect sense and regardless of what institutions have come along to replace it. Those of us who care about classical music in America, and the health of the nonprofit field generally, have the collective responsibility to understand what happened and do all we can to prevent similar missteps from occurring elsewhere.

APPENDICES

Appendix A

The Competitive Marketplace for Classical Music in Silicon Valley

The following text is taken from a March 10, 2003, presentation by Wolf, Keens & Company. The presentation was based on research conducted for the so-called Symphonic Music Working Group formed to consider the future of symphonic music in Silicon Valley.

- There are at least 54 organizations offering 387 classical music events in Silicon Valley. This is a small fraction of the total events available in the entire Bay Area.

- There are 28 orchestras offering classical music in Silicon Valley:
 - 5 professional symphony orchestras
 - 9 community orchestras
 - 4 professional chamber orchestras
 - 1 amateur chamber orchestra
 - 9 youth orchestras

- Additionally, Silicon Valley offers another 26 organizations providing classical music:
 - 4 opera companies
 - 9 choral groups
 - 10 performing arts series
 - 3 classical music festivals

- These 54 organizations are currently offering an average:
 - 7.5 performances/week
 - 1 performance for each 6,000 residents of Silicon Valley (2,300,000 total population)
 - 1 performance for every 250 classical music prospects (assuming a high penetration rate of 4%)

- The 28 orchestras offer 190 performances in Silicon Valley:
 - 33 professional symphony orchestra performances
 - 67 community orchestra performances
 - 21 professional chamber orchestra performances
 - 4 amateur chamber orchestra performances
 - 65 youth orchestra performances

- The other 26 organizations providing classical music offer 197 performances in Silicon Valley:
 - 84 opera company performances
 - 40 choral group performances
 - 49 performing arts series performances
 - 24 classical music festival performances
- There is a broad distribution of performances by month:
 - September: 22 (5 weekdays; 17 weekends)
 - October: 34 (3 weekdays; 31 weekends)
 - November: 56 (9 weekdays; 47 weekends)
 - December: 30 (3 weekdays; 27 weekends)
 - January: 16 (3 weekdays; 13 weekends)
 - February: 52 (9 weekdays; 43 weekends)
 - March: 55 (4 weekdays; 51 weekends)
 - April: 29 (5 weekdays; 24 weekends)
 - May: 51 (6 weekdays; 45 weekends)
 - June: 16 (1 weekday; 15 weekends)
 - July: 4 (0 weekdays; 4 weekends)
 - August: 22 (11 weekdays; 11 weekends)
- There is a broad distribution of performances by geography:
 - Palo Alto/Menlo Park/Los Altos/Mountain View—151
 - 80 orchestra
 - 71 other
 - San Jose/Santa Clara—121
 - 28 orchestra
 - 93 other
 - Saratoga/Cupertino—32
 - 24 orchestra
 - 8 other
 - Santa Cruz/Gilroy/San Juan Bautista/Salinas—31
 - 22 orchestra
 - 9 other
 - Fremont/Hayward/Livermore—27
 - 7 orchestra
 - 10 other
 - San Mateo/Redwood City—25
 - 19 orchestra
 - 6 other

- Certain venues are used most frequently for classical music:
 - Montgomery Theatre, San Jose—57
 - Le Petit Trianon, San Jose—38
 - Spangenberg Theatre, Palo Alto—35
 - Lucie Stern Theatre, Palo Alto—18
 - Mountain View Center for the Performing Arts—16
 - Flint Center, Cupertino—14
- There are a minimum of 92,073 admissions to orchestral performances in Silicon Valley annually comprised of:
 - 78,290 paid admissions
 - 13,783 unpaid admissions
- The minimum aggregate expenditure for tickets for orchestra concerts in Silicon Valley is $1,767,680 (based on reporting from 24 organizations out of a sample of 28).
- The aggregate budgets of the Silicon Valley–based orchestra organizations is $3,807,435.
 - This works out to $33.11 per classical music prospect.
 - This does not include money paid to organizations from outside the area that perform in Silicon Valley but does include the San Francisco Symphony budget for the Flint Series.

• Conclusion 1
There are many opportunities to attend live classical music events in Silicon Valley. For those willing to travel to San Francisco, the opportunities expand exponentially.

• Conclusion 2
Given the many opportunities to attend live classical music concerts in Silicon Valley and the Bay Area, any new orchestral venture must differentiate itself in terms of mission, programming, the performance experience, quality, and/or other dimensions.

• Conclusion 3
Given long-established institutional loyalties to existing classical music organizations, a new symphonic venture must offer potential ticket buyers and funders something they regard as worthy of additional support.

• Conclusion 4
Many organizations will regard any new symphonic venture as competitive, and they could work actively against its success unless there are incentives for them not to do so. Competition can include fund-raising, ticket sales, venues, musicians, and other areas.

• Conclusion 5
Any new symphonic venture must make sense in terms of a Bay Area strategy for classical music.

Appendix B

2000 / 2001 Ticket Sales Data

The chart on the following pages summarizes data in a San Jose Symphony report entitled *2000-2001 Season Subscription and Single Ticket Sales*.

2000/2001 Season Analysis

Date	Venue	Subscriptions	Subscrip. $	Single Tickets	Single $	Total Capacity	% Sold
SIGNATURE SERIES							
9/22/00	CPA	907	25,926	94	2,607	2,673	37%
9/23/00	CPA	1,115	31,652	103	3,150	2,673	46%
9/24/00	Flint	1,188	25,319	132	3,181	2,427	54%
		3,210	82,897	329	8,938	7,773	46%
10/6/00	CPA	903	24,650	392	9,718	2,673	48%
	CPA	1,271	35,432	561	15,014	2,673	69%
		2,174	60,082	953	24,732	5,346	58%
10/20/00	CPA	908	25,941	128	2,768	2,673	39%
	CPA	1,115	31,755	160	4,512	2,673	48%
	Flint	1,169	25,105	147	3,014	2,427	54%
		3,192	82,801	435	10,294	7,773	47%
11/17/00	CPA	909	24,797	603	14,245	2,673	57%
	CPA	1,269	35,206	795	18,764	2,673	77%
	Flint	1,210	25,794	601	13,721	2,427	75%
		3,388	85,797	1,999	46,730	7,773	69%
1/5/01	CPA	917	26,245	218	6,441	2,673	42%
	CPA	1,132	32,030	313	9,077	2,673	54%
	Flint	1,194	25,801	259	5,867	2,427	60%
		3,243	84,076	790	21,385	7,773	52%
2/1/01	CPA	914	24,967	323	8,051	2,673	46%
	CPA	1,296	36,039	577	14,781	2,673	70%
		2,210	61,006	900	22,832	5,346	58%

Date	Venue	Subscriptions	Subscrip. $	Single Tickets	Single $	Total Capacity	% Sold
2/16/01	CPA	917	26,243	345	9,606	2,673	47%
	CPA	1,132	32,030	535	15,102	2,673	62%
	Flint	1,218	25,986	514	11,412	2,427	71%
		3,267	84,259	1,394	36,120	7,773	60%
3/2/01	CPA	912	24,887	77	2,027	2,673	37%
	CPA	1,284	35,610	129	3,495	2,673	53%
	Flint	1,194	25,801	97	2,165	2,427	53%
		3,390	86,298	303	7,687	7,773	48%
3/30/01	CPA	919	26,323	158	4,047	2,673	40%
	CPA	1,144	32,459	401	9,771	2,673	58%
		2,063	58,782	559	13,818	5,346	49%
4/20/01	CPA	912	24,887	275	6,194	2,673	44%
	CPA	1,284	35,610	448	12,279	2,673	65%
	Flint	1,207	25,876	366	9,664	2,427	65%
		3,403	86,373	1,089	28,137	7,773	58%
5/11/01	CPA	919	26,323	608	8,256	2,673	57%
	CPA	1,144	32,459	721	21,519	2,673	70%
		2,063	58,782	1,329	39,775	5,346	63%
6/8/01	CPA	912	24,887	421	12,110	2,673	50%
	CPA	1,284	35,610	457	12,757	2,673	65%
	Flint	1,194	25,801	604	15,090	2,427	74%
		3,390	86,298	1,482	39,957	7,773	63%
SIGNATURE SERIES SUMMARY							
	CPA	10,949	306,076	3,642	96,070	32,076	45%
	CPA	14,470	405,892	5,200	140,221	32,076	61%
	Flint	9,574	205,483	2,720	64,114	19,416	63%
	Total	34,993	917,451	11,562	300,405	83,568	56%
FAMILY							
10/1/00	CPA	1,254	15,098	457	4,850	2,673	64%
2/4/01	CPA	1,254	15,098	600	6,162	2,673	69%
4/1/01	CPA	1,256	15,122	432	4,436	2,673	63%
FAMILY SUMMARY							
		3,764	45,318	1,489	15,448	8,019	66%

Date	Venue	Subscriptions	Subscrip. $	Single Tickets	Single $	Total Capacity	% Sold
FAMILIAR CLASSICS							
11/4/00	Flint	835	22,084	254	5,921	2,427	45%
1/27/01	Flint	844	22,332	387	9,665	2,427	51%
3/1/01	Flint	844	22,332	688	13,195	2,427	63%
5/26/01	Flint	835	22,084	376	7,812	2,427	50%
FAMILIAR CLASSICS SUMMARY							
		3,358	88,832	1,705	36,593	9,708	52%
SUPER POPS							
10/28/00	Flint	1,396	38,692	241	8,268	2,427	67%
	Flint	1,361	28,522	389	10,197	2,427	72%
		2,757	67,214	630	18,465	4,854	70%
12/16/00	Flint	1,398	38,749	31	437	2,427	59%
	Flint	1,368	28,688	311	7,849	2,427	69%
		2,766	67,437	342	8,286	4,854	64%
2/10/01	Flint	1,399	38,781	206	6,962	2,427	66%
	Flint	1,371	28,743	241	5,978	2,427	66%
		2,770	67,524	447	12,940	4,854	66%
3/24/01	Flint	1,399	38,781	416	13,932	2,427	75%
	Flint	1,371	28,743	312	8,265	2,427	69%
		2,770	67,524	728	22,197	4,854	72%
5/5/01	Flint	1,399	38,781	121	3,764	2,427	63%
	Flint	1,370	28,723	207	4,879	2,427	65%
		2,769	67,504	328	8,643	4,854	64%
6/2/01	Flint	1,399	38,781	285	9,434	2,427	69%
	Flint	1,370	28,723	329	7,932	2,427	70%
		2,769	67,504	614	17,366	4,854	70%
SUPER POPS SUMMARY							
		8,390	232,565	1,300	42,797	14,562	67%
		8,211	172,142	1,789	45,100	14,562	69%
		16,601	404,707	3,089	87,897	29,124	68%
SPECIAL PROGRAMS							
10/1/00	CPA	0	0	1,087	63,275	2,673	41%
2/4/01	CPA	0	0	1,436	40,066	2,673	54%
4/1/01	SJSU	0	0	2,349	111,415		
SPECIAL PROGRAMS SUMMARY							
				2,523	103,341	5,346	47%

Appendix C

Wage Scale and Benefits History

The following chart is a San Jose Symphony report on musicians' wage scale and benefits history.

SAN JOSE SYMPHONY MUSICIANS' WAGE SCALE AND BENEFITS HISTORY

Category	1989/90	1990/91	1991/92 1st half	1991/92 2nd half	1992/93	1993/94 1st half	1993/94 2nd half	1994/95
Wage Scale								
Section	69.00	73.00	73.00	77.00	80.00	80.00	82.00	84.00
Asst. Principal	79.35	83.95	83.95	88.55	92.00	92.00	94.30	96.60
Principal	86.25	91.25	91.25	96.25	100.00	100.00	102.50	105.00
% Increase	5.8	2.74	6.66		1.25	3.7		4.76
Guaranteed Services								
Group A	190	193	193		171	180		185
Group B	174	177	177		155	164		169
Group C	118	118	140		119	128		133
Group D*	0	0	106		91	97		101
Group E*	0	0	39		34	36		37
Vacation	5	5	5		5	5		5
(Services included above)								
Personal/Sick Leave (number of paid services)								
Group A	10	10	10		8	8		9
Group B	8	8	8		7	7		8
Group C	5	5	5		5	5		6
Group D*	0	0	5		5	5		6
Group E*	0	0	5		5	5		6
Pension	0.00%	0.00%	2.50%		2.50%	2.50%		2.50%
		2.50%						
Medical	515.46	1,034.48	1,205.91		1,205.91	1,205.91		1,205.91
		1,145.76						
Contract Groups (number of musicians)								
Group A	20	20	20		20	20		20
Group B	40	40	40		40	40		40
Group C	27	27	27		26	26		26
Group D*	0	0	1		2	2		2
Group E*	0	0	1		1	1		1

Category	1995/96	1996/97	1997/98	1998/99	1999/00	2000/01	2001/02
Wage Scale							
Section	88.00	92.00	96.00	100.0	107.00	114.49	122.50
Asst. Principal	101.20	105.80	110.40	115.00	123.05	131.66	140.88
Principal	110.00	115.00	120.00	125.00	133.75	143.11	153.13
% Increase	4.54	4.34	4.16	7	7	6.99	
Guaranteed Services							
Group A	185	185	185	185	185	185	185
Group B	169	169	169	169	169	186	196
Group C	140	140	140	140	147	147	147
Group D*	106	106	106	112	112	112	112
Group E*	39	39	39	41	41	41	41
Vacation	5	5	5	5	5	5	5
(Services included above)							
Personal/Sick Leave (number of paid services)							
Group A	9	9	9	9	9	9	9
Group B	8	8	8	8	8	8	8
Group C	6	6	6	6	6	6	6
Group D*	6	6	6	6	6	6	6
Group E*	6	6	6	6	6	6	6
Pension	0.00%	3.50%	4.00%	5.00%	6.00%	7.00%	8.00%
Medical	515.46	1,284.56	1,374.45	1,547.01	1,655.17	1,655.17	1,655.17
Contract Groups (number of musicians)							
Group A	20	20	20	20	20	20	20
Group B	40	40	40	40	46	50	55
Group C	26	26	26	26	21	17	12
Group D*	2	2	2	2	1	1	1
Group E*	1	1	1	1	1	1	1

*Groups D and E began in 1991/92.

NOTES

1. After flirting with the idea of a Chapter 11 bankruptcy that would have permitted reorganization, the decision was made to file for a Chapter 7 bankruptcy, which led to total dissolution.

2. The Wolf Organization, Inc., *The Financial Condition of Symphony Orchestras* (Washington, DC: American Symphony Orchestra League, 1992). This work traces orchestra finances during the decades of the 1970s and 1980s. It is interesting to note that artistic costs as a percentage of total costs remained at about the same level for almost two decades. Indeed, it was not only the cost of musicians that was increasing—all costs were increasing.

3. Seventy-four percent of subscribers and 71 percent of single-ticket buyers sang in a choir or played a musical instrument at some time in their lives (Audience Insight LLC, *How Americans Relate to Classical Music and Their Local Orchestras* [Miami, FL: Knight Foundation, 2002], p. A-164).

4. AMS Planning & Research, "A Public Survey of Participation and Attitudes Towards Arts and Culture in Santa Clara County and the City of San Jose," in *20/21: A Regional Cultural Plan for the New Millennium* (Petaluma, CA: City of San Jose and Arts Council of Santa Clara County, 1997), vol. 3, section 1, p. 18.

5. Figures are for 1996 and come from *Joint Venture: Silicon Valley 1996 Index* (San Jose, CA: Joint Venture Silicon Valley Network). In fact, age and education are the two highest demographic factors that correlate with symphony attendance.

6. Cultural Initiatives Silicon Valley, *Creative Community Index* (San Jose, CA: Cultural Initiatives Silicon Valley, 2002), p. 9.

7. AMS Planning & Research, "A Public Survey," section 1, p. 12.

8. Alan Brown, *Analysis of Demand for Live Classical Music Programs in Silicon Valley* (Southport, CT: Audience Insight LLC, 2002), p. 11.

9. Audience Insight, *How Americans Relate*, p. 7.

10. John Kreidler, Executive Director, Cultural Initiatives Silicon Valley, personal e-mail communication, December 28, 2004. Kreidler was a program officer of the San Francisco Foundation at the time.

11. Brown, *Analysis of Demand*, p. 17.

12. Alan Brown, *Online Survey and Focus Group Research on Classical Music Participation in Silicon Valley* (Southport, CT: Audience Insight, LLC, 2003).

13. A privately commissioned study by the top eleven orchestras by budget size shows that between the 1995/1996 season and the 2003/2004 season, the total number of tickets sold declined by 13 percent. The number of subscriptions sold declined by 20 percent.

14. Brown, *Analysis of Demand*, p. 16.

15. Although the number of guaranteed services for Group A musicians (twenty players) decreased from 190 to 185 over the period 1989/1990 to 2001/2002, the number of guaranteed services for Group B grew from 174 to 196 (13 percent growth), and Group C grew from 118 to 147 (25 percent growth). The total number of musicians over the period 1989/1990 to 2001/2002 did not expand significantly (growing from eighty-seven to eighty-nine), but it is important to note that a number of musicians moved from Group C (which has fewer guaranteed services) to Group B (with the highest level of guaranteed services). This resulted in an increase in guaranteed services from 13,946 in 1989/1990 to 16,397 in 2001/2002 (an increase of 18 percent).

16. When the ballet reduced its service count, the SJS decided to increase educational and community outreach service components. The Project Music program was begun in 1998/1999. Through this program, SJS musicians offered free concerts in community settings, as well as ensemble and soloist performances. Unfortunately, there was no earned revenue supporting this program, and after a generous sponsorship from AboveNet in the program's first year, no further sponsorship support was secured. This meant that the carrying costs for the symphony were not reduced, even as revenue was dropping significantly.

17. The trend to reduce the number of salaried musicians with guarantees is not limited to smaller-budget orchestras. In the most recent contract of the Philadelphia Orchestra, approved on November 20, 2004, the number of musicians under contract was reduced (by attrition) by six. The Chicago Symphony also reduced its overall workforce numbers.

18. Thomas Wolf, *Managing a Nonprofit Organization in the 21st Century* (New York: Simon & Schuster, 1999), p. 48.

19. Many board members represented companies in Silicon Valley, and their contributed support to the symphony for the most part came through the companies with which they were associated. This form of philanthropic support worked to some effect during the boom years of the technology industry in Silicon Valley, but when the companies stopped contributing, it did not serve the symphony well.

20. Bruce Coppock, *Report to the Community Foundation Silicon Valley Regarding the State of the San Jose Symphony with an Evaluation of its Plans for the Fox Theatre* (December 11, 1997), p. 4.

21. Coppock, p. 16.

22. Thomas Wolf and Gina Perille, "The 21st Century Music Director: A Symposium," *Harmony* 14, April 2002.

23. Wolf and Perille.

24. Coppock, p. 16.

25. Wolf Organization, Inc., *Financial Condition*.

26. The source for these statistics is the *Joint Venture: Silicon Valley 1996 Index* (San Jose, CA: Joint Venture Silicon Valley Network).

27. Civic Strategies Inc. Metro Areas Scan (www.civic-strategies.com/resources/metros/san_jose.htm).

28. Brown, *Online Survey*, p. 2.

29. AMS Planning & Research, *Silicon Valley Performance Facility Inventory*, January 2003, p. 5.

30. The Fox Theatre (now the California Theatre) was subsequently renovated by the San Jose Redevelopment Agency, with assistance from the Packard Humanities Institute, and is currently being used by a local orchestra that came into existence after the demise of the SJS. Reports are that despite the disadvantages of its smaller size, it is a greatly improved option for orchestra concerts.

31. AMS Planning & Research, "A Public Survey," section 1, p. 36.

32. City of San Jose and Arts Council of Santa Clara County, *20/21: A Regional Cultural Plan for the New Millennium (San Jose, Santa Clara County, Silicon Valley)*, 3 vols., May 1997.

33. Coppock, pp. 11-12.

34. Coppock, p. 23.

35. "Confidential Report from the San Jose Symphony Advisory Panel to the Executive Transition Board of the San Jose Symphony: Findings and Recommendations," May 1, 2002.

36. John Kreidler, personal e-mail communication, December 28, 2004. For an in-depth analysis of the demise of the Oakland Symphony, see Melanie Beene's excellent monograph, *Autopsy of an Orchestra* (San Francisco: Melanie Beene, 1988). Further analysis of this same symphony is available in an article by James A. Phills, Jr., "The Sound of No Music," *Stanford Social Innovation Review* (Stanford Graduate School of Business, Stanford, CA, Fall 2004).

37. Kreidler.

ACKNOWLEDGMENTS

Much of the research cited in this book was carried out with funds from the David and Lucile Packard Foundation through the Arts Council Silicon Valley. Our thanks to the Packard Foundation and to Bruce Davis, executive director of the Arts Council, for his assistance.

Jane Culbert, a senior consultant at Wolf, Keens & Company, pulled together much of the research, developing charts and analyses, and editing drafts of this manuscript. Without her help, the book would probably never have been completed.

Many of those who contributed insight to this volume are credited in the footnotes. Four people read early drafts and made important suggestions (though they should not be held responsible for any errors of fact or judgment). Our thanks to them:

Alan S. Brown, *Principal, Alan S. Brown & Associates*
Bruce Coppock, *President and Managing Director, Saint Paul Chamber Orchestra*
Joseph Kluger, *Executive Director, Philadelphia Orchestra*
John Kreidler, *Executive Director, Cultural Initiatives Silicon Valley*

Several individuals listed below agreed to be interviewed in order to provide additional context and background. Their assistance is gratefully acknowledged (though once again, it should be emphasized that the opinions expressed are the authors' own): Jerry Allen, Brent Assink, Tim Beswick, Marie Bianco, Carl Cookson, Mary Curtis, Christopher Greene, Michael Hackworth, Jay Harris, Bob Kieve, Galen Lemmon, Doug McClendon, Mike McSweeney, Ben Miyaji, Peter Pastreich, Nancy Ragey, Kathleen Rydar, Joan Simpson, Lou Tersini, Alexandra Urbanowski, and Nancy Wiener.